The Story of American Painting

ABRAHAM A. DAVIDSON

The Story
of American
Painting

HARRY N. ABRAMS, INC., PUBLISHERS, NEW YORK

FRONTISPIECE

Jasper Johns, *Flag* (see plate 139)

RUTH EISENSTEIN, *Editor*

LISA PONTELL, *Picture Editor*

LIBRARY OF CONGRESS CATALOGING IN PUBLICATION DATA

Davidson, Abraham A.
 The story of American painting.

 Companion volume: The story of painting,
by H. W. and D. J. Janson.
 1. Painting, American—History. I. Title.
ND205.D23 759.13 74-5116
ISBN 0-8109-2069-7

Contents

Chapter One THE BEGINNINGS OF AMERICAN PAINTING 6
THE LIMNERS AND THE PATROON PAINTERS 8
THE COLONIAL ARTIST 13
LATER PRIMITIVE PAINTING 18

Chapter Two THE HISTORY OF AMERICA IN PAINTINGS 24
AMERICA'S YOUTH: THE YEARS BEFORE THE CIVIL WAR 25
THE CIVIL WAR YEARS AND AFTER 35

Chapter Three NOTABLE AMERICAN PORTRAITS 44
"THE MOVERS AND THE SHAKERS":
PORTRAITS OF CELEBRATED AMERICANS 46
PORTRAITS OF UNSUNG AMERICANS 59

Chapter Four THE AMERICAN NATURAL LANDSCAPE 66
THE HUDSON RIVER SCHOOL 68
THE ROCKY MOUNTAIN SCHOOL 75
THE LUMINISTS 77
LATE-NINETEENTH-CENTURY LANDSCAPISTS 81

Chapter Five AMERICANS AT WORK AND PLAY 82
GENRE PAINTING BEFORE THE CIVIL WAR 82
GENRE PAINTING AFTER THE CIVIL WAR 91
GENRE PAINTING IN THE WEST 97

Chapter Six THE VISIONARY TRADITION 98
VISIONARIES ASSOCIATED WITH OTHER TRADITIONS 100
THE ECCENTRIC VISIONARIES 109

Chapter Seven THE AMERICAN URBAN LANDSCAPE 118
THE ASH CAN SCHOOL 120
LATER REALISTS 124
EARLY MODERNISTS 127

Chapter Eight NONOBJECTIVE PAINTING 134
EARLY NONOBJECTIVE PAINTING 136
ABSTRACT EXPRESSIONISM 140

Chapter Nine PAINTING IN THE 1960s 150
POP ART 153
POST-PAINTERLY ABSTRACTION 163

INDEX 166

1. Joseph Blackburn.
Isaac Winslow and His Family.
1755. Oil on canvas, 54 1/2 × 79 1/2″.
Museum of Fine Arts, Boston.
Abraham Shuman Fund

CHAPTER ONE
The Beginnings of American Painting

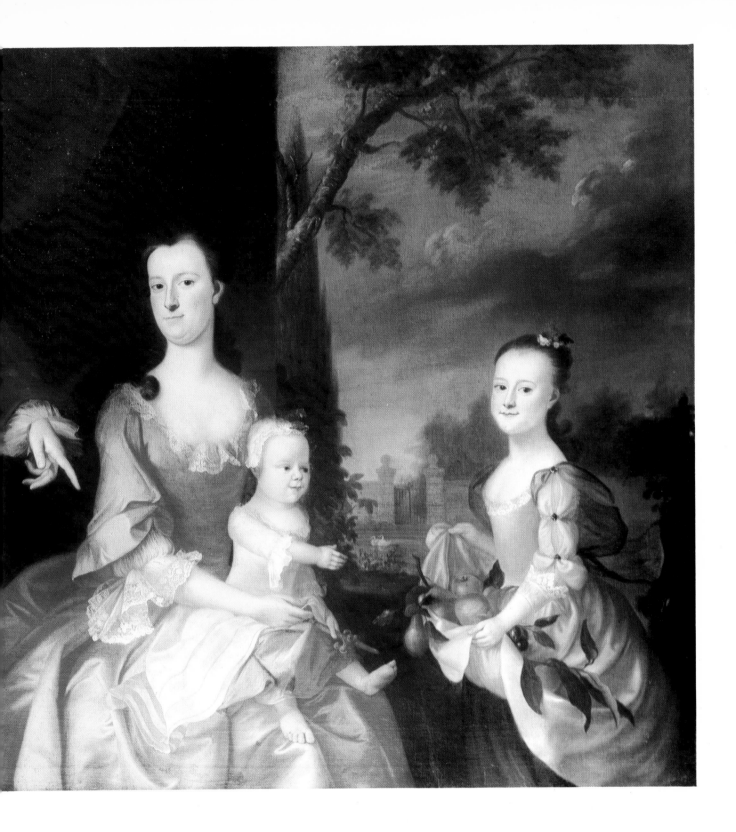

The earliest American painting that has come down to us dates from shortly after the middle of the seventeenth century, over a hundred years before the separation of the colonies from England. This was roughly the time when Vermeer and Rembrandt were painting in the Netherlands and Velázquez in Spain. It was some sixty years earlier, in 1607, that the English, under the leadership of Captain John Smith, had made their first permanent settlement in America—in Jamestown, Virginia.

THE LIMNERS AND THE PATROON PAINTERS. The earliest American painters we know of, who worked from the 1660s to about 1700, were designated in the documents and letters of the time as "limners" (from the word "limn," meaning to draw). Since few of their works are signed, their real names are for the most part unknown to us. The best we can do is to refer to them by the names of their subjects. Thus the creator of *Mrs. Elizabeth Freake and Baby Mary* (plate 2) is often called the Freake Limner. Experts in the field, studying the fine points of painting style, have identified other works by this artist, and they have attributed a whole group of portraits to other unknown limners.

Traveling from town to town to gain a meager living, the limners were regarded as artisans or tradesmen rather than as artists, because in fact their livelihood came not so much from painting portraits as from composing and painting trade signs, painting the walls of houses, and staining furniture. Some of the earliest American portraitists must have been trained as artisans in European guilds. Arrived in this country, they suffered many hardships—the difficulty of making their way through uncharted forests, the hostility of Indians, the scarcity of food, the bitter cold of New England winters. They had no original works of art—except their own—to study, and there were, of course, no art schools. As for art supplies, they had to mix their own paints and make their own brushes, canvases, and stretchers.

Many of the figures painted by the New England limners seem flat: they give us no sense of mass or volume. This is not because these limners were unsophisticated painters unable to model their figures by indicating a light source through the gradation of values from light to dark. Rather, it was because they chose not to have their figures appear solid in the Renaissance manner of painters on the Continent. The flat, decorative manner of these New England painters derives from the Tudor tradition of English portraiture, which flourished during the reign of Elizabeth I and after, yielding gradually to the influence of Van Dyck after he settled in London in 1632. Nonetheless, the paintings of the New England limner represent an original approach. No longer seen are English color schemes and compositional arrangements. In a few of these paintings there is felt a hesitation as to how far to follow the Tudor flatness, a struggle to attain a new coherence. These New England limners are groping toward illusionism, that is, they are impelled to reproduce more accurately what they see. In place of the earlier English assuredness, these paintings have a new directness and power.

In *Mrs. Elizabeth Freake and Baby Mary*, of about 1674, the mother is holding her child lightly yet securely. She looks absently away from Baby Mary toward the spectator, and in her expression there is the slightest shade of resentment at the invasion of their privacy. The baby pushes against her mother with her left hand, but she reaches for her mother's left hand with her right. (Examination with X-rays has revealed that the artist attempted several positions of the baby's left arm before reaching the present solution.) The bertha around Mrs. Freake's shoulders and the border of her skirt below the knee are heavily ornamented zones that contrast effectively with the undecorated areas of the remainder of the clothing. The group is comfortably situated in the ample space of the canvas. Infant and mother are together, and their world is complete. The relationship is one of protective love unmarred by tawdry affectation. Appropriate to this quiet mood are the soft tints of greenish yellow, blue, and gray, and the pale flesh tints, relieved by an occasional bright red in the underskirts and sleeve adornments—all in wonderful accord.

A remarkable portrait of the late seventeenth century from Boston is the *Self-Portrait* of

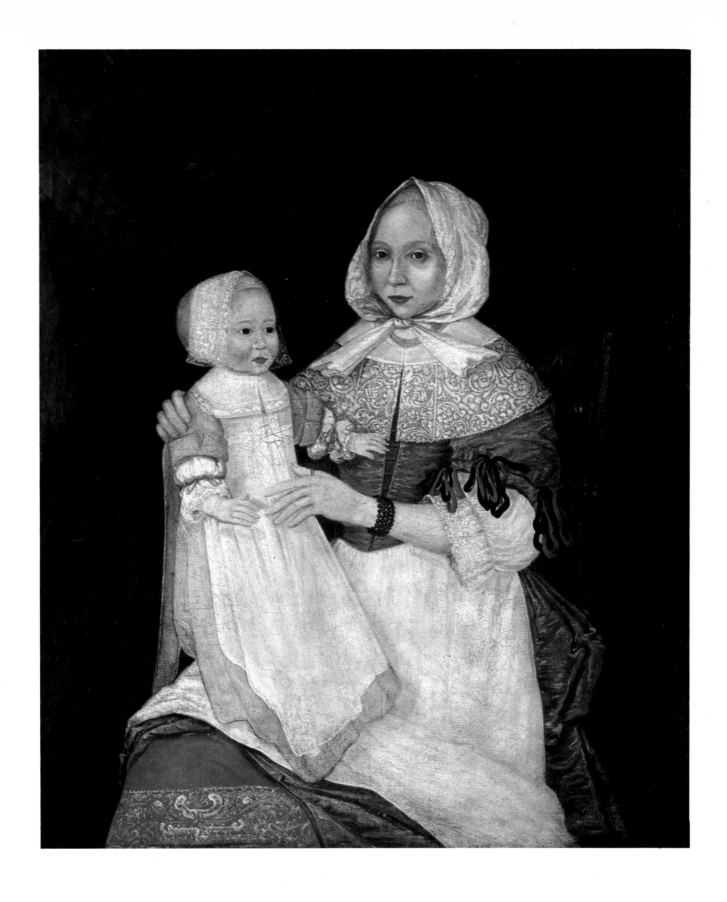

2. Unknown artist. *Mrs. Elizabeth Freake and Baby Mary.*
c. 1674. Oil on canvas, 42 1/2 × 36 3/4″. Worcester Art Museum. Gift of Mr. and Mrs. Albert W. Rice

Captain Thomas Smith (plate 3). Smith is believed to have been a mariner who came to New England from Bermuda about 1650. The captain's features are strongly delineated, and the eyes look steadfastly at us. But the brow is wrinkled, the chin noticeably sags, and on the face there is a look of resignation—the look, perhaps, of a resourceful fighter who, depicting himself in his later years, regretfully anticipates the end of an active career. Through the window, to the right of Smith's head, as if he were remembering it, a fierce naval battle is seen raging; the artist may be recording a specific event of his life. His right hand rests on a skull—symbol of aging and death and the vanity of human life—beneath which is a sheet of paper inscribed with the following lines:

> Why why should I the World be minding
> therein a World of Evils Finding.
> Then Farwell world: Farwell thy Jarres
> thy Joies thy Toies thy Wiles thy Warrs.
> Truth Sounds Retreat: I am not sorye.
> The Eternall Drawes to him my heart
> By Faith (which can thy Force subvert)
> To Crown me (after Grace) with Glory.

The signature is in the form of the monogram ℱ. The flat, crystalline quality of the painting of most New England limners does not obtain here. The texture of Smith's hair is soft and shimmery; his jabot is diaphanous; and the naval battle behind him is handled almost impressionistically, with the smoke from the guns drifting above translucent water. Baroque Continental rather than English Tudor influence is probable; it is even possible that Smith had been trained in Europe. But the illusionistic approach seen in the treatment of the jabot is not followed consistently; the body is handled flatly. Although the various areas of the com-

3. Thomas Smith. *Self-Portrait.*
c. 1690. Oil on canvas, 24 1/2 × 23 3/4".
Worcester Art Museum

4. Unknown artist.
Anne Pollard.
1721. Oil on canvas,
27 1/2 × 22 1/2".
Massachusetts Historical
Society, Boston

position are clumsily added to one another, and the styles conflict, there is strength in the directness of the portrayal.

Even after 1700 a native literalness and the bite of truth keep cropping up in the painting of unknown New England limners. An instance is the portrait *Anne Pollard* (plate 4), painted in 1721, when the sitter was a hundred years old. Anne Pollard—having, as a girl of eight, jumped from Governor Winthrop's boat and waded ashore in the shallow water—claimed to be the first settler of Boston. A one-time tavern keeper who could boast a hundred and thirty descendants, Mrs. Pollard must have had remarkable resources of body and mind to have endured so long the rigors and risks of seventeenth- and early-eighteenth-century New England. Her face, homely to the point of grotesqueness, reminds us vaguely of twentieth-century German Expressionism, in which form was purposely distorted. Yet the unsophisticated, little-trained limner, trying merely to be faithful to appearances, has revealed not only the frailty of the hand and the watery gaze of the eye but an exaggerated stanchness that catches the character of the sitter far more directly than could a more objective representation. Although probably striving to do no more than to preserve the literal record of a face, the

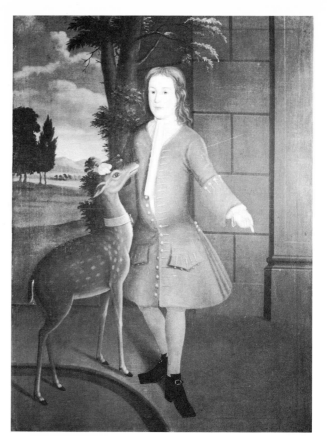

5. Gerret Duyckinck. *Mrs. Gerret Duyckinck.*
c. 1700. Oil on panel, 30 1/4 × 24 7/8″.
The New-York Historical Society, New York

6. Unknown artist. *John Van Cortlandt.*
c. 1731. Oil on canvas, 57 × 41″. The Brooklyn
Museum, New York. Dick S. Ramsay Fund

limner has succeeded in conveying something of the inward spirit of an indomitable woman and in expressing the resoluteness of dauntless old age.

When in 1664 the Dutch settlement of New Amsterdam became the English colony of New York, the Dutch character of the place persisted. Brick buildings with stepped gables could be seen everywhere. Dutch art, unlike English court art, which was influenced by the sometimes flamboyant Roman Catholic art of Flanders, is sober, prosaic, and rooted in the middle classes. New England painting seems to have developed a matter-of-factness despite its English beginnings, but New York painting tended in this direction largely because of its Dutch origin. With no Tudor heritage in its background, however, New York painting appears to be based on an ideal not of flatness but of modeling in light and shade.

There are three extant portraits from the 1660s; whether they were executed before or after New Amsterdam became New York is not known. Prominent among the New York painters of the late seventeenth and the early eighteenth century were members of the Duyckinck family. Evert Duyckinck I came to New Amsterdam in 1638 as a young professional soldier. After settling down he became an artisan: he is referred to as a limner, a sign painter, a glazier, and a glass burner. His son Gerret was known principally as a glazier, but his activity extended to teaching, drawing and painting, and decorating church windows. Among the portraits assigned to Gerret is one of his wife, painted around the turn of the century. *Mrs. Gerret Duyckinck* (plate 5) presents a stolid, somewhat dull woman, with a pleasant but not

really attractive face. The contrast between the *Mrs. Duyckinck* and the *Anne Pollard* points up the difference between the artistic sensibilities of early New York and early New England. In the Pollard portrait the artist gets through to the inner life of the sitter, to the extent of transforming her appearance (just as in the Smith *Self-Portrait* and in the portrait *Mrs. Freake and Baby Mary* there are insights into human feelings and motivations). In the New York portrait the appearance of the sitter—her physical individuality—is strongly preserved, but this is far from a study in character. We are offered the record of a face: the turned-up nose, the weak mouth, the hint of a double chin are all presented without interpretation, without emphasis. Mrs. Duyckinck's right hand rests limply on a table next to some pieces of fruit; the intrusion of the still life, characteristic evidence of Dutch interest in interior detail, establishes —also for the record—the sitter's role as a homemaker.

The most attractive portraits produced in the New York region during the entire colonial period were those of the six or seven patroon painters, as they are called, who served the powerful old Dutch landholders (the patroons) between 1715 and 1730. In these the subject is usually painted full-length, or nearly full-length, against a lush landscape. The faces are not individualized, and there is no delving into character; it is through the beauty of the bright colors and the sensitivity of the compositions that these portraits excel. Gone is the three-dimensional modeling of the *Mrs. Duyckinck;* the figures appear weightless, and this weightlessness goes well with the mood of innocence typically communicated through the scene as a whole. In the portrait *John Van Cortlandt,* of about 1731 (plate 6), the boy stands on a kind of patio against a landscape as carefully pruned as a private garden. Beside the boy is a deer, fully tame, gazing docilely up at him. There seems to be a secret communion between boy and deer: the worlds of nature and of man are in accord. Compositionally this harmony is expressed in curves that subtly answer one another—the boy's arm and the deer's back, for example. No dissonant note is struck. The azure sky is streaked with fleecy clouds. The expression on the boy's face is as peaceful as the beautiful world he inhabits.

As American painting developed through the eighteenth and nineteenth centuries and painters arose who were able to capture on canvas the actual appearance of the visible world, the work of the limners and the patroon painters came to be looked upon as no more than clumsy beginnings. This attitude prevailed until the time—roughly the 1940s and 1950s— when the various modern movements, such as Cubism and nonobjective painting, had expanded our ways of seeing. From then on, the earliest beginnings of American painting have been valued as constituting some of its brightest jewels.

THE COLONIAL ARTIST. The first fully chronicled artist in America was John Smibert. No painter in New England, possibly in all the colonies, was more famed than he before the Revolution. However, his acclaim was earned largely through factors other than the merit of the works he produced. A Scot, he arrived in New England with what seemed to Americans a considerable reputation. He had studied art in London, had toured Italy, and was closely associated with the philosopher-theologian George Berkeley. It was as a member of the Berkeley company that Smibert landed in Newport, Rhode Island, in January of 1729. A year later he settled in Boston, where he remained until his death, in 1751.

Smibert was past forty when he ventured to the New World, but the risk proved well worth the taking. Competition among painters in the London he decided to leave was ex-

tremely keen, and there he was regarded as merely competent: he felt that with his English training he would be ruler of the roost in America. All Smibert's expectations came to pass; indeed the opinion prevailed among Bostonians that he had single-handedly brought art to America. He was valued, too, as a popularizer of European works. In Italy he had made copies of paintings by Raphael, Titian, Poussin, Van Dyck, and others, and he showed these, together with his own paintings, in 1730 (the first recorded art exhibition in America), thus giving Bostonians their introduction to the art of the Old World. He was the architect of Boston's original Faneuil Hall, which burned to the ground soon after he died. Smibert's house, with his collections, became an important art center after his death, and served later artists, among them John Singleton Copley; at one time it was occupied by Washington Allston.

That Smibert should have been so esteemed attests to the New Englander's disparaging attitude to his own native limners. Alongside the painting of the limners, Smibert's represented polish, professional know-how, virtuosity. His first painting in the New World, *The Bermuda Group: Dean George Berkeley and His Family*, of 1729 (plate 7), is also his most ambitious. The commanding figure of Berkeley stands to the right; Mrs. Berkeley and their child are seated beside him; to the left, painted with special care, is Berkeley's secretary. Among the four other persons depicted is Smibert himself, at the extreme left, quizzically eyeing the spectator. This large group portrait, the most complex painting attempted in America until then, was seen as both a great novelty and a most significant accomplishment. No one before him had approached the dexterity and range of Smibert as evidenced in the careful detail of the turkey-work rug covering the table and the extensive landscape forming the background behind the eight sitters; the sheen and texture of materials are rendered more accurately than ever before. At the same time there is a lack of grace. The figures are uncomfortably arranged and overcrowd the space allotted them. The hands of Smibert's people seem obtrusive, their lips pudgy, their gestures forced. Such inelegancies might have melted into a work in a more primitive manner; they are glaringly apparent beside the obvious sophistications of this London-trained artist.

By the fourth decade of the eighteenth century artists who are not itinerant but command much of the portrait trade in a given area can be localized. Two painters who were important in Boston after Smibert were Joseph Badger and Joseph Blackburn.

Badger was Boston's most important painter from 1748 to about 1758, or from the period when Smibert's health was beginning to fail until the emergence into prominence of John Singleton Copley. Badger's painting is uneven. Many of his portraits are marred by a disturbing emptiness, and this is not at all alleviated by the insertion into the background of a pasty, ill-defined, hazy foliage, quite out of key with the limner-like rendering of the figure. His representation of depth is unconvincing, his draftsmanship weak, and his delineation of character undistinguished. But Badger shines as a portrayer of children: what is awkward openness in his adults becomes in them a charming innocence. Their stiffness suggests not a shortcoming on the part of Badger but a greater awareness, since it seems to connote the young sitter's annoyance at being forced to pose instead of being allowed to play. Badger's grandson James seems rather uncomfortable in his portrait, of 1760 (plate 8); he is dressed in his best clothes and is ill at ease in them. Badger has this in common with the Freake Limner: he attains to an empathy with his subject that can be felt even if the means by which it is conveyed cannot be precisely identified.

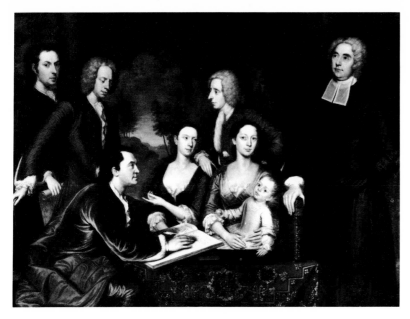

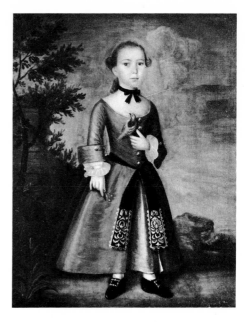

7. John Smibert. *The Bermuda Group: Dean George Berkeley and His Family.* 1729. Oil on canvas, 69 1/2 × 93".
Yale University Art Gallery. Gift of Isaac Lothrop of Plymouth, Massachusetts, 1808

8. Joseph Badger. *James Badger.* 1760.
Oil on canvas, 42 1/2 × 33 1/8".
The Metropolitan Museum of Art, New York. Rogers Fund, 1929

Joseph Blackburn is believed to have been a Scot or an Englishman. Between 1753 and 1763 he painted the portraits of New England's best families. His handling of paint was light and quick, and he shows the influence of contemporaneous Rococo painters in England. In *Isaac Winslow and His Family,* of 1755 (plate 1), we see that his draftsmanship surpasses that of Smibert, his flesh tones and landscape backgrounds are richer in texture, his draperies more sumptuous, and the air of his sitters less obtrusive and ungainly. But the faces of his people are typically marked by a mannered, simpering smile. Toward the end of his career, thanks to the influence exerted on him by the somewhat younger Copley, he developed a more mature power of characterization.

A contemporary, writing of Robert Feke in 1741, provided our first description of the person of an American artist: "This man has exactly the phiz of a painter, having a long pale face, sharp nose, large eyes—with which he looked upon you steadfastly—long curled black hair, a delicate white hand, and long fingers." Feke was one of America's greatest early painters. He was a brilliant portraitist, though the power of characterization interested him only in some of his early works. As a decorative master he had no equal.

Coming from the New York region (Oyster Bay, Long Island), Feke may well have been familiar with the patroon paintings. A similar bucolic innocence appears in his work, blended with a new interest in an aristocratic elegance reflecting the growing prosperity in some of the colonial cities. In his portraits of both men and women, among them the *Mrs. James Bowdoin II,* of 1748 (plate 9), Feke pays the strictest attention to the details of the fashions of the time, fastidiously incorporating expanses of gleaming drapery into his compositions. The personality of the sitter does not emerge. With a few exceptions, his attractive women are of one type: brunette, ample-bosomed, innocently wide-eyed; no hint of concern clouds their radiant faces. Here is the feminine ideal toward which the upper-class women of Feke's

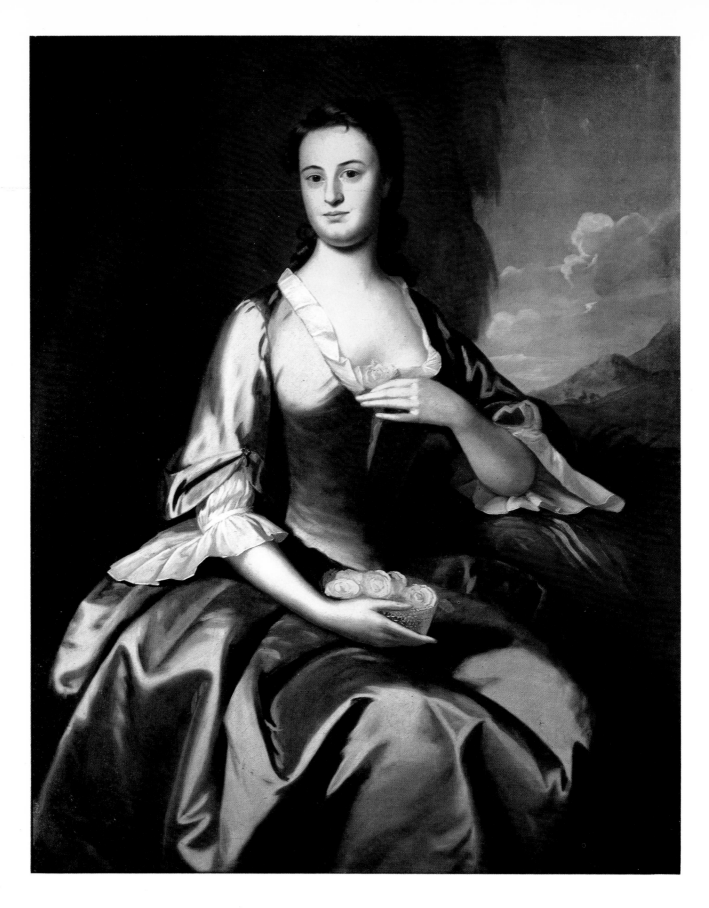

9. Robert Feke. *Mrs. James Bowdoin II.*
1748. Oil on canvas, 50 1/8 × 40 1/8″. Bowdoin College Museum of Art, Brunswick, Maine

generation must have aspired. The backdrop of a lush landscape beneath an azure sky, reminiscent of the patroon paintings, reinforces the impression that all's right with the world. Feke worked in the main centers: in 1742 he was residing in Newport, Rhode Island, where he remained until 1745; in 1746 he spent some time in Philadelphia; and in 1748, when Smibert's sight was failing, Feke sensed a new opportunity and left for Boston. After 1750 his life is undocumented.

Gustavus Hesselius, who was born in Stockholm to a family of ministers, settled near Wilmington, Delaware, in 1712. Philadelphia became his principal base of operations, but he also painted extensively on the eastern shore of Maryland, in Delaware, and in Virginia. By mid-century he had become the leading painter in the Middle Colonies. His earlier portraits have much in common with Feke's portraits; they reflect the aristocratic standards of the time. His later ones, such as that of his wife, painted about 1740 (plate 10), are more searching, but what he brings out in most of his sitters is tiredness and dejection rather than any hint of confidence or nobility. Hesselius himself must have experienced spiritual uncertainty, since he converted from the Swedish Lutheran Church to the Church of England, and then before his death returned to the church of his origin. In the unfolding of American painting, he is remembered as one of the first artists to extend the scope of his interests beyond the portrayal of colonial worthies and their wives and children. He painted a classical subject, a Bacchanalian revel, and portraits of two Indian chiefs; for the vestry of Saint Barnabas Church in Prince George's County, Maryland, he painted a *Last Supper* (based on a print) in 1721.

In the latter half of the seventeenth century Lord Shaftesbury, who had aided in the restoration of Charles II, tried to re-create a semifeudal order in the Carolinas, without success. But great estates—the plantations—did become a feature of the South in the early eighteenth century. The work of German-born Justus Engelhardt Kühn, who painted for a time in Annapolis, gives us a glimpse of this abundant life. His portrait *Eleanor Darnall*, of about 1712 (plate 11), is marked by an ostentation nonexistent in the New England and the New York portraits, in which the sitter was always the focus. Kühn treats Eleanor as though she were but another one among the numerous props making up the composition. The daughter of the house seems not to rule over her possessions but to be ruled by them. Eleanor stands before an elaborate balustrade; on the pier to her left rests an extravagantly ornamented vase. To her right is a great curtain; at her feet sits a dutiful dog; and behind the balustrade, stretching as far as the eye can see, are the terraced grounds and houses of the property—all magnified and embellished for the painting. Kühn himself appears to have been a man who took pride in his possessions: it was said of him that his clothes were so fine one would never suspect that he was a painter.

In the North the limner tradition died hard. Ralph Earl's seated figure of *Roger Sherman*, of about 1775 (plate 12), could have been painted—were it not for the cast shadows and the atmospheric sense of the background—a hundred years earlier. Sherman sits as awkwardly and as stiffly as if made of wood. The setting is altogether different from that in *Eleanor Darnall*. Here, in keeping with the austerity of the sitter, there is nothing in excess. The colors are somber, with deep browns, reds, and blacks dominating. Unlike Feke, who painted in the main centers, Ralph Earl, until his trip to England in 1779, worked in the rural areas of Connecticut. Earl's painting represents the more provincial and naive aspect of late colonial

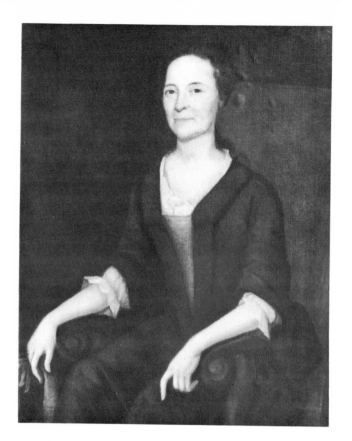

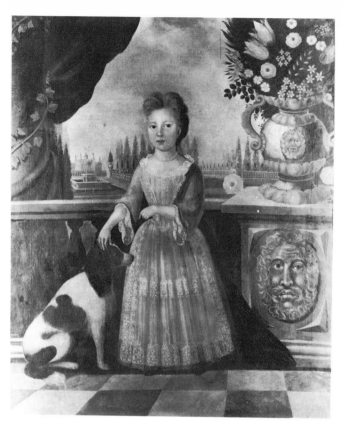

10. Gustavus Hesselius. *Mrs. Gustavus Hesselius.*
c. 1740. Oil on canvas, 36 1/4 × 28".
The Historical Society of Pennsylvania, Philadelphia

11. Justus Engelhardt Kühn. *Eleanor Darnall.*
c. 1712. Oil on canvas, 53 3/4 × 44".
The Maryland Historical Society, Baltimore

art. Yet the very awkwardness and stiffness of a portrait like the *Roger Sherman* serve to catch
the character of the sitter. Sherman rose from humble beginnings to prominence as a states-
man and jurist: he helped draft and was a signer of the Declaration of Independence. A
contemporary observed of him that his demeanor was grotesque and laughable but that as
he became known his ability and accomplishments would be respected. It is the quality of
perseverance and grim determination of a man who has pulled himself up by his bootstraps
that is brought out through the style of the painting.

LATER PRIMITIVE PAINTING. The painting of the limners and patroon painters is similar in
style to the American primitive painting of the nineteenth and twentieth centuries though
produced under very different circumstances. Such artists as the Freake Limner, the Pollard
Limner, Joseph Badger, and, to an extent, Ralph Earl worked within an artistic milieu in
which a flatness of the figures, a lack of atmospheric perspective, a clear-cut delineation of
shapes, and a certain awkwardness of drawing were the norms—or at least were generally
accepted. This is why there is a homogeneity about their works taken as a whole; there is no
reason for assuming that they and the many other painters who worked before the Revolu-
tion were personally of a similar character, one that could be described as naive, innocent,
and forthright.

However, to paint in a primitive manner in more modern times is generally the mark of persons of such a character. American primitives of the nineteenth and twentieth centuries, whatever their age and occupation, whenever and wherever they have lived, have tended to regard the world simply and directly. In art, they have been largely self-taught. All, in their way, have been unsophisticated, the kind of people one cannot imagine at a cocktail party, in a gambling casino, or at a diplomatic conference—in short, in any situation where the stock-in-trade includes guile, artifice, and innuendo. Their paintings reveal an attitude that is straightforward and uncomplicated. Since on the stylistic level these painters represent, in broad terms, a continuation of the limner tradition of pre-Revolutionary times, it is appropriate to include them in this chapter on the beginnings of American painting.

Edward Hicks, born in 1780, spent most of his life preaching, without remuneration, in eastern Pennsylvania, out of dedication to his Quaker faith. To support himself he painted decorations and emblems for coaches, tavern signs, street markers, and the like. In the years between 1820 and 1849 he painted a large number of versions of his picture *Peaceable Kingdom* (plate 13), illustrating the vision of the prophet Isaiah (11: 6–9) of eternal peace, the time when even the normal hostility of animals will give way to brotherly love. In his paintings he drew upon engraved illustrations found in the Bibles of the time and other sources, but his own imagination endowed his scenes with an appealing concreteness. His animals are converted into wonderfully vivid patterns, revealing the decorative approach of the sign painter, and their physiognomies have some human characteristics. Hicks preached that people must redirect themselves by discovering and governing their temperaments, that true peace could not be legislated by governments. In his day he was far more noted as a preacher than a painter; today it is the other way around.

John Kane, who was born in Scotland, arrived at Braddock, Pennsylvania, in 1879, when he was nineteen. Unskilled, he shuttled from job to job, paving streets and mining for coal, working on construction and in factories. It was a railroad accident in which he lost a leg that actually set him on his circuitous course, via carpentry and house painting, toward art. Most of his paintings are detailed views of the industrial landscape around Pittsburgh and in Ohio. His *Self-Portrait*, of 1929 (plate 14), was painted two years after he first had a picture accepted for exhibition. Kane was then sixty-nine. He showed himself bare-chested— lean, hard, and muscular, the way he remembered himself. The flatness with which the figure is painted and the rigidity of the pose are reminiscent of some of the work of the early New England limners. Kane's body is held in tense alertness; the muscles are flexed, the face is grim, even bitter, reflecting the many misfortunes he had known. The three arches above his head are, fittingly, like ingots of steel.

Anna Mary Robertson ("Grandma") Moses spent her life first as a hired girl, then as the wife of a farmer. She lived in Virginia from 1887 to 1905, when she moved to Eagle Bridge, New York. She began to paint in earnest in 1938 at the age of seventy-eight, after giving up embroidery because of arthritis. Her first exhibition was held two years later, and with it came sudden and dramatic success. People were attracted by the story of this self-taught, gifted octogenarian who had pursued her artistic muse in utter obscurity. And they were moved by the homespun flavor of her rustic scenes, opening up to them a world marked by the peace and simplicity they yearned for—the world that Grandma Moses had known all her life.

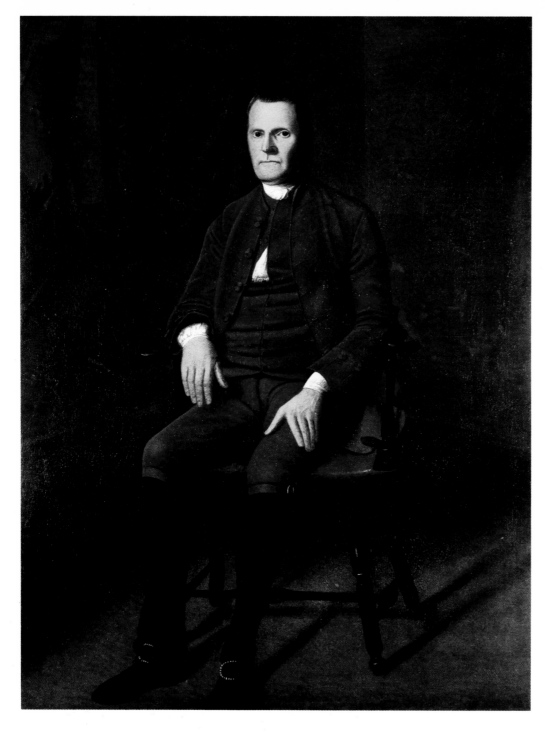

12. Ralph Earl.
Roger Sherman.
c. 1775. Oil on canvas,
64 5/8 × 49 5/8".
Yale University Art
Gallery. Gift of
Roger Sherman White,
B.A. 1899

Grandma Moses' earliest pictures were painted after postcards or magazine illustrations. Then she began to draw upon her own memories of country life. She preferred communal activities such as harvesting, "sugaring off" (the collecting of sap from trees), bringing in Christmas trees, and country fairs—happy times, with everyone pitching in. She treated these as panoramic vistas with many tiny active figures. Well aware—like any observant country person—of the characteristics of the changing seasons in her native New York State, she chose appropriate color schemes for the different times of year: white for winter, as in the *Hoosick Falls, N.Y., in Winter*, of 1944 (plate 15), light green for spring, deep green for summer, and brown for autumn.

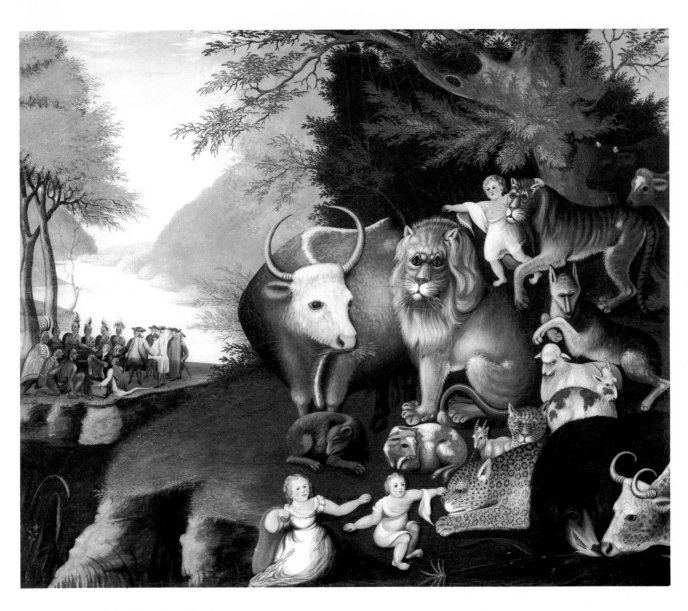

13. Edward Hicks. *Peaceable Kingdom*.
c. 1830. Oil on canvas, 30 × 35 7/8″.
Collection Edgar William and
Bernice Chrysler Garbisch, New York

14. John Kane. *Self-Portrait*.
1929. Oil on canvas over composition board,
36 1/8 × 27 1/8″.
The Museum of Modern Art, New York.
Abby Aldrich Rockefeller Fund

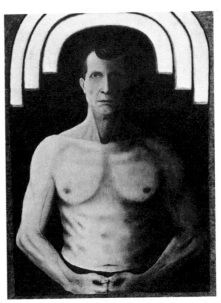

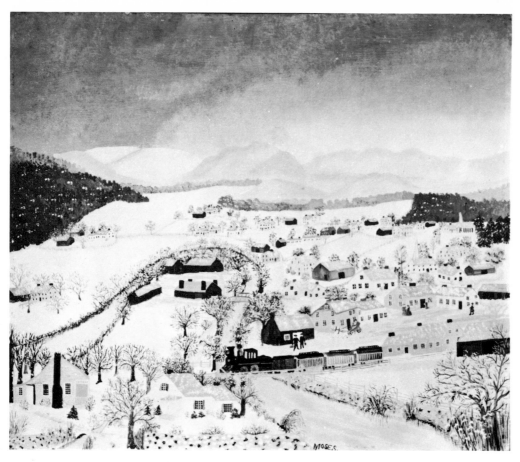

15. Grandma Moses (Anna Mary Robertson Moses). *Hoosick Falls, N.Y., in Winter.*
1944. Oil on canvas, 20 × 24″. The Phillips Collection, Washington, D.C.

16. Morris Hirshfield. *Tiger.*
1940. Oil on canvas, 28 × 39 7/8″.
The Museum of Modern Art, New York. Abby Aldrich Rockefeller Fund

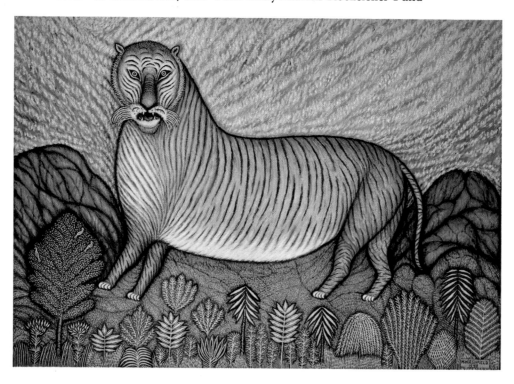

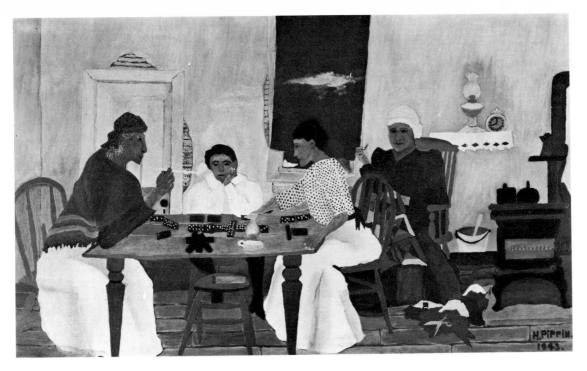

17. Horace Pippin. *Domino Players.*
1943. Oil on composition board, 12 3/4 × 22″. The Phillips Collection, Washington, D.C.

The background of Morris Hirshfield is a far cry from that of Grandma Moses—a proof, if one were needed, of how varied are the environments of the primitives. He came from a small town in Russian Poland near the German border. At an early age he was making wood carvings and prayer stands for his synagogue. In 1890, when he was eighteen, he came to America and worked in the manufacture of clothing and, later, of women's slippers. He began to paint only upon his retirement. His working experience—the cutting of patterns and the manipulation of ornament—played an important part in determining the style of his painting: the surfaces of many of the animals and people in his canvases have the look of textile appliqués. In Hirshfield's best work, the type of patterning is aptly suited to the subject. In his *Tiger*, of 1940 (plate 16), he used pointed, flamelike patterns for the trees, veinlike red patterns for the hills, and an ominous radiating pattern for the sky—all in keeping with the snarling ferocity of the beast.

As a Negro boy in West Chester, Pennsylvania, Horace Pippin started working at the age of fourteen. He was hotel porter, ironmonger, and junk dealer before he enlisted in the army to fight in World War I. Wounded in action, he lost most of the use of his right arm, but he discovered he could keep his right wrist steady with his left hand and found an outlet in painting. Except for a series of paintings on the abolitionist John Brown, one painting on the theme of prejudice, and one war picture based on his own experiences, Pippin ignored social issues; he concentrated on the people and places of his native West Chester as in *Domino Players*, of 1943 (plate 17). His intuitive feel for two-dimensional design, for the arrangement of his bright patterns, was remarkable; Pippin is one of the finest primitives that America has produced. In the success of a primitive painter, as in that of a painter who is highly trained, native endowment is what matters most. Self-trained, Pippin had an instinctive sense of what was artistically sound. He could well say, as could other primitives, "To me it seems impossible for another to teach one of Art."

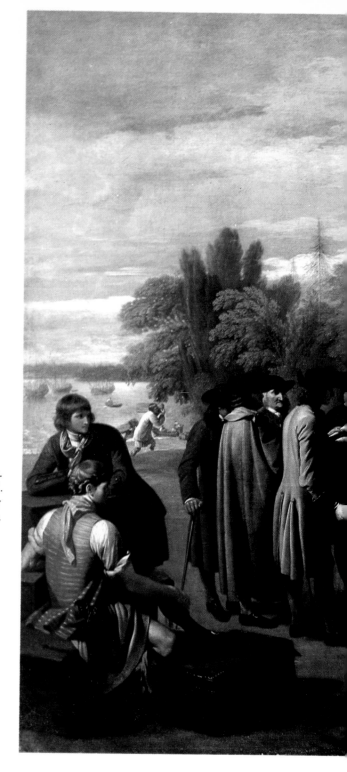

18. Benjamin West. *Penn's Treaty with the Indians.*
1771. Oil on canvas, 6′ 3 1/2″ × 9′ 3/4″.
The Pennsylvania Academy
of the Fine Arts, Philadelphia

CHAPTER TWO
The History of America in Paintings

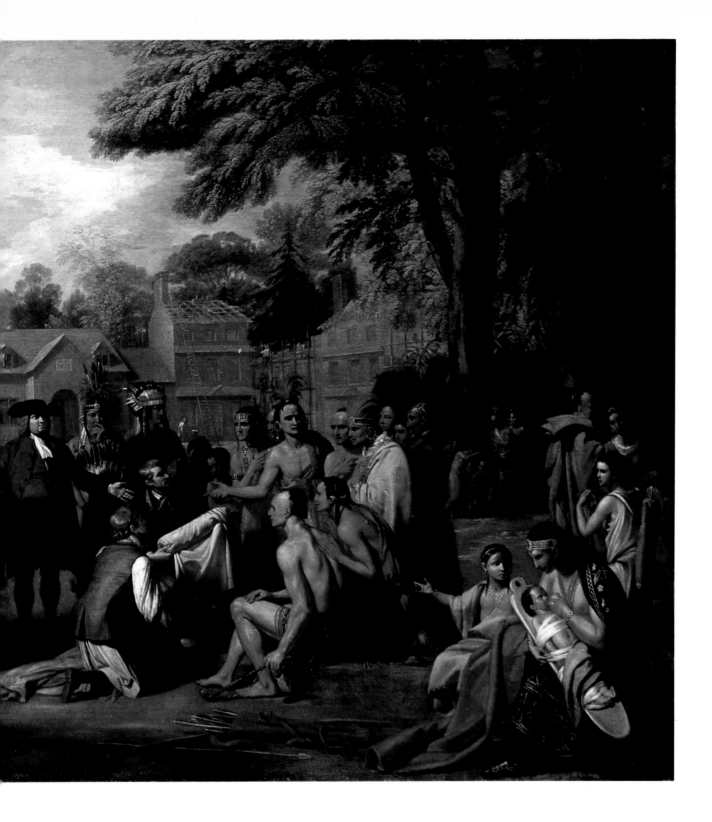

AMERICA'S YOUTH: THE YEARS BEFORE THE CIVIL WAR. Until the victory of the Continental armies over England, and the subsequent creation of a national domain, there was no history painting in America. So far as is known, no original European history paintings had found their way here to serve as examples (Smibert had made some copies), and no painter appeared on this continent to record the epochal events. While the European powers held sway, there was no market for such paintings. The practical-minded colonial settlers saw the painted canvas chiefly as a means of capturing individual likenesses. But two American-born

painters settled in England before the signing of the Declaration of Independence—Benjamin West in 1763 and John Singleton Copley in 1775—and there produced a number of epic paintings dealing with American colonial and English history.

West, who was born near Philadelphia, by all accounts gave evidence of prodigious talent as a very young child. By the time he came to Rome, in 1760, at the age of twenty-two, he was an established portraitist in Philadelphia and New York. He was intelligent, charming, and attractive, and as the first American painter to make his appearance on the Roman scene he was enthusiastically received and made much of by the international circle. The fact that he came from so remote a place as America (some expected him to be an Indian) added an exotic element to his appeal. After three years in Rome he started his journey back home. Stopping off in London, he was taken up as cordially as he had been in Rome, and he stayed in England for the rest of his life. In 1772 he became historical painter to George III, and this relationship survived the strain of 1776 and, despite breaks due to the recurrent royal madness (and its interaction with court intrigues), endured until 1820, the year of the king's death and his own. In 1792 West succeeded Sir Joshua Reynolds as president of the Royal Academy of Arts, in whose foundation he had played a major role, and he held this post (except for one year) for the rest of his life. In his eminent position as an artistic arbiter West proved consistently hospitable and generous to the many young American painters who came to London. Gilbert Stuart, Charles Willson Peale, John Trumbull, Thomas Sully, and Samuel F.B. Morse were among those who benefited from his teaching and his friendship.

West came to Europe during the time, around mid-century, when the Neoclassical movement, centering on a renewed interest in antiquity, was at its height. In painting, lofty subjects dealing with Greek and Roman themes were chosen. The figures were idealized, and their bearing was properly grave, to inspire the eighteenth-century spectator to ennobling thoughts. The painter who perhaps best represented the Neoclassic style, as based upon a more forceful reinterpretation of classical antiquity, was Jacques-Louis David. In France in the late 1780s the style became a revolutionary weapon against the monarchy, which favored and had been identified with the previous more frivolous, lightly erotic Rococo style. But well before the rise of David, West was one of Europe's most important Neoclassical painters.

In *Penn's Treaty with the Indians*, of 1771 (plate 18), West did not use a classical setting, since the event took place not in Europe but in America. But in keeping with the spirit of Neoclassicism, the theme is an elevated one and the composition has a quiet grandeur. The various elements are skillfully disposed in the space of the canvas, so that the spectator discerns the theme easily. The Quaker William Penn was already legendary in West's time. In consideration of a debt owed his father by the Crown, in 1681 he had persuaded Charles II to grant him a province in the New World. (This was to be the area of West's own origin.) In the administration of this province, which was called Pennsylvania, or "Penn's woods," in memory of his father, Penn proved a practical idealist. He respected the rights of the previous German, Swedish, and English settlers and drafted laws ensuring liberty of conscience for all, suffrage for all taxpayers, and the right to trial by jury. He even paid the original Indian owners for the land. The Leni-Lenape of the Delaware valley called Penn "the White Truth Teller," and the name of the capital of the province, Philadelphia, is the Greek for "brotherly love."

In *The Death of Wolfe*, of 1770 (plate 19), West was not fully accurate in his interpretation

of history but contrived his groupings and positionings of figures in accordance with Neo-classic ideals. James Wolfe was the young English general whose troops in 1759 defeated Montcalm and took Quebec in the key battle of the French and Indian Wars. His victory ended French ambitions for a large empire in the New World. The dying Wolfe is shown supported by his lieutenants; the scene takes place upon what is presumably the Plains of Abraham, just outside Quebec. The figures are arranged as in a traditional Lamentation or Deposition. It is not likely that Wolfe actually died in a manner so closely corresponding to traditional Christian imagery. West's disposition of the figures was calculated to kindle in the spectator a warm reverence, a solemn veneration for a man who gave his life for his coun-try's dynastic ambitions. In contrast to the untroubled sky of *Penn's Treaty*, here the clouds are storm-tossed and the heavens are dark, in keeping with the subject. But as in that paint-ing, the figures are in contemporary dress. King George and others would have preferred the classical robes and setting of the typical Neoclassic painting, but again West defended his choice on the grounds that the battle had taken place in a part of the world which had never known Greeks or Romans.

The history paintings of John Singleton Copley were produced in England in the second half of his dual career, the first part pursued in Boston, where he was born, the second in London. Building upon what he learned from Joseph Blackburn and from his stepfather, the painter and mezzotint engraver Peter Pelham, the precociously talented Copley had become the best portraitist in all the colonies by the time he was nineteen (see Chapter Three). But he was not satisfied: he longed to become something better—a history painter. Though it had found no place in the colonies, history painting was esteemed in Europe as the highest of all the branches of painting. Copley had been in correspondence with West, who had settled in England, and in 1766 his *The Boy with a Squirrel*, a portrait of his half-brother Henry Pelham, was shown in an exhibition of the Society of Artists in London. It won the praise of, among many others, Sir Joshua Reynolds, who patronizingly added to his

19. Benjamin West.
The Death of Wolfe.
1770. Oil on canvas, 59 1/2 × 84″.
National Gallery of Canada,
Ottawa. Gift of
the Duke of Westminster, 1918

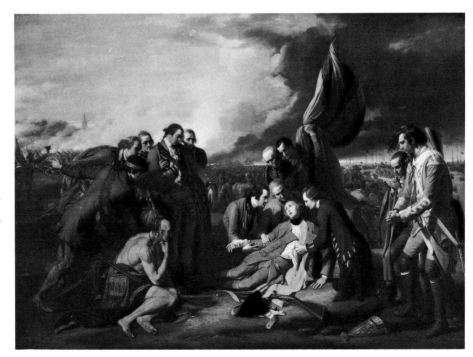

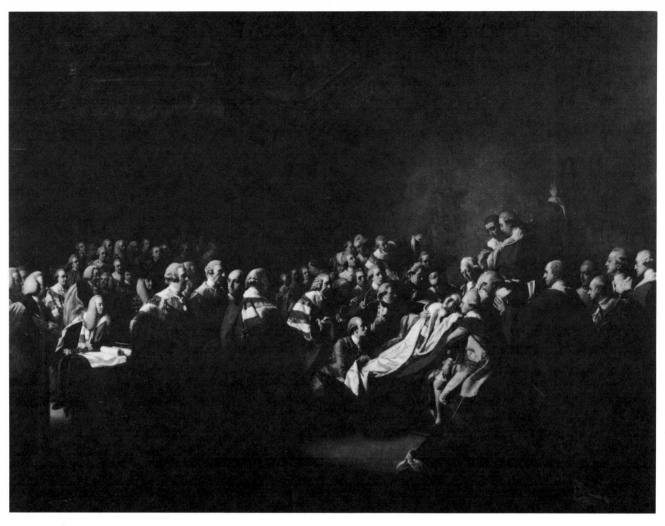

20. John Singleton Copley. *The Collapse of the Earl of Chatham in the House of Lords.*
1779–80. Oil on canvas, 7'5" × 10'. The Tate Gallery, London

commendation that Copley ought to have the advantages that Europe could offer before it was "too late in life, and. . . [his] Manner and Taste were corrupted or fixed by working in [his] little way at Boston." Copley had for many years longed to study the great masters in Europe, but it was eight years before he took the decisive step. In 1774, urged on by the growing violence of a struggle in which he endeavored to remain uninvolved, he finally left Boston. He toured and painted in Italy for a while, and settled in England in October of 1775. He was on the threshold of a new career.

Among the history paintings that Copley produced in England is *The Collapse of the Earl of Chatham in the House of Lords*, executed in 1779–80 (plate 20). The elder William Pitt, the Earl of Chatham, as Prime Minister had been instrumental, through his able choice of military commanders and his close direction of their activities on the field of battle, in the victory of the English in the French and Indian Wars. After leaving office in 1761, he opposed his government's policies toward the American colonies. While addressing the House of Lords on the American issue on April 7, 1778, he collapsed of a stroke, and he died soon after. Like West, Copley, in painting a tragic event known to all Englishmen of the time, took certain

liberties with the facts. Pitt, shown in the traditional *Pietà* attitude, did not in fact die in the House of Lords, and of the fifty-five lords included in the painting, many were not present at the time of Pitt's address. Furthermore, formal robes of scarlet and gold were not usually worn during debate. The scene is somewhat overcrowded, since Copley wished to present a record of the membership of the House of Lords. The lighting is appropriately dramatic. There is in the painting a complexity and a degree of artificiality that had never tempted the Copley working in his "little way" in Boston.

John Trumbull was the first American artist to produce in America history paintings dealing with contemporary American events (many of these paintings were begun in England under the guidance of Benjamin West). Unfortunately for Trumbull, the young, war-worn nation, beset by economic and political problems, and straining to recover from the eight long years of the Revolution, failed to appreciate his great project of commemorating the epoch-making struggle in a series of twelve large narrative paintings.

Trumbull, the son of Jonathan Trumbull, colonial governor of Connecticut, and the youngest graduate in the class of 1773 at Harvard, served in the Continental army from 1775 to 1777. Though he rose quickly in the ranks (for a brief time he was Washington's aide-de-camp), he ended his military career at the age of twenty-one, piqued because his commission as colonel was delayed. He reverted to his early interest, painting, and pursued it for a time in America, chiefly Boston, and then, from 1780, in London. His studies there with Benjamin West were interrupted by his arrest as a suspected spy, followed by an eight-month imprisonment. After he was freed, he returned to America and considered other pursuits. His father favored law, and when Trumbull argued for art, citing the honors paid to artists in ancient times, his father's rejoinder was, "You appear to forget, sir, that Connecticut is not Athens."

In 1784 Trumbull was back in London, once more studying under West; he remained until 1789. It was there that he began work on his paintings of the great Revolutionary battles. In the twelve battle scenes painted between 1786 and 1794, Trumbull caught with masterly skill the excitement and sweep of the campaigns. In contrast to most European history paintings of the time, and the history paintings of Copley and West that were produced in England, it is not the single major figure so much as the general mood of the battle that dominates. Such a group approach constitutes recognition of the new national consciousness. Among these paintings is *The Capture of the Hessians at Trenton*, of 1787–94 (plate 21), recalling Washington's surprise attack on the German mercenaries on Christmas night in 1776, an encounter in which thousands of prisoners were taken.

Trumbull's *The Declaration of Independence*, of 1786–97 (plate 22), is a painting of particular historical significance. Of the forty-eight figures crowded into the canvas, thirty-six were painted from life. Standing at the table before John Hancock are John Adams, Roger Sherman (painted more than a decade earlier by Ralph Earl, plate 12), Robert R. Livingston, Thomas Jefferson, and Benjamin Franklin. The painting lacks the dramatic force of such a scene as Copley's *Collapse of the Earl of Chatham*; there is no movement or action. Yet it is hard to see how the greatness of the moment could have been conveyed any more effectively.

In 1794 Trumbull sailed again for London, this time as secretary to John Jay; he remained abroad until 1804. After one more period in London, 1808–16, he settled finally in America. The national commissions he had counted on obtaining through his history paintings

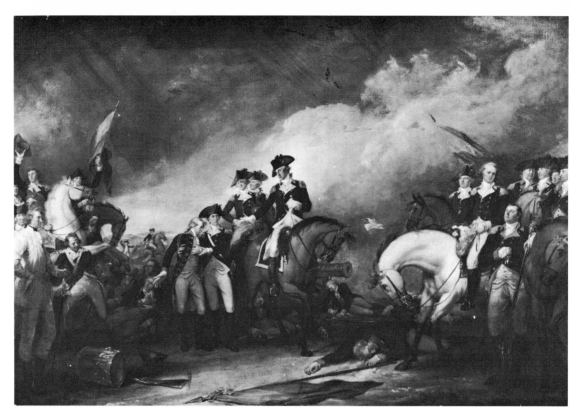

21. John Trumbull. *The Capture of the Hessians at Trenton.*
1787–94. Oil on canvas, 21 1/4 × 31 1/8″. Yale University Art Gallery, New Haven

22. John Trumbull. *The Declaration of Independence.*
1786–97. Oil on canvas, 21 1/8 × 31 1/8″. Yale University Art Gallery, New Haven

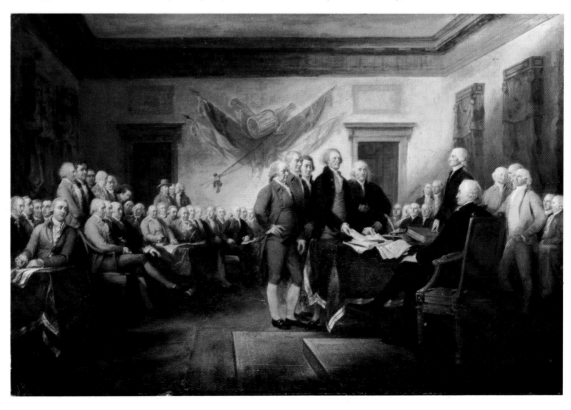

were not forthcoming, partially because of a prickly temperament, which led him to run afoul of so influential a friend as Jefferson. In 1818, when he was past sixty and his powers as an artist were on the wane, Trumbull was finally commissioned to paint a series of Revolutionary War scenes for the Capitol rotunda in Washington.

Up to the Civil War, painters followed Trumbull's example and offered their versions of the exploits of the heroes of the Revolution, especially George Washington. Unlike Trumbull, many of these painters depended exclusively on portraiture for their livelihood. One who studied with Trumbull was Thomas Sully. A native of England, Sully had come to America in 1792, when he was nine; after his brief period with Trumbull in New York, he studied with Gilbert Stuart in Boston, and then (1808–9) with Benjamin West and Sir Thomas Lawrence in London. In the second and third decades of the nineteenth century he was known as the best portraitist in Philadelphia and the surrounding regions. Sully painted with deftness and assurance, but unevenly; often, striving for Stuart's subtle flattery, he fell into a cloying sentimentalism. He came from a theatrical family, and some of his favorite subjects were actors and actresses (among those who sat for him was the renowned Fanny Kemble, toast of two continents). In Sully's gigantic history piece of 1819, *Passage of the Delaware* (plate 23), the General bestrides his fiery charger with the aplomb of an actor performing a role. One looks to Sully not for deep characterization or penetrating insights into the meaning of history but for such handsomely painted passages as the windswept sky and the muffled row of troops pulling their cannon in this painting.

A Revolutionary painting familiar to generations of schoolchildren is Emanuel G. Leutze's *Washington Crossing the Delaware*, of 1851 (plate 24). Its unmatched fame must be attributed in large part to its colossal size (it measures over twenty-one feet in length). But it is also popular because Washington is here at his most inspirational, standing undaunted amid his embattled soldiers as they carry their flag over the ice-choked water. The painting is rather dryly executed, in a manner typical of Düsseldorf, Germany, where it was executed. Leutze, a native of Germany, lived in America from 1825 to 1840; in the latter year he left for Düsseldorf, not to return until 1859.

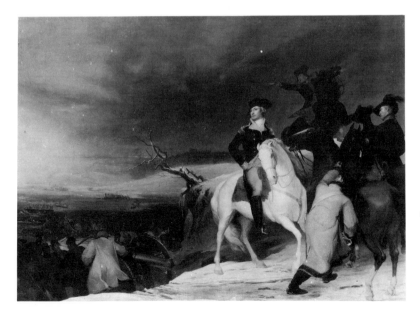

23. Thomas Sully. *Passage of the Delaware.*
1819. Oil on canvas, 12′ 2 1/2″ × 17′3″.
Museum of Fine Arts, Boston.
Gift of the owners of the
Old Boston Museum

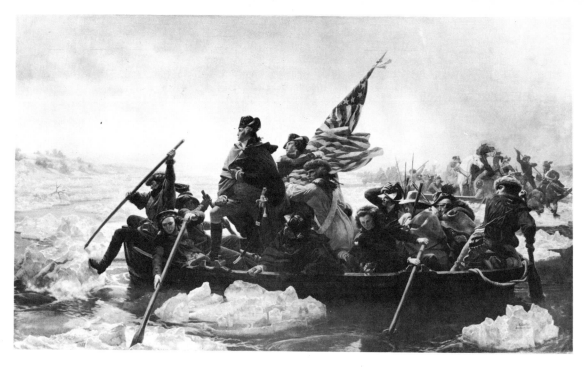

24. Emanuel G. Leutze. *Washington Crossing the Delaware.*
1851. Oil on canvas, 12′5″ × 21′3″.
The Metropolitan Museum of Art, New York. Gift of John S. Kennedy, 1897

Typically what is remembered about the Revolution is its chief actors and major battles: Washington, Gates, Howe, Arnold, John Paul Jones, Lafayette, Burgoyne, Cornwallis; Bunker Hill, Trenton, Princeton, Saratoga, Cowpens, Yorktown. For the most part, the myriad individual tragedies, the acts of courage, of cruelty, and of compassion that go to make up the sum total of war, disappear in time, if indeed they are even noted when they happen. The tragedy of Jane McCrea was an exception; it was kept alive in American and European prose and poetry, prints and paintings. On July 27, 1777, near Fort Edward, New York (in the area in which General Burgoyne was moving south from Canada to cut New England off from other rebellious territories), this young girl was scalped by Indian mercenaries in the employ of the British. The irony of it was that she was a Loyalist engaged to a young officer in Burgoyne's army and the Indians were escorting her to the camp.

One of those who memorialized the story was John Vanderlyn, an artist born in Kingston, New York. Hoping to make a career as a history painter, Vanderlyn spent seventeen years abroad, in Paris and Rome, from 1796 to 1801 and from 1803 to 1815; his chief patron was Aaron Burr, who was elected vice-president with Thomas Jefferson in 1800 and later mortally wounded Alexander Hamilton in a duel. It was the excellence of Vanderlyn's copy of Stuart's portrait of Burr that had attracted Burr's attention to the young artist in the first place. In Vanderlyn's *The Death of Jane McCrea*, painted in Paris in 1804 (plate 25), we see evidence of the Neoclassicism that Benjamin West had helped foster: the attitudes of the Indians call to mind the Greek statues on which they were based. Vanderlyn probably felt that by investing this Revolutionary event with the ideals of antiquity he was endowing it with a timeless significance. He was more successful in achieving his Neoclassic goals with his later paintings *Marius amid the Ruins of Carthage*, of 1807 (M.H. de Young Memorial Museum,

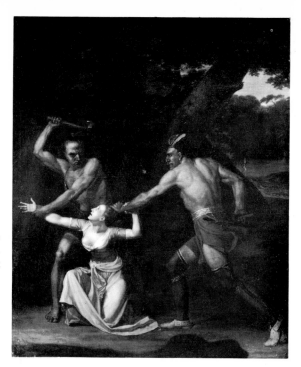

25. John Vanderlyn. *The Death of Jane McCrea.*
1804. Oil on canvas, 32 × 26 1/2".
Wadsworth Atheneum, Hartford, Connecticut

San Francisco), and *Ariadne Asleep on the Island of Naxos*, of 1812 (Pennsylvania Academy of the Fine Arts, Philadelphia).

Vanderlyn was among the group of American artists who at the end of the eighteenth and in the first half of the nineteenth century aspired to rise above portraiture and to explore in their painting subjects of historical and topical interest. Since they could find in America neither instruction in these areas nor encouragement, they spent many years abroad. Trumbull died embittered; Vanderlyn, impoverished.

Samuel Finley Breese Morse, of Charlestown, Massachusetts, a painter educated at Andover and Yale, dreamed of being among those who would revive the glories of the High Renaissance; in pursuit of this aim he sailed for England in 1811 with Washington Allston. He studied with Allston and with West and stayed abroad until 1815. Back in Boston, hoping to continue the career as a history painter he had auspiciously begun in England, he discovered that only his portraits would sell. Even a painting with so strong a national appeal as *The Old House of Representatives* (plate 26) brought no real response. Probably the finest of his large history pieces, this canvas was completed in 1822. In the Neoclassic ambience of the elegant old hall the artist has placed his highly contemporaneous subject, a well-worked-out grouping of the legislators (all but one of whom actually sat for Morse). We have in this painting a faithful record of the Lower House, or the House of Representatives, as it appeared in 1821. The eighty-six figures take on the solemnity of the vast interior. To augment the drama, Morse chose candle-lighting time; the members are assembling for an evening session, and the room is suffused with a soft orange-red glow.

The year after painting this canvas, Morse settled in New York, and returned reluctantly to portraiture. His famous portrait of Lafayette, of 1826 (plate 38), was commissioned by the city. But his success in this field was no consolation to him, and in the early 1830s, when his application to decorate the national Capitol failed of acceptance, he gave up art, reverting to an interest of his early college years—electricity. After about ten years of effort his revolutionary invention, the telegraph, became a reality. Though, as he himself declared in

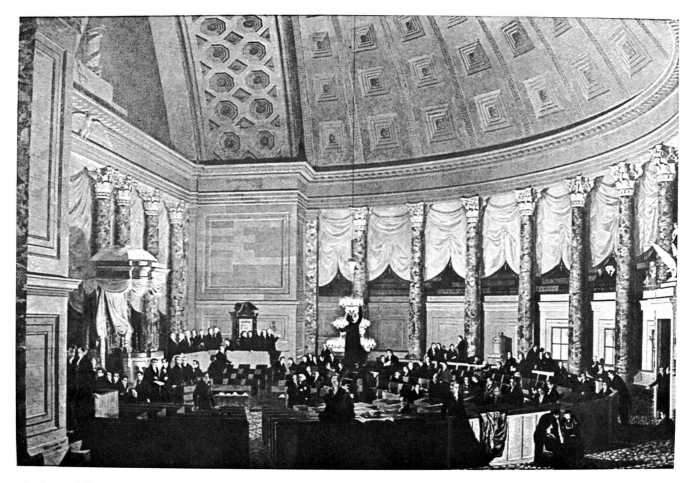

26. Samuel F. B. Morse. *The Old House of Representatives.*
1822. Oil on canvas, 7′ 2 1/2″ × 10′ 10 3/4″. The Corcoran Gallery of Art, Washington, D.C.

a letter of 1849, his view of painting had been too exalted and painting had been a "cruel jilt" to him, he never gave up his interest in art. He founded the National Academy of Design and served as its president from 1826 to 1842 and again in 1861–62.

The military victories that led to Independence and the ideological and political debates that produced the Constitution are, of course, only a part of the story of America before the Civil War. During these years, for example, great strides were being made in science. Morse's invention of the telegraph has already been mentioned. In 1767 the astronomer David Rittenhouse designed an orrery, an apparatus for illustrating the motions and positions of the planets. In 1793 Eli Whitney invented the cotton gin. Robert Fulton developed one of the world's first steam-driven boats and made its use practical; John James Audubon drew and classified hundreds of species of American birds; a Boston dentist, W.T.G. Morton, in 1846 performed the first successful operation on an etherized patient; and the chemist and geologist Benjamin Silliman advanced the importance of scientific research in general.

A scientific expedition that took place in 1801 in Newburgh, New York, is the subject of a history painting of uncommon interest not only in itself but because the artist who painted it is also the scientist who engineered and directed the event. The talented and versatile painter, inventor, and natural historian Charles Willson Peale set up a gallery for his portraits of heroes of the Revolution and, as an extension of his portrait gallery, built up a natural history museum, which housed stuffed and preserved creatures set within skillfully reproduced

34

bits of their natural habitats, all carefully labeled. The skeleton of the mastodon that Peale reconstructed from the bones he himself had helped dig up in the expedition depicted in his *Exhuming the First American Mastodon*, of 1806–8 (plate 27), became the prime attraction of his museum. Of the many figures in the scene, only three had in fact taken part in the digging: Peale himself, who holds up the drawing of a bone and gestures toward the marl pit; his eldest son, Rembrandt, who stands beside him and helps him hold the drawing; and the farmer on whose land the excavation took place, John Masten, in the foreground climbing out of the pit on a ladder. The other figures are mostly members of Peale's large family and friends of his, some deceased—all posed as in a great family portrait. The idea of combining all these elements, representing the many eventful changes in Peale's own life (including his three marriages and his seventeen children), may have been linked in his mind with the momentous changes in geological history suggested by the extinct mastodon.

In 1790 nearly ninety-five percent of the American population was situated east of the Alleghenies; by 1850 the number had decreased to fifty-five percent. But statistics alone give no inkling of the great drama of the opening up of the West that was unfolding during these years. Even prior to 1830, missionaries and traders and trappers seeking overland wagon routes traveled through the Louisiana Purchase, acquired in 1803, all the way into Oregon. Artists often accompanied the largest of the caravan trains and military expeditions into the new territories to record the appearance of unmapped terrain and the activities of the Indian tribes inhabiting them.

One of the most extensive pictorial records of the Old West was produced by an artist from Baltimore, Alfred Jacob Miller. After studying with Sully in 1831–32, Miller had continued his training for two years in Paris and Rome. Returned and settled in New Orleans, he had to abandon his hopes of becoming a historical painter and settle for the lesser career of an itinerant portrait painter. When he was offered the job of "artist-in-residence" to an expedition heading west, he could not but be interested. The offer came from a Scottish nobleman bound for adventure in the West, Captain William Drummond Stewart, whose idea was that the artist would later record the events of the trip on the walls of his castle. Together with a caravan of the American Fur Company, Stewart's party set forth from Independence, Missouri, followed the course of the Platte River into Fort Laramie, and then journeyed on into the Green River valley in the Oregon country. This great trek into uncharted territory, with its many adventurous side trips, offered Miller a wealth of subject matter, of which he took full advantage. His watercolors include such scenes as *Laramie's Fort*, of 1858–60 (plate 28), depicting the fur trading post that was used from 1849 to 1890 as a United States fort for the protection of travelers on the Oregon Trail (it had been begun in 1834 as a stockade and was later rebuilt and enlarged); landscapes, Indian encampments, fur trappers, and buffalo hunts were others of the many subjects recorded by his lively, disciplined brush. After returning from the expedition and completing the mural assignment in Scotland, Miller was able to make an adequate living by selling oils and watercolors based on his Western sketches.

THE CIVIL WAR YEARS AND AFTER. The Revolutionary War is remembered as the stirring opening chapter in the history of the United States, the Civil War as its most tragic chapter. With the preservation of the Union hanging in the balance, friend fought against friend, in some cases brother against brother. There had been a foretaste of the violence to come in 1859. In

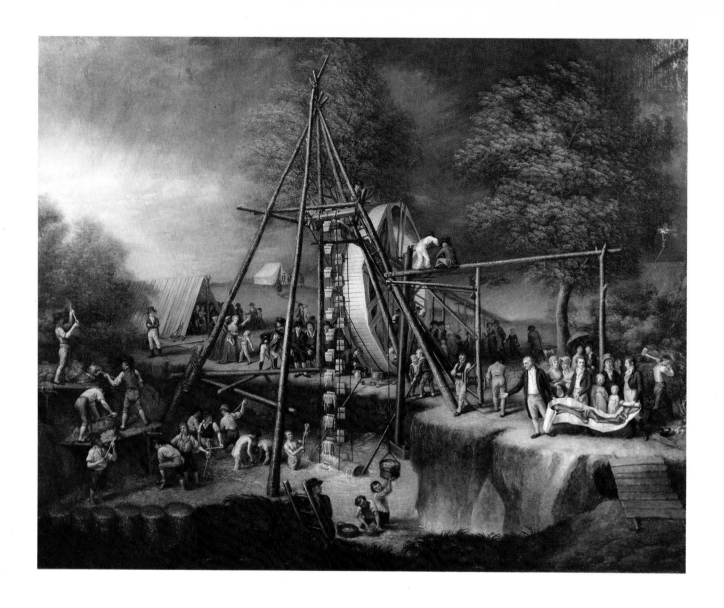

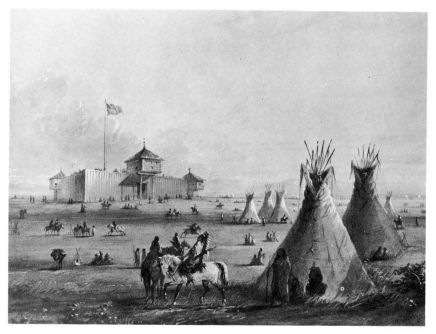

27. (above)
Charles Willson Peale. *Exhuming the First American Mastodon.*
1806–8. Oil on canvas, 50 × 62 1/2″.
The Peale Museum, Baltimore.
Gift of Mrs. Harry White
in memory of her husband

28. Alfred J. Miller. *Laramie's Fort.*
1858–60. Watercolor, 8 1/2 × 11 3/4″.
The Walters Art Gallery, Baltimore

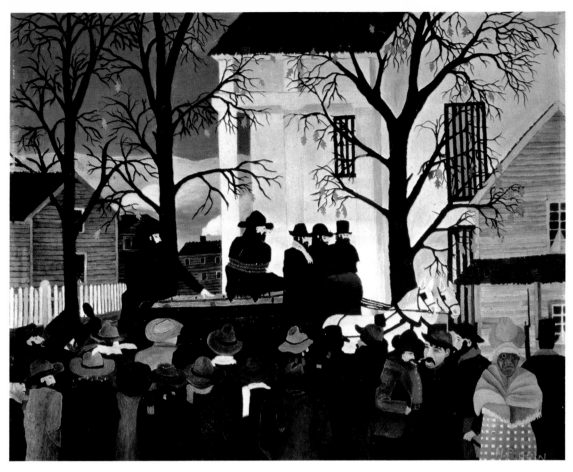

29. Horace Pippin. *John Brown Going to His Hanging.*
1942. Oil on canvas, 24 × 30″. The Pennsylvania Academy of the Fine Arts, Philadelphia

that year, on October 16, John Brown, fiercely uncompromising in his antislavery sentiments, with a group of men seized the United States arsenal at Harpers Ferry, Virginia, as a first step toward organizing an armed slave insurrection. Brown was captured in the battle between his men and the marines. He was hanged on December 2, 1859. During the height of his activity Brown was disavowed by all but the most fiery of abolitionists and in the South he was regarded as a deluded fanatic, but Brown's objective was ultimately justified by history: the abolition of slavery was one of the results of the Civil War. And Brown himself became a legend through the famous Union song of the war "John Brown's Body." To the primitive painter Horace Pippin, whose grandparents were born slaves and whose grandmother witnessed the hanging, Brown was a folk hero. In 1942, Pippin, in his usual style characterized by large, flat shapes, painted *John Brown Going to His Hanging* (plate 29). He captures the winter atmosphere in the lines of the almost bare trees and in the huddled, bundled-up shapes of the onlookers, many wearing bright scarves. The demeanor of the doomed man gives us no hint of his feelings; indeed the artist seems to have succeeded in investing the entire painting with the straightforward calm and dignity with which Brown conducted himself at his trial. But to the right a woman—perhaps Pippin's grandmother—faces us accusingly.

Few heroic battle paintings came out of the Civil War. It would have been difficult for an artist to make something heroic out of the carnage at Gettysburg, or General Sherman's devastating march to the sea, across Georgia into Savannah. Most Civil War pictures are an-

ecdotal and deal with life in the camp, the maneuvers of the soldiers, the care of the wounded on the field. The most famous of the Civil War pictures, *Prisoners from the Front* (plate 30) by Winslow Homer, was completed in 1866. A New Englander, Homer had been working in New York as a free-lance illustrator when the war broke out, and he accompanied the Union army as an artist-correspondent for *Harper's Weekly*, the leading periodical of the time. *Prisoners from the Front* is one of several wartime subjects in oil that Homer painted. In his subsequent career, Homer was to excel as a painter of genre (see Chapter Five), especially the activities of children, and as a masterly interpreter of the sea. But nowhere did he delve more incisively into character than in *Prisoners from the Front*. The young Union officer to the right is Major General Francis C. Manning Barlow, Homer's superior in the Army of the Potomac. He is looking over three Confederate prisoners: an old man who has been through it all, a terrified boy of about eighteen or twenty, and a defiant Confederate officer of about his own age. The two officers at first glance offer a sharp contrast. Barlow seems to have come to his role accidentally; whatever he was before the war, he was not an aristocrat brought up in the tradition of the martial arts, as was the Confederate officer, who eyes him with disdain. Yet, as Homer manages to bring out, they now share a deep kinship: it is their common lot to try to destroy each other. Similar ideas to those Homer expressed with graphic means must have been occupying the mind of Herman Melville, author of *Moby Dick*, when he wrote "The March to Virginia," a poem about the First Manassas (Bull Run), which contains these lines:

> Did all the lets and bars appear
> To every just or larger end,
> Whence should come the trust and cheer?
> Youth must its ignorant impulse lend—
> Age finds place in the rear.
> All wars are boyish, and are fought by boys,
> The champions and enthusiasts of the state. . . .

World War I, which is receding into the dim past and is remembered vividly by fewer and fewer Americans, was not as disastrous for the nation as the Civil War. It was fought on foreign soil, and the number of casualties was far smaller. America did not officially declare war against the Central Powers (Germany, Austria, and Turkey) until April 6, 1917, after five American ships had been sunk during nine days beginning March 12 of that year. By the fall of the following year, Germany was unable to resist any longer, and an armistice was agreed to on November 11, 1918. Childe Hassam's *Allies Day, May 1917* (plate 31), gives us a glimpse of Manhattan's Fifth Avenue just after America had entered the war. On May 9 and 11, Allies Day parades took place on Fifth Avenue (named "Avenue of the Allies" for the occasion) in honor of War Commissioners Marshal Joffre of France and British Foreign Secretary Arthur James Balfour, who had come to America to develop plans for our participation as a new member of the Allies. Hassam's viewpoint was at Fifth Avenue and Fifty-second Street; he completed the painting on May 17. The buildings are shown bravely bedecked with British, French, and American flags symbolizing the unity of the respective nations against the Central Powers. No American painter was closer than Hassam to the French Impressionist style. The sketchy strokes, the forms dissolving in light, the milling crowds seen from a high vantage point, and the high-keyed bright colors of *Allies Day* are hallmarks of many of the city-

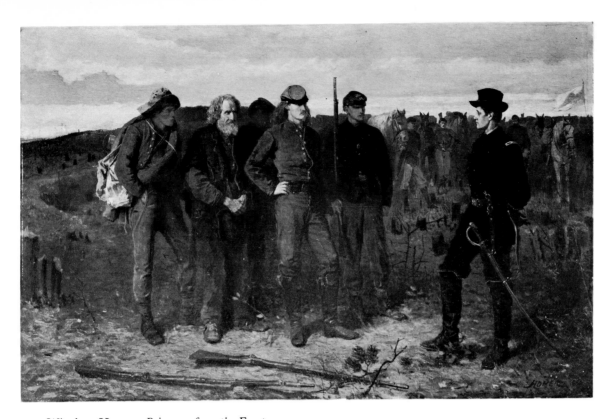

30. Winslow Homer. *Prisoners from the Front.*
1866. Oil on canvas, 24 × 38".
The Metropolitan Museum of Art, New York. Gift of Mrs. Frank B. Porter, 1922

scapes of Pissarro and Monet in the 1870s and 1880s. Hassam, who had been in Europe, most-ly in England, in 1883, 1889, and 1897–98, especially admired the work of Whistler and of the French artists Millet and Corot, as well as the Impressionists generally. He may have visited Claude Monet at Giverny.

In the wake of the Armistice and the Peace of Versailles came the Roaring Twenties, whose end coincided with the Great Depression. The widespread hardship of the Depression years, pointing to a variety of injustices, including unfair distribution of wealth, corruption in politics and the courts, and prejudice against nonwhites and recent immigrants, gave im-petus to an art of social protest. Many artists of the thirties were politically and emotionally involved in the liberal causes of the time; they used their art as a vehicle both of protest and of exposure. Numbered among this group were the New Yorker William Gropper, who laid bare the inequities in New York's court system, the stupidity and greed of her politicians, and the ensuing plight of the poor and unprivileged; the Lithuanian-born Ben Shahn, who came to New York when he was eight, trained as a lithographer, and recorded the American scene with camera and brush and a profound concern for the human condition; and the Negro artist Jacob Lawrence of Atlantic City, New Jersey, who has concentrated on the uprooted-ness of the blacks in American society. Since the aim of the Social Realists, who developed out of the tradition of periodical illustration, was to communicate immediately, directly, and emphatically, much of their art has a posterlike quality.

Shahn first came forcefully to public attention with the twenty-three gouaches he painted in 1931–32 dealing with the trial and execution of Nicola Sacco and Bartolomeo Vanzetti, Italian immigrants who were convicted on July 2, 1921, of a holdup and murder that had

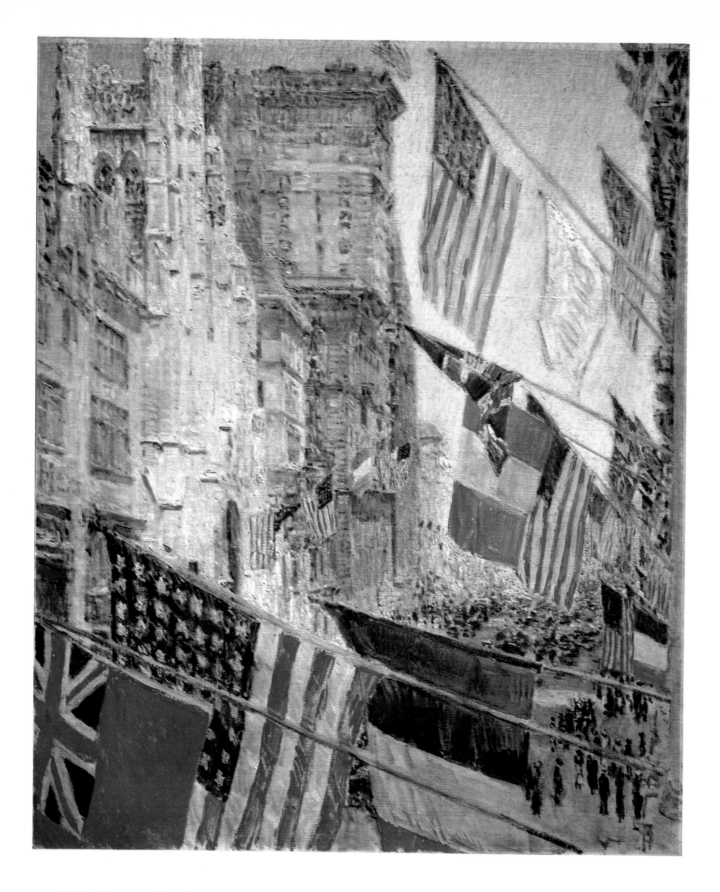

31. Childe Hassam. *Allies Day, May 1917.* 1917.
Oil on canvas, 36 3/4 × 30 1/4″. National Gallery of Art, Washington, D.C.
Gift of Ethelyn McKinney in memory of her brother, Glenn Ford McKinney

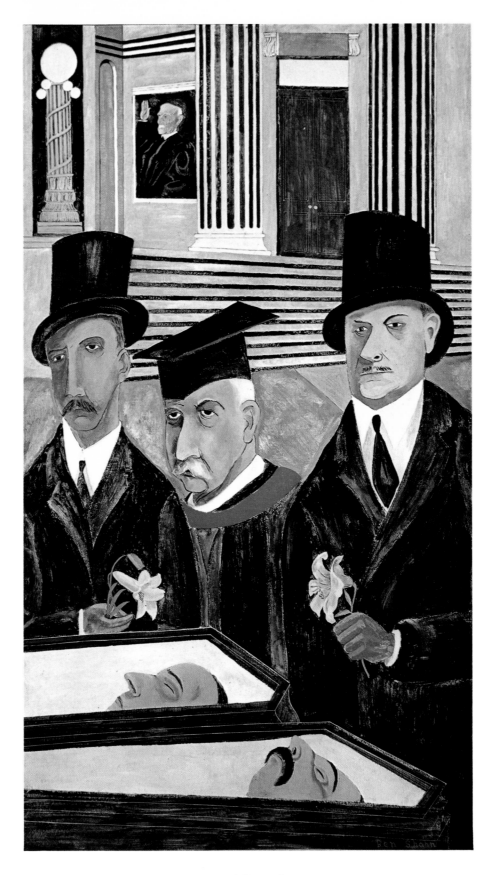

32. Ben Shahn. *The Passion of Sacco and Vanzetti*. 1931–32.
Tempera on canvas, 84 1/2 × 48″. Whitney Museum of American Art,
New York. Gift of Edith and Milton Lowenthal in memory of Juliana Force

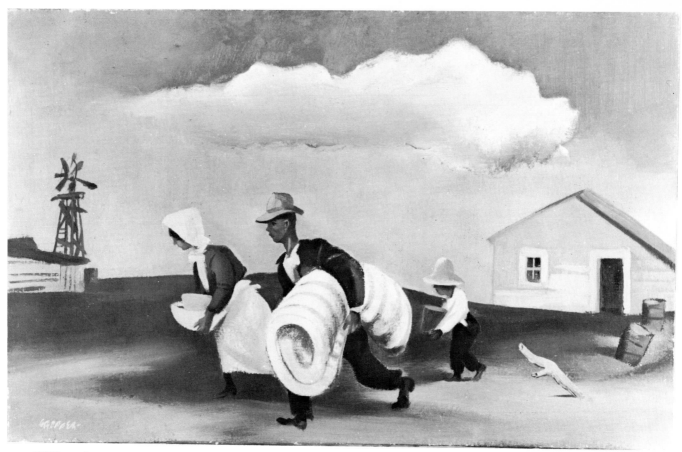

33. William Gropper. *Migration.* 1932. Oil on canvas, 20 × 32″.
Arizona State University, Tempe. Oliver B. James Collection of American Art, University Art Collections

taken place in South Braintree, Massachusetts, on April 15, 1920. From the time of their conviction until the summer of 1927, when a three-man committee was appointed by the governor of Massachusetts to make a final review of the case, they were held in prison under sentence of death, kept alive by numerous motions for repeal and requests for clemency based on lack of conclusive evidence. The committee having decided against them, they were executed on August 23, 1927. While in prison, they had attracted the sympathy of most liberalminded Americans, who were convinced that the original sentence would have been different had they not been Italian immigrants and anarchists, and they are still widely regarded as martyrs (as the title of Shahn's painting implies) to the antiradical hysteria of the twenties. *The Passion of Sacco and Vanzetti,* of 1931–32 (plate 32), shows the two men lying in their coffins. Looking on are the three members of the committee, President A. Lawrence Lowell of Harvard University, President Samuel W. Stratton of the Massachusetts Institute of Technology, and the former probate judge, Robert Grant; in the background is Judge Webster Thayer, who passed the original death sentence. The correctly mournful bearing of these Boston aristocrats makes all the more bitter the subtle satire of this expressive painting.

In his *Migration,* of 1932 (plate 33), William Gropper turned from urban problems to the plight of the dispossessed farmers of the Southwestern dust bowl, who had to become sharecroppers or migrant workers to gain a pitiful subsistence. Gropper silhouettes against a barren plain a small family carrying their meager possessions. The lines of the bent figures are simplified and sharply angularized to render their gaunt awkwardness. Gropper, long an il-

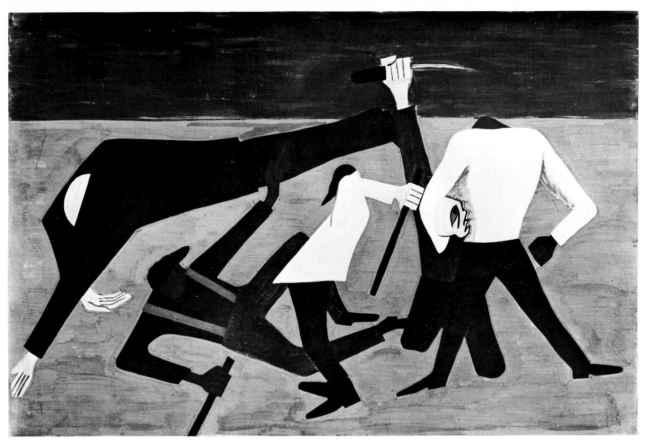

34. Jacob Lawrence. *"One of the largest race riots occurred in East St. Louis,"* from the series *The Migration of the Negro.* 1940–41. Tempera on composition board, 12 × 18″. The Museum of Modern Art, New York. Gift of Mrs. David M. Levy

lustrator, had drawn cartoons for *The Masses* and other publications during the 1920s, and *Migration* has a certain cartoonlike quality. This might well be an illustration of the wretched uprootedness of the fruit tramps and other migrant workers brought to light by John Steinbeck in *The Grapes of Wrath.* Small homesteads dotting the Great Plains were already falling into disrepair by the mid-1920s, for after World War I much of the land was torn up to supply an ever-growing demand for wheat. From 1930 to 1933 there was a severe drought in the Great Plains, and from 1933 to 1935, probably after *Migration* was painted, great blizzards laid waste millions of grazing and farm acres. Here were problems during the Depression above and beyond those affecting the urban population.

In twentieth-century America no problem is more vital than race relations. Its history and its future reach into every consciousness, and the sensitivity of the artist responds in many forms. In a panel entitled *"One of the largest race riots occurred in East St. Louis"* (plate 34), from his series of 1940–41, *The Migration of the Negro,* Jacob Lawrence conveyed a sense of the racial riot's violence. Flat, angularized forms, brutally constricted by the edges of the canvas, press outward with explosive energy. Sticks and a knife are contained in clenched fists. One prominent dark human form is shaped like an ax. Years after Lawrence painted this prophetic work, between 1964 and 1969, racial tension reached a peak and parts of Newark, Los Angeles, Detroit, Boston, and other cities were burned and looted.

After 1945, major events in American history continued to be made subjects of paintings, but the principal painters, as we shall see, turned elsewhere.

35. James Abbott McNeill Whistler.
Arrangement in Grey and Black No. 1:
The Artist's Mother.
1871. Oil on canvas, 56 × 74".
The Louvre, Paris

CHAPTER THREE
Notable American Portraits

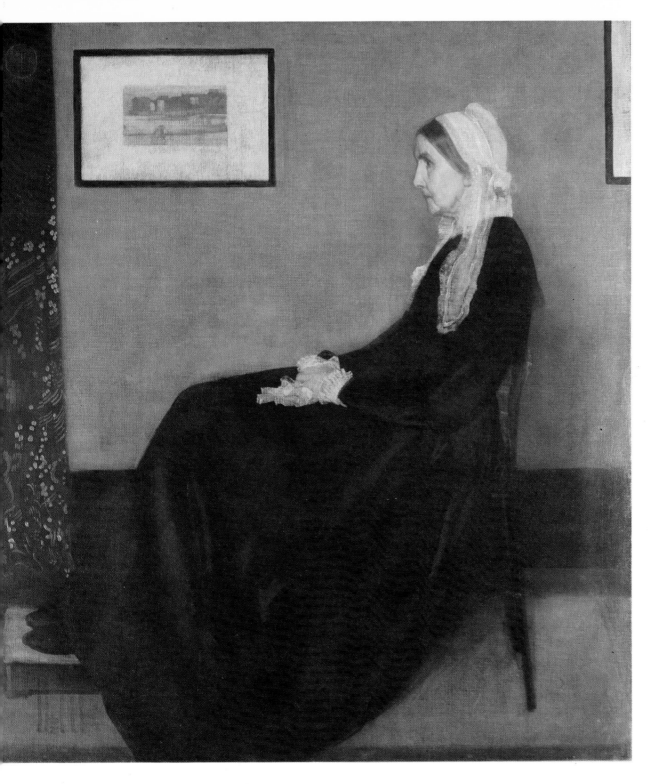

The momentous events in American history depicted in the paintings that were the subject of Chapter Two changed many lives, and their memory has endured. As events change lives, so the lives of some individuals change events. Indeed it has long been debated whether history brings forth men of destiny or men of destiny make history. If we study the life of a leader like George Washington, we realize that the truth lies somewhere in between the two views: in the 1770s the time was ripe for a charismatic leader, and had not a man with his resources of mind and character appeared, events might not have moved as quickly as they did—or in the same direction.

Throughout the course of American history there have appeared talented and versatile men and women who have made their mark in many fields. Of most of them we have likenesses, and through these portraits we are enabled both to recognize the faces and to perceive something of the character of these memorable people, as well as to become acquainted with the styles and methods of interpretation of the artists. In some cases the interpretation may reveal more about the attitude of the artist than about the character of the sitter.

Most Americans have, of course, lived relatively uneventful lives and are remembered only by the few who knew them well and whom they influenced directly. The shopkeepers, the farmers, the factory workers, the teachers—we have a record of only a handful of them, and here too we are indebted to the painter (later the photographer) who portrayed them. This chapter presents a selection of painted portraits of Americans both celebrated and unsung.

"THE MOVERS AND THE SHAKERS": PORTRAITS OF CELEBRATED AMERICANS. The most accomplished of the colonial portraitists, John Singleton Copley, has left us a convincing visual record of some of the chief personages of the days when the Revolution was brewing. We gain an inkling from these portraits of the seething emotions of the time. On the one hand there are the forceful, prosperous merchants and the suave, pompous Tory governors and officials who were trying to sit on the fence, and on the other hand there are the patriots like John Hancock, Paul Revere, and Samuel Adams, who were coming to see that accommodation to the Crown was impossible. Uncompromising by temperament, Adams was a fiery agitator and a leader of the Boston radicals. He circulated a list of the colonists' grievances and was largely responsible for the Boston Tea Party. More than any other of the colonial rebels, he brought the colonies to the break with England. Copley showed Adams as he undoubtedly wished to be remembered, at a high point of his revolutionary activity, on the day after the Boston Massacre of March 5, 1770, when he boldly confronted Governor Hutchinson. In Copley's portrait (plate 36), Adams is pointing to the old Charter of William and Mary to Massachusetts, which he believed guaranteed the rights of the colonists. Of all the people who sat for Copley, no one is more grimly intent or more tautly poised than Sam Adams in this portrait, of about 1770–72. The face is stony, the eyes gaze piercingly, the body is rigid, the right hand grips the scroll like a vise. It is hardly to be wondered at that (as he later recalled) Adams observed the Governor's knees shaking during the confrontation.

Less inflexible than Adams, and of a warmer nature, Paul Revere was equally involved in the Revolutionary cause. He is best remembered for his famous ride from Boston to Lexington on the night of April 18, 1775, to warn Adams and John Hancock of an impending British raid on Concord. In Copley's *Paul Revere,* of 1768–70 (plate 37), the patriot is shown in his professional role as a silversmith, holding upon the hammering pillow a completed teapot, ready for tooling. Revere, vigorous and alert, is in his shirt sleeves with the tools of his trade at hand—a setting calculated to suggest his practicality and his democratic inclinations. No Briton of substance would have allowed himself to be painted in this way. Revere, in addition to being a master silversmith, was a metalsmith and engraver; he designed the first seal for the United Colonies and later designed and printed the first Continental bond issue. After the war he invented a method for rolling sheet copper for shipbuilding.

Copley's colonial portraits, in their straightforward characterization, are linked stylistical-

ly with the New England limner paintings of nearly a century earlier (see Chapter One). But no limner—nor any of the European-trained painters who came after them, such as Smibert and Blackburn (whose works the young Copley studied)—could match Copley's extraordinary realism: the polished mahogany workbench top in the *Paul Revere,* with its reflections of shirt sleeves and tools, is without precedent in the art of the colonies. Like the limners, however, Copley painted his portraits slowly and methodically, taking care to reproduce faithfully what was before him and giving his subjects a full three-dimensional quality. In connection with Copley's painstaking methods, the story was told by a woman who had sat for the artist fifteen or sixteen times, six hours a session, that after one of these sittings she had stolen a look at the picture only to find it "all rubbed out." Unfortunately, Copley regarded his portraits of colonials as hardly worthy of being called art; he yearned to be a higher sort of painter, a painter of history pieces (for which there was then no market in the colonies).

Inspired by the Americans' devotion to the ideal of liberty, a number of eminent foreigners came to these shores between 1776 and 1783 to support their resistance to the British. The young Polish general Thaddeus Kosciusko played a part in the victory of the Americans over the British at Saratoga. The Polish count and military leader Casimir Pulaski served at Brandywine and Germantown and later headed his own cavalry unit; he was mortally wounded in the attack on Savannah. The German-born Johann Kalb ("Baron de Kalb"), who had been an army officer under Frederick the Great, was appointed a major general in the Continental army in 1777 and died heroically in the battle of Camden in 1780.

The most dashing of these foreign champions of the colonial cause, the Marquis de Lafayette, came here in 1777, at the age of nineteen, and not only served capably as an officer but lent support in other ways. He bought uniforms for the Americans with his own money, and in 1780 persuaded the French king to send troops (this force helped General Washington win the decisive battle of Yorktown). To the Americans, Lafayette always remained a romantic hero; he was given a tumultuous welcome when he returned here in 1784 and again in 1824. Lafayette had also participated in the French Revolution and in the July Revolution of 1830. His own countrymen, though, were more inclined to regard him as an impractical idealist than as a great liberator. Samuel F. B. Morse's *Lafayette* (plate 38) was painted in 1826, when the Marquis was sixty-nine and his place in American history was assured. In this painting, Lafayette is a grand and impressive figure. Behind him is a rich sunset, symbolic of the evening of his life and probably suggesting as well the immortality that he has earned. To his right are three pedestals; on the first two are busts of Washington and Franklin, and it is clear that the third is destined to hold his own (an anticipation of his death that some might find disturbing). It is a resplendent, melodramatic painting, far from Copley's restrained taste. But to Americans of the time no treatment was too grand for the young nobleman who had unstintingly thrown in his lot with theirs when their fortunes were at their bleakest.

George Washington was the grandest figure of all. To most Americans the face of the first president of the United States is as familiar as that of any of the public figures whom we see daily in our newspapers, and though several artists painted Washington from life, it is Gilbert Stuart's Washington that we picture when we think of the man who came to be known as the Father of His Country. It was Gilbert Stuart who best succeeded in giving him the august bearing suitable to his lofty position in American history; one of Stuart's iconic images of Washington decorates our dollar bills.

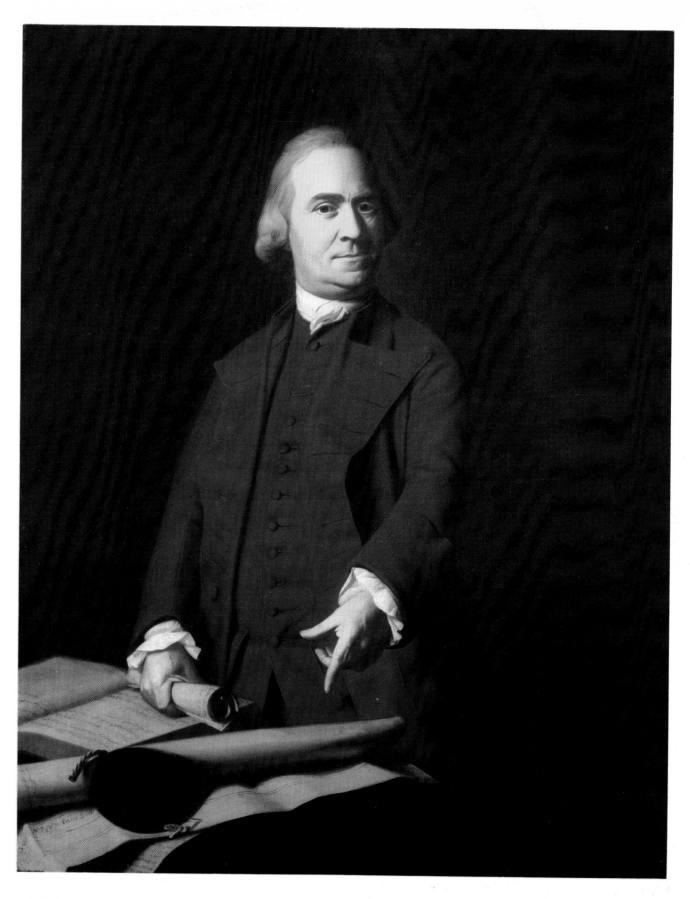

36. John Singleton Copley. *Samuel Adams*. c. 1770–72. Oil on canvas, 50 × 40 1/4″.
Museum of Fine Arts, Boston. Deposited by the City of Boston

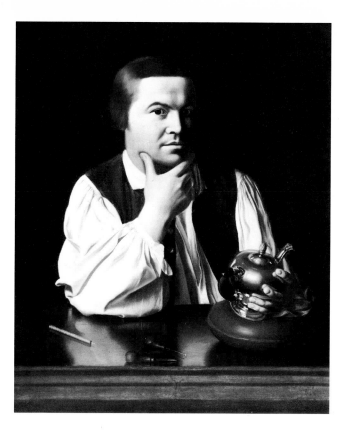

37. John Singleton Copley. *Paul Revere*.
1768–70. Oil on canvas, 35 × 28 1/2″.
Museum of Fine Arts, Boston.
Gift of Joseph W., William B., and
Edward H. R. Revere

38. Samuel F. B. Morse. *Lafayette*.
1826. Oil on canvas, 96 × 64″.
Art Commission, City of New York

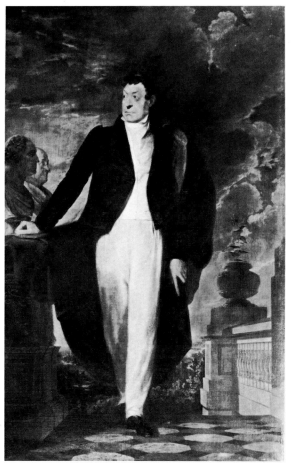

In 1796, when Stuart painted the *Athenaeum Portrait of George Washington* (plate 39), which is unfinished, Washington was in the third year of his second term as president. His active career had begun in the 1750s, when he had been an officer in the British service in the French and Indian Wars. Returned to his plantation after the war, he had served in the Virginia legislature, and was instrumental in shaping its resistance to British colonial policy. In 1774–75 he was a delegate to the Continental Congress, and in 1775 he was made commander of the Continental forces. For seven years he was the leader and guiding spirit of the troops, holding them together in battles from Boston to Long Island, through the terrible winter of 1777–78 at Valley Forge, and on to the surrender of Cornwallis at Yorktown, Virginia, in 1781. First in war, he was now first in peace: he presided over the Constitutional Convention in Philadelphia, and after the ratification of the Constitution was unanimously elected president of the young nation.

Gilbert Stuart, while he had achieved the distinction of being the leading portraitist of the day, was cut out of very different cloth. Indeed the two men were opposites, and this may have contributed to the imposing and authoritative air with which Stuart invested his sitter. Washington wears no symbols of rank, which makes the assurance, calm, and dignity of his person all the more impressive. The story goes that Stuart, in his customary breezy way, tried to get Washington to relax while sitting by suggesting that their respective stations be forgotten—a suggestion that was icily rejected. Stuart, whose life had begun in poverty and was, because of his self-indulgence and lack of discipline, to end in destitution, had been born in Rhode Island, had gone through many lean years in London until Benjamin West befriended him and brought his talent to maturity, had tried his fortune in Dublin (where he wound up in prison), and only then returned to America.

Stuart's approach was more facile and spontaneous than Copley's, which was laborious and painstaking. While Copley took pains to reproduce accurately the features of his sitter, Stuart had no compunctions about taking liberties. Stuart was especially sure of himself in the case of Washington, whose face he had come to memorize; he had painted a great number of likenesses, usually finishing within a few hours, and could use his own paintings as a model.

In setting his course somewhere between the ideal and the literal, Stuart charted a new direction for the painting of portraits of well-known personages, and every important society portraitist in America during the first half of the nineteenth century was influenced by him, either directly or at second hand. But for the precedent of Stuart's subtle departures from the factual, Morse's flamboyant interpretation of Lafayette (plate 38) would probably not have come about.

Stuart painted portraits of most of the leading personalities of the early republic. John Adams of Massachusetts sat for him in 1823, when he was in his ninetieth year (plate 40). This was twenty-four years after Adams—who, unlike Washington, was never able to win the undivided support of the nation—lost the election of 1800 to Jefferson after serving one term as president. Without at all slurring the lineaments of age, down to the clawlike hand resting on the cane, Stuart forcefully projects the alertness and wisdom of the man among whose official acts was the appointment of "the great Chief Justice"—John Marshall.

By defeating the British, the Americans not only secured their independence but gained possession of a great deal of new territory. By the terms of the Treaty of Paris of 1783, which

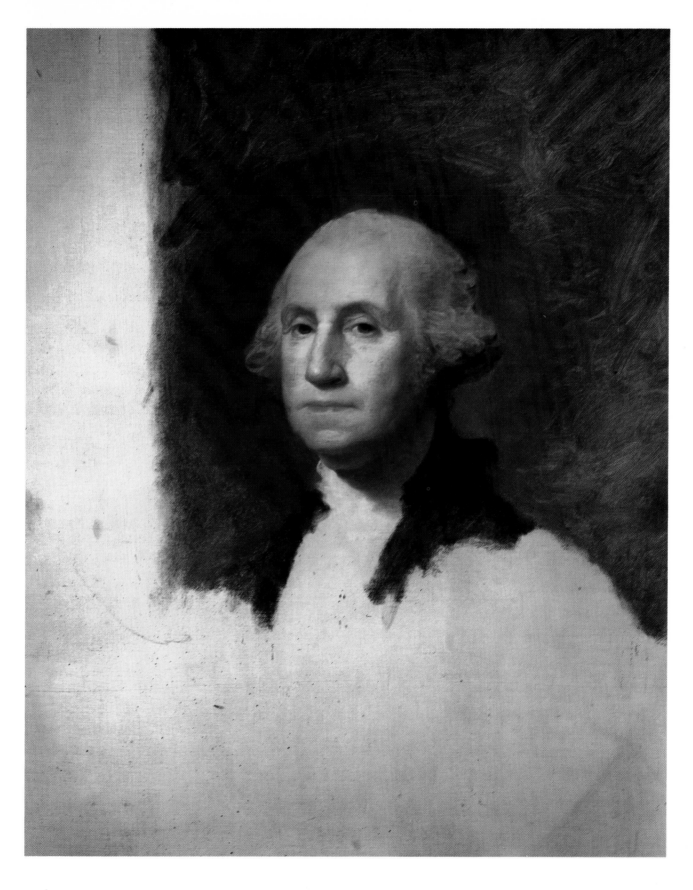

39. Gilbert Stuart. *Athenaeum Portrait of George Washington.*
1796. Oil on canvas, 48 × 37″. Museum of Fine Arts, Boston. Deposited by the Boston Athenaeum

formally recognized the new nation, there was ceded to them a tract reaching westward from the original boundary of the thirteen colonies to the Mississippi and from Canada in the north to the northern border of Florida in the south. The region known as the Old Northwest (which included the present states of Ohio, Indiana, Illinois, Michigan, Wisconsin, and part of Minnesota) became, by the Ordinance of 1787, the first national territory of the United States, with the provision that once the population of any portion of it reached sixty thousand it might apply for admission to the Union as a state. To the south, in what is now Kentucky and Tennessee, the Federal government set up in 1790 "The Territory of the United States South of the River Ohio"—known as the Southwest Territory.

The area west of the original colonies had to be explored and mapped out before settlers would dare to venture beyond the Appalachians. Among the brave men who contributed to the eventual establishment of the settlements, Daniel Boone was and is the most famous; he became a legend in his own lifetime. Boone first explored Kentucky in 1769–71. In 1775 he crossed the mountains through the natural passage called Cumberland Gap, blazing the trail that became known as the Wilderness Road and pushing on to the Kentucky River, where he established Boonesborough. Later in life, finding the new settlements too crowded, he crossed the Mississippi and settled in Missouri. His portrait (plate 41) was painted, probably in 1820, the last year of his life, by Chester Harding, who had ventured forth from Boston in search of him. Harding, who was himself a woodsman and had in his checkered career worked as farmhand, saloon keeper, chairmaker, and peddler, must have seen in Boone a kindred spirit.

In 1803, under President Jefferson, the area of the United States was more than doubled through the Louisiana Purchase, by whose terms it acquired from France a tract of over 800,000 square miles, which extended westward to the Rockies and from Canada in the north to the Gulf of Mexico in the south. Long eager for exploration of the West, Jefferson now sent an expedition out to the Pacific Northwest by way of the Missouri and Columbia valleys. To head it he appointed his private secretary, Captain Meriwether Lewis, who had had considerable experience in the West; for his associate Lewis picked a young army officer with a strong interest in natural history, William Clark, who had lived among the Indians of the Northern Plains. During the two-and-a-half-year expedition, which started from St. Louis in the spring of 1804 and returned there in the autumn of 1806, Clark served as guide, mapmaker, and chronicler. We have a smoothly flattering likeness of Clark, undated (plate 42), which was painted by the leading New York portraitist, John Wesley Jarvis, an artist who had learned much from the painting of Gilbert Stuart.

In opening the way for further travel, in establishing relations with Indian tribes, and in amassing data about the territory, the Lewis and Clark Expedition was tremendously successful, and it was followed by numerous other exploring ventures. After the explorers came the fur traders, then the miners, cowboys, and ranchers.

But as the White Man advanced, the Indians lost more and more of the land that had been theirs, and the buffalo, their chief source of food, was virtually exterminated by cattle herders and railroad builders. Such great Indian leaders as Chief Crazy Horse of the Oglala Sioux, Chief Sitting Bull of the Teton (or Prairie) Sioux, Geronimo of the Apache, and Chief Joseph of the Nez Percé were powerless to do more than delay the slaughter of some tribes and the relegation of others to reservations. The last important victory for the Indians was the

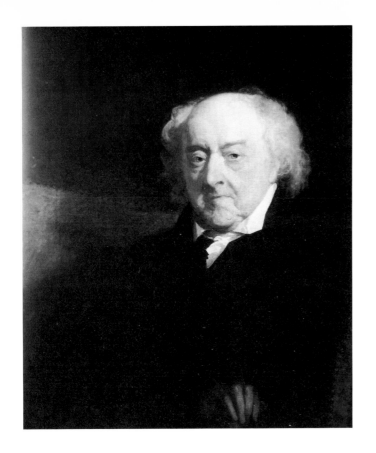

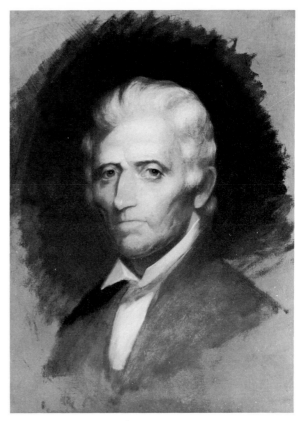

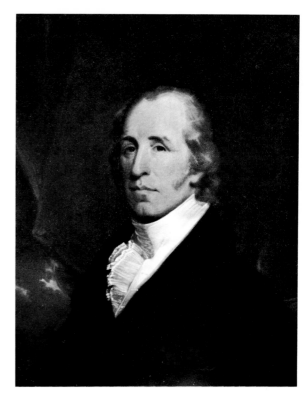

40. (*above*) Gilbert Stuart. *John Adams*. 1823.
Oil on canvas, 30 × 25″.
Collection Charles F. Adams, Boston

41. (*above, right*) Chester Harding. *Daniel Boone*. 1820.
Oil on canvas, 21 1/2 × 16 1/2″.
Massachusetts Historical Society, Boston

42. (*right*) John Wesley Jarvis. *William Clark*. Not dated.
Oil on canvas, 30 × 25″.
Missouri Historical Society, St. Louis

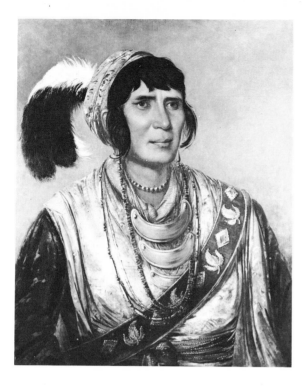

43. George Catlin.
Osceola, the Black Drink, Distinguished Warrior.
1838. Oil on canvas mounted on aluminum,
30 3/4 × 25 3/4".
National Collection of Fine Arts,
Smithsonian Institution, Washington, D.C.

defeat in 1876 of the 7th Cavalry under General George A. Custer at Montana's Little Big Horn River. The Federal Bureau of Indian Affairs created in 1824 did not adequately enforce the treaties that were made with the various tribes.

Only a small minority of Americans saw and deplored what was happening. One—a lawyer turned artist named George Catlin—had the vision to turn his talents to the making of a record of the civilization of the North American Indians. Catlin left a successful career as a portraitist in New York in 1832 and went west to spend eight years among the Indians of the Great Plains. He painted over six hundred pictures of them, and his paintings are one of our chief sources of information about people and folkways that have perished. To paint his portrait *Osceola, the Black Drink, Distinguished Warrior,* of 1838 (plate 43), he had to go to Fort Moultrie, in South Carolina, where this great leader of the Seminole Indians had been imprisoned in 1837. Osceola had led the resistance to the treaties of 1832 and 1833, which would have forced his fellow tribesmen to move from their native Florida to the West. In the portrait, Osceola, whose personal bravery was legendary, appears rather mild of mien. Catlin remarked on the mobility of his countenance, which would become very fierce when his anger was aroused.

In the annals of America there is no dearth of great scientists, among them many outstanding in the field of medicine. A picture that can be called a portrait of a famous doctor, if the description is not too limiting, is also one of the most important paintings in the history of American art—*The Gross Clinic,* painted by Thomas Eakins in 1875 (plate 44). Dr. Samuel Gross, whose presence dominates this dramatic painting, is noted for the valuable contributions he made to his profession through his teaching, his inventions, and his writings. Philadelphia's leading surgeon, he taught at Jefferson Medical College, where Eakins had studied anatomy. In 1875, when Eakins painted Gross in his role as teacher, the distinguished surgeon was seventy. The painting caused a sensation because of its uncompromising realism: the Philadelphia of the day was not ready for this master of the naturalistic approach.

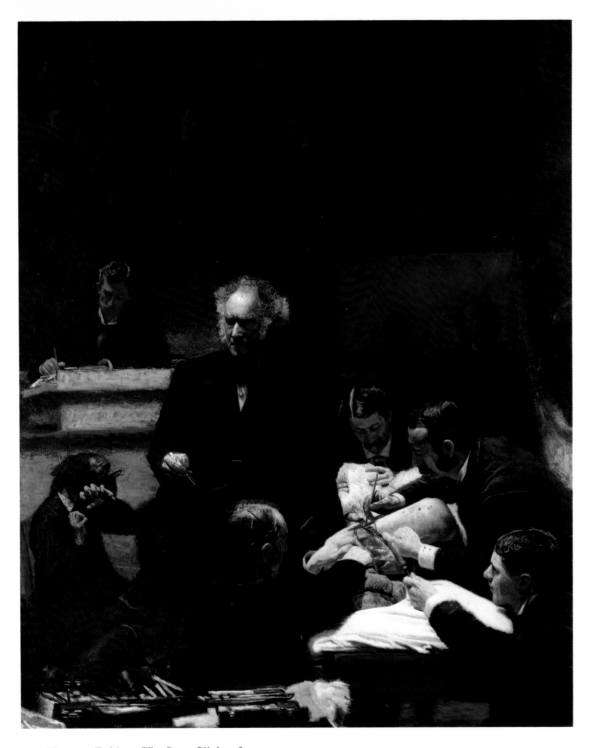

44. Thomas Eakins. *The Gross Clinic*. 1875.
Oil on canvas, 96 × 78″. Jefferson Medical College of Thomas Jefferson University, Philadelphia

(Even into the twentieth century, as we shall see, the American artist was not expected to deal with the unpleasant facts of existence.) Today we can appreciate *The Gross Clinic* as one of the most moving portraits ever painted in America. Dr. Gross, his face in light, seems to be caught at the moment of decision. He is the center around which the action flows. His is a majestic presence, embodying total dedication, brilliance, compassion, and the ability to use knowledge effectively.

A far different image of a great scientist is the portrait of that illustrious American-by-

adoption Albert Einstein, painted by Joseph Scharl in 1950 (plate 45). Scharl, fifteen years older than Einstein, had fled Germany with him in the early 1930s. Unlike Eakins's attitude toward Dr. Gross, Scharl's relation to Einstein probably contained no element of awe; in his portrait he concentrates not on his friend's visionary brilliance but on his amiability and mild eccentricity. He painted the author of the theory of relativity under the aspect of the gentle original who shuffled through Princeton in a knitted cap and baggy trousers.

A portrait of extraordinary interest in the story of American painting is a picture of one exceptionally important American artist painted by another—William Merritt Chase's *James A. McNeill Whistler* (plate 46). The picture was painted in 1885 in London, where the two artists met and became warm friends. Whistler had left America in 1855, drawn to the Paris that was the art center of the world, and settled in London in 1859. Chase also spent some years abroad, going to Munich to study in 1872, but in 1878 he pointedly returned to America, where, except for European trips, he remained, painting and teaching with a skill and enthusiasm that won him acclaim in both fields. His works included landscapes, still lifes, and portraits. The portrait of Whistler represents him as arrogant and aloof. The flat silhouette treatment of the figure and the luminous, undetailed background recall Whistler's own work; the Whistleresque quality reminds us of one of the major influences on Chase's brilliantly eclectic style.

The tradition of portraiture is a very old one, not only in American art but in the art of the whole world, going back no one knows how far. The factor of likeness in the portrait is one that has varied with different artists and different styles in different periods; the constant factor is that the portrait must indicate the personality of the subject. The nonobjective direction taken by art in the post–World War II period of artistic revolution, with its divergence from the pursuit of illusion, obviously diminished, or even suppressed, the factor of likeness in the portrait. But it did not affect the principle that the portrait must convey the subject's essence.

Thus Willem de Kooning, working in the loose, improvisational manner of his Abstract Expressionism (see Chapter Eight), when he painted his portrait *Marilyn Monroe* (plate 47) in 1954, gave us a reality that illusionism could never convey. The rapid handling of the strokes and their almost chancy arrangement suggest a beauty that is superficial and transient. The gaudy red of the lips and heavy blue of the eyes have the quality of lipstick and mascara. This is the portrait of a face that was fashioned for the public. It is a product of the "superstar" system that, with the growth of the motion picture industry, blossomed in the 1940s and 1950s. The superstar, not necessarily an actor of extraordinary ability, was made into a charismatic personality through publicity media. Millions of Americans, bored with the routine of their own lives, nourished their fantasy life by following the star's every activity. Marilyn Monroe, at once seductive and innocent, openly seeking affection both on and off screen, became such a personality.

In an earlier phase of the nonobjective current in painting, we come to the "poster" portraits of Charles Demuth, a member of the school of painters known as Precisionists (see Chapter Seven). In these the Lancaster (Pennsylvania) artist represented the subject by symbolic objects and characters that summon up his particular personality. Some of Demuth's friends and associates in the world of art and literature were thus represented. *I Saw the Figure 5 in Gold*, of 1928 (plate 48), evokes his close friend the physician-poet William Carlos Wil-

45. Joseph Scharl. *Albert Einstein.*
1950. Oil on burlap, 32 × 25″.
National Portrait Gallery,
Smithsonian Institution,
Washington, D.C.

46. William Merritt Chase.
James A. McNeill Whistler.
1885. Oil on canvas, 74 3/8 × 36 1/4″.
The Metropolitan Museum of Art, New York.
Bequest of William H. Walker, 1918

47. Willem de Kooning. *Marilyn Monroe.*
1954. Oil on canvas, 50 × 30″.
Collection Neuberger Museum,
State University of New York at Purchase

liams. The imagery is based on Williams's description of a fire engine in the short poem "The Great Figure":

> Among the rain
> and lights
> I saw the figure 5
> in gold
> on a red
> firetruck
> moving
> tense
> unheeded
> to gong clangs
> siren howls
> and wheels rumbling
> through the dark city.

Three figure 5s recede into the background; the initials, nickname (Bill), and middle name of Williams, and the headlights and part of the body of a fire engine also appear. Demuth could

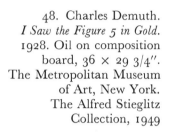

48. Charles Demuth.
I Saw the Figure 5 in Gold.
1928. Oil on composition
board, 36 × 29 3/4″.
The Metropolitan Museum
of Art, New York.
The Alfred Stieglitz
Collection, 1949

hardly have chosen a more appropriate symbolic distillation of Williams's qualities—his personal gruffness, his radical audacity in the construction of poetry, his humanity in the practice of medicine (the fire engine is also an instrument of salvation).

PORTRAITS OF UNSUNG AMERICANS. Some Americans have been accorded places in the national hall of fame not through their own accomplishments but because of the accomplishments of the painters of their portraits. It is their entrance on the American scene at a given time and place and under given circumstances that ensured their immortality. Fame has been thrust upon them by a certain look, perhaps a chance appearance in a certain setting, or an intriguing visual problem that impelled an artist to create an unforgettable image.

Charles Willson Peale, whose scientific interests were noted in Chapter Two in connection with his painting *Exhuming the First American Mastodon* (plate 27), was a man who was not content with the usual or the accepted. Perpetually energetic, he was one of the most inventive and enterprising characters of the early republic as well as one of its most active patriots. Besides establishing and maintaining a combined museum of natural history and portrait gallery, he patented a chimney that conserved heat and a new type of wooden bridge (the first bridge patented in this country), perfected, in collaboration with his friend Thomas Jefferson, the polygraph (a portable writing machine that can make several copies at once), developed a technique of projecting a type of moving picture by means of transparencies, was one of the founders of the Pennsylvania Academy of the Fine Arts in 1805, and wrote papers on natural history, engineering, hygiene, and public affairs. He was the intimate friend of Franklin, Jefferson, and Washington. His accomplishments included dentistry, and Washington, whom he fitted with a set of false teeth, was a beneficiary of this.

Peale was innovative in his painting as well, producing one of America's first examples of *trompe l'oeil,* or illusionistic painting, *Staircase Group,* of 1795 (plate 49). The artist framed the

portrait of his sons Titian Ramsay and Raphaelle in a doorway with an actual step projecting from the painted stairs. This setting, together with the careful modeling of the figures, the cast shadows, and such minute details as the dropped card, a ticket to the Columbianum (Associated Artists of Philadelphia) exhibition in which the painting was shown, and the stocking clocks, creates an effect so close to reality that Washington is reputed to have been deceived into absent-mindedly bowing to the young Peales as he went by. Raphaelle later became a painter, mostly of still lifes and portraits, and himself produced, as a practical joke, a fine and witty *trompe l'oeil*—the well-known *After the Bath* (Nelson Gallery-Atkins Museum, Kansas City), in which a towel hanging on a line shuts from view all but the feet and one hand, drying the long auburn tresses, of the presumably nude bather.

A Philadelphia ironsmith by the name of Pat Lyon is remembered chiefly because of John Neagle's famous portrait of 1826–27, *Pat Lyon at the Forge* (plate 50). But the doughty Irishman who commissioned this portrait of himself contributed to its fame. Pat Lyon's unmatchable skill as a locksmith placed him under suspicion in the robbing of a bank and he spent three months in jail. When he was fully vindicated and could well afford (with the help of the damages he was awarded) to engage the services of a leading Philadelphia portraitist, he insisted that he be portrayed with the offending Walnut Street jail in the background and with all the attributes of the workingman that he was—a setting unique among American portraits of the time. Neagle's painting reflects the influence of Gilbert Stuart, but the sugary sweetness of the affable, ebullient Lyon and, especially, of his cherubic apprentice does not bear comparison with that master's easy grandeur.

The name of John Singer Sargent brings to mind a very different image from that of Neagle's Pat Lyon, who made a point of not being portrayed as a gentleman. In the last quarter of the nineteenth and into the twentieth century, Sargent was the chosen portraitist of America's international elite, to which he himself belonged.

As a boy, he had spent many years in Europe with his parents; he was born in Florence, and at an early age he began to study art there. Determined to be a painter, he continued his studies in Paris, and it was in Paris that his first successes were achieved. One of these was *The Daughters of Edward D. Boit*, of 1882 (plate 51), the sensation of the Salon of that year. It was a painting clearly influenced by the subtle tonalities, painterliness, and compositional vitality of Velázquez, whose works Sargent had seen in Spain. There is an intriguing touch of social comment, too, a capturing of the feel of Victorian elegance and of the reactions of some of those who moved in that ambience. The four little girls in their pinafores seem dwarfed by the spaciousness of the room and the scale of the mammoth Oriental vases that are among its furnishings. Their stance is patient and somewhat demure. Their breeding is evident, and yet they do not lack the spontaneity of childhood: one is seen in profile and leans against the vase at the left, and the littlest one has plumped herself down on the rug. To the manner born, they are not, like Joseph Badger's grandson James, painted over a century and a quarter earlier (plate 8), unhappy at having to pose in their best clothes and impatient to go out and play.

It was two years later, in 1884, when Sargent was twenty-eight, that he painted *Madame X—Madame Pierre Gautreau* (plate 52), portrait of the wife of a Parisian banker (an erstwhile Louisiana belle, born in New Orleans). By this time Sargent was the portraitist most in demand in London, New York, and Boston, but the outspoken realism of his portrait of this

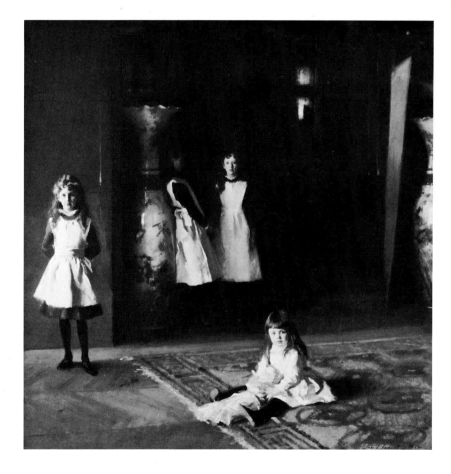

49. (above) Charles Willson Peale.
Staircase Group. 1795.
Oil on canvas, 89 × 39 1/2″.
Philadelphia Museum of Art.
George W. Elkins Collection

50. (above, right) John Neagle.
Pat Lyon at the Forge.
1826–27. Oil on canvas, 93 × 68″.
Museum of Fine Arts, Boston.
Deposited by the Boston Athenaeum

51. (right) John Singer Sargent.
The Daughters of Edward D. Boit.
1882. Oil on canvas, 87 × 87″.
Museum of Fine Arts, Boston.
Gift of Mary Louisa Boit,
Florence D. Boit, Jane Hubbard Boit,
and Julia Overing Boit, in memory of
their father, Edward D. Boit

beauty, a reigning queen of Parisian society whose reputation was somewhat uncertain, created a scandal. Vain of her complexion, Mme Gautreau applied cosmetics of a special blend to achieve the strange creamy tone that we see in the portrait. Most striking about the work is the starkness of the figure. There is nothing to distract the eye—no jewelry, no bright spots of color, no rugs, chests, or curtains. Both the sitter and her mother were shocked: they considered the pose repelling and the whole look unflattering, and they tried to keep Sargent from exhibiting the painting. This compounded the scandal, and it was then that Sargent moved his studio from Paris to London.

In addition to painting a number of famous persons—among them General Grant, Robert Louis Stevenson, Theodore Roosevelt, Joseph Jefferson—Sargent painted many portraits of the cultivated rich—the Vanderbilts, Mrs. Potter Palmer, Miss Charlotte Louise Burckhardt (*The Lady with the Rose;* Metropolitan Museum of Art, New York), and others. Most of these sitters moved in the world of high fashion, and their furs, silks, and laces, as well as the antique bric-a-brac in the background, are all handled with admirable facility.

Sargent's portraits offer a strong contrast to the portraits by Thomas Eakins, and indeed there is much in the lives of the two artists to account for the contrast. For one thing, they moved in utterly different circles—Sargent, a continual traveler, in the cosmopolitan and international orbit of the wealthy American and British upper classes, Eakins within the boundaries of the professional and academic community of Philadelphia. Sargent had his studio first in Paris and then in London; Eakins, after one European sojourn (1868–70), remained in and did virtually all his work in his native city. The contrast holds, too, for worldly success: Sargent achieved it early, Eakins never.

In the portraits by Eakins, as in those by Sargent, what is to be appreciated is the insight of the artist and his keen observation of how the sitters had been molded by the environment in which they moved. The elegance and glitter of Sargent's world is necessarily reflected in the appearance of his subjects, and this tends to suggest, rather unfairly, a judgment of superficiality. By contrast, the mood of Eakins's subjects tends to be one of reflection bordering on melancholy, as we note particularly in his portraits of women painted in the latter part of his career, from about 1890 to 1910. Among his most moving portrayals, these show us some of his pupils, friends of the family, local singers and teachers—Philadelphians with whom he was familiar. These people have about them, despite an inner strength, a sense of deep, brooding disappointment. There is in them a nobility akin to that of the surgeon Dr. Gross, but not the confidence, the forcefulness, the air of accomplishment. Again we have to ask, is this contemplative quality inherent in the characters of these subjects or was it in the mind of the artist? Probably there is something to be said for both views. Certainly it was a quality to which Eakins was attuned, and which he tended to bring out in these sitters.

Addie (plate 53) was Miss Mary Adeline Williams, who had been a close friend of Eakins's sister Margaret, and who, at the invitation of Eakins's father, joined the Eakins household in 1900 (the year the portrait was painted). She was then forty-five years old. It is hard to conceive of two women representing more complete opposites than the rather plain-looking Addie, with her air of stoical resignation, and the glamorous Mme Gautreau, product of a world of artifice and illusion.

In many of the portraits by James Abbott McNeill Whistler, character analysis counts for less than the interplay of forms. The sitter becomes part of the overall design, his (or her)

53. Thomas Eakins. *Addie* (*Miss Mary Adeline Williams*). 1900. Oil on canvas, 24 1/8 × 18 1/4". Philadelphia Museum of Art. Given by Mrs. Thomas Eakins and Miss Mary A. Williams

52. John Singer Sargent. *Madame X—Madame Pierre Gautreau*. 1884. Oil on canvas, 82 1/8 × 43 1/4". The Metropolitan Museum of Art, New York. Arthur H. Hearn Fund, 1916

form being balanced against the other forms within the compositional space.

Whistler was as irreverent and colorful a figure as America produced during the nineteenth century. He affected the pose of a dandy and a snob but was in fact a significant revolutionary in art. Born in Lowell, Massachusetts, Whistler spent most of his adult life in London and Paris. (As a boy he had lived in the splendor of St. Petersburg, where his father, a civil engineer, was working on the St. Petersburg–Moscow railroad. Returning to America, he entered West Point, but was discharged after three years because of difficulties with chemistry —the weakness that occasioned his famous quip that if silicon had been a gas, he would have become a general.) In London he brought a libel suit against the influential critic John Ruskin for accusing him of "wilful imposture," of "flinging a pot of paint in the public's face." The "pot" was one of his Nocturnes, priced at two hundred guineas. Asked during the trial how long he had worked on the picture, Whistler replied that the price represented "the knowledge of a life-time." He won the case and was awarded a farthing in damages, but the tension and notoriety of the trial lost him much of London's influential portrait trade, and he was forced into bankruptcy. The trial embittered Whistler, and he became more aloof than ever. It was seven years after the trial, in 1885, that William Merritt Chase's portrait of him (plate 46) was painted.

Possibly the most iconoclastic American painter of the nineteenth century, Whistler argued against the artist's dependence upon nature. Nature is not always right, in fact it is rarely right, and it is up to the artist to pick and choose elements from nature and to impose order and harmony upon them. "To say to the painter," he wrote, "that Nature is to be taken as she is, is to say to the player, that he may sit on the piano." Whistler liked to make analogies between painting and music. He felt that painting, like music, ought to be a pure art and should stand alone, and that it is the poor painter who merely imitates what is before him.

Whistler's *Arrangement in Grey and Black No. 1: The Artist's Mother,* of 1871 (plate 35), illustrates these views on art. It was only later that the picture came to be known as *Whistler's Mother* and, oddly, to be regarded widely as a universal representation of motherhood. Whistler himself declared that the fact that the woman was his mother ought to be of no concern to the viewer. If we look at the *Arrangement* freshly, we see that it is made up of rectangles of different sizes and patternings (the curtain to the left, the framed pictures and part of another above, the floor running horizontally the length of the canvas) and that the asymmetrical figure of the woman is set up as a foil in their midst. The colors—black, gray, gray-green for the curtain, light gray with a tinge of green for the wall, grayish flesh tones—do in fact make up an arrangement in gray and black. The shallow space and the flattened forms within it show the effect of what was then one of the most advanced influences on European taste, Japanese prints, together with the works of artists like Édouard Manet, which were partially based on them. In its spirit, Whistler's *Arrangement in Grey and Black* anticipates America's nonobjective art of almost three generations later, when many artists had no qualms about leaving the world of visual appearances far behind.

Running counter to the artistic inclinations and theories of such cosmopolitan, expatriate American artists as Whistler and Sargent (to whom England also feels it has title) the American Regionalist movement took shape after World War I. The Regionalist artist concentrated on types of people and settings that were authentically American. For the most part

54. Grant Wood. *American Gothic.*
1930. Oil on beaverboard, 29 7/8 × 24 7/8″.
The Art Institute of Chicago.
Friends of American Art Collection

this meant the rural folk and ambience of the southern, western, and midwestern parts of the country. Eastern city people were seen as too sophisticated and cosmopolitan. Paralleling the interest of the Regionalist painters in the American scene were the music of Aaron Copland and such novels of the thirties as John Steinbeck's *The Grapes of Wrath* and *Of Mice and Men,* dealing with itinerant farmworkers, and William Faulkner's *Light in August,* dealing with rural life in the South.

Grant Wood used his sister and a friend as models for his *American Gothic,* of 1930 (plate 54). The painting, then, is a portrait of Midwestern farmers only in a general sense. That Wood should have chosen such a subject at the time is not accidental; it was in line with the Regionalist direction of American painting.

In *American Gothic,* Wood deliberately used a style reminiscent of that of the early limners and the American primitives. The two people stand stiffly. Behind them is their farmhouse, with an upper arched window in a Gothic style. Such a style was meant to be in keeping with the austerity and simple virtue of American farming people like those in the painting. There is no question that Wood, had he wished, could have painted the couple less stiffly and modeled his forms more fully. He had earlier left his native Iowa to study in Paris and Munich, where he concentrated on the work of the fifteenth-century Flemish artists. No true primitive could have shown the wrinkles on the face of the old farmer so realistically.

Most Regionalist painting extolled the rugged virtues of the homespun life (this outlook is apparent, for example, in the work of Thomas Hart Benton). With Grant Wood the issue is more complex, as we can gather from his famous painting. Wood saw the negative aspects of America's rural simplicity, and the man and woman whose portraits make up *American Gothic* can be interpreted as straitlaced to the point of priggishness and insular to the point of prejudice. But this view overlooks the power and the high seriousness of this meticulously composed double portrait.

55. Fitz Hugh Lane.
Owl's Head, Penobscot Bay, Maine.
1862. Oil on canvas, 16 × 26″.
Museum of Fine Arts, Boston.
M. and M. Karolik Collection

CHAPTER FOUR
The American Natural Landscape

In the 1820s and 1830s American painting branched out. No longer were portraiture and occasional history pieces its only concerns. Throughout the nineteenth century some of the most talented painters in America depicted landscape vistas and the daily activities of ordinary people. By 1825 the Revolutionary War had been over for several decades. The colonies were now an independent republic, and prosperity had come—bringing with it the opportunity and inclination for these painters to contemplate their surroundings. As they pushed out from the early settlements or departed from such large cities as Philadelphia and Boston, they began to appreciate the pristine beauty of American scenery.

These painters, as well as their patrons, were struck by the fact that American scenery differed from European, partly because in its unsettled state it looked wild, untrammeled, primeval. Most early American landscape painters stressed this aspect of their native terrain. In his "Essay on American Scenery," of 1835, Thomas Cole, who is generally regarded as America's first major landscapist, and one of its greatest Romantic painters, observed that the magnificence, beauty, and sublimity of America's landscape are the birthright of each inhabitant of the land and that this landscape is distinctive "because in civilized Europe the primitive features of scenery have long since been destroyed or modified." In this country, amidst the many beauties of nature, one can feel close association with God the creator, for "they are his undefiled works, and the mind is cast into the contemplation of eternal things."

THE HUDSON RIVER SCHOOL. America's first group of landscape painters came to be known as the Hudson River School, even though the vistas they painted extended into the White Mountains of New Hampshire, the Adirondacks of upstate New York, the Berkshires of western Massachusetts, the Connecticut River valley, and up and down the eastern coast of the United States. They lovingly explored the woods and hills and streams of this terrain.

Cole, the greatest talent among the founders of the Hudson River School, was born in Lancashire, England. His enthusiasm for the natural beauties of America, as pictured in books, was a factor in the decision of his family to emigrate to this country. They came to Philadelphia in 1819, when he was eighteen, and shortly afterward settled on the frontier in Steubenville, Ohio. Here his love of the wild beauty of the continent was nourished, and since he could not gain a livelihood from landscape painting, he roamed from village to village as an itinerant portrait painter. He was too poor to own a horse, but he had a saddle that had been his payment for a commission, and on this he would rest at night in the woods on his wanderings. In 1823 and 1824 he worked at his landscape painting in Philadelphia and then, in 1825, moved with his family to New York, where his landscapes were "discovered."

Cole's landscapes drew increasing appreciation, and when he returned to his native England at the age of twenty-eight, he was regarded as one of America's leading painters. Before he left for this European visit, in 1829, he was advised by his friend the poet William Cullen Bryant:

> Fair scenes shall greet thee where thou goest—fair,
> But different—everywhere the trace of men,
> Paths, homes, graves, ruins, from the lowest glen
> To where life shrinks from the fierce Alpine air.
> Gaze on them, till the tears shall dim thy sight,
> But keep that earlier, wilder image bright.

Cole spent three years abroad—nearly two in England, where he met Lawrence and Turner (whose early works he admired) and exhibited at the Royal Academy. He stayed in Italy for a year and a half; he was struck by the "softness and beauty" of the Italian skies and took delight in the treasures of Florence. He returned to America in November 1832. In 1836 he married a girl from the village of Catskill and they established their home in that village in the heart of the Hudson River region that he found so inspiring.

The typical Hudson River School scene consists of a portion of virgin landscape, extend-

56. Thomas Cole. *The Oxbow (The Connecticut River near Northampton)*. 1836. Oil on canvas, 51 1/2 × 76''.
The Metropolitan Museum of Art, New York. Gift of Mrs. Russell Sage, 1908

ing into the far-off distance; often, tiny foreground figures are set against it. Sometimes, as in
Cole's painting *The Oxbow (The Connecticut River near Northampton)*, of 1836 (plate 56), there is
also a blasted tree prominent in the foreground, to suggest to the viewer the desolation of the
terrain. Within this general format there are of course stylistic differences. Asher B. Durand's
trees and rocks are usually dryly painted and handled with much careful detail, an outgrowth
of his artistic beginnings as an engraver of bank notes, of famous paintings by John Trumbull
and others, and of illustrations for the books of James Fenimore Cooper. In Thomas Dough-
ty's landscapes the contours of the mountains are gently curved rather than jagged, the leaves
of the trees are disturbed by no breath of air. Doughty's landscape is tranquil; Cole's is often
turbulent, as in *Oxbow*, with the trees twisted and gnarled and the clouds storm-tossed. Cole
and Durand, his disciple, differed as to the freedom permissible to the artist in arranging the
elements of a landscape. Durand held that the artist should accurately portray a particular
scene as it existed, whereas it was Cole's preference to combine the accurate sketches he had
made of various scenes, so that his final painting, while suggesting, through its compositional
unity, a specific location, was actually a composite view. Yet the two artists were not so far
apart as we might at first suppose. Cole sought out the stormiest skies, the most rugged moun-
tains, and the most irregular trees; Durand, while he refused to change the details of a scene

57. Asher B. Durand. *Kindred Spirits*.
1849. Oil on canvas, 46 × 36″.
The New York Public Library.
Astor, Lenox, and Tilden Foundations

58. Asher B. Durand. *The Evening of Life*.
1840. Oil on canvas, 49 1/2 × 83 1/4″.
National Academy of Design, New York

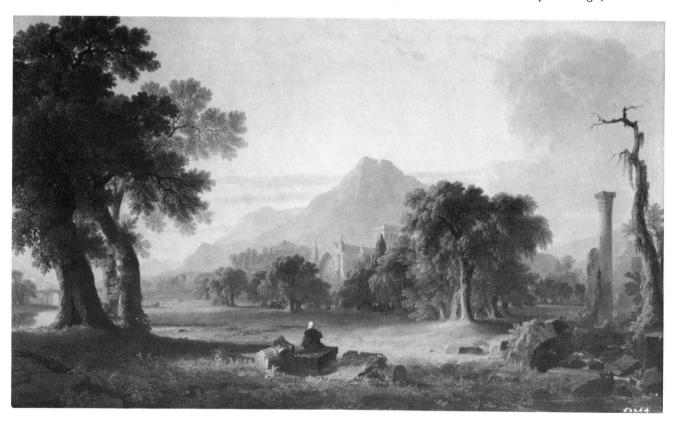

59. Thomas Cole. *The Voyage of Life: Youth.*
1840. Oil on canvas, 52 1/2 × 78 1/2″. Munson-Williams-Proctor Institute, Utica, New York

as it existed, carefully selected the most grandiose and inspiring scenes he could find, as in his *Kindred Spirits*, of 1849 (plate 57).

The lonely grandeur of the American terrain proved for all to see that the land itself was hardier and more durable than its would-be settlers, in other words, that people and civilizations pass away while the land itself remains, almost unchanging. This is a theme, found also in contemporaneous European painting, that proved especially popular in America. It is the message in the pair of canvases of 1840 that Durand portentously titled *The Morning of Life* and *The Evening of Life* (plate 58). In the *Morning* a young shepherd and his family are shown in a forest clearing, against a background in which stands a classical temple (this was the Greek Revival period in American architecture). In the *Evening* we see the shepherd, now an old man, sitting amid the ruins of a temple, against a background in which a Gothic cathedral rises. We are being told that the men and the civilizations that take their place upon the earth inevitably age and crumble. In his cycle of 1839–40, *The Voyage of Life*, Cole, like Durand, employed landscape to express the theme of the passing of time and the stages of human life. In *Childhood* a guardian angel leads a baby in a boat into the river that represents life; in *Youth* (plate 59) the young man is at the helm of the boat, guiding it toward a visionary temple in the sky; in *Manhood* the boat makes its way past shadowy and menacing ravines and caves; in *Old Age* the angel once more leads the boat, its passenger now old and bent.

Thus, through their landscapes, the early Hudson River painters sought to convey something beyond the mere appearance of nature. Nature meant more to these painters than sim-

60. Thomas Doughty. *In Nature's Wonderland*. 1835. Oil on canvas, 24 1/2 × 30".
The Detroit Institute of Arts. Purchase, the Gibbs-Williams Fund

ply remoteness from civilization; the typically desolate grandeur of the American landscape led them to discern in nature something it was difficult to discern in the affairs of men—the stamp of God's power and perfection, the indication of a higher moral purpose. By studying nature men could perceive a moral purpose in their lives and return to their homes uplifted, inspired, ennobled through their recognition of the presence of a superior Mind. Typically, in Hudson River paintings, the tiny figures placed against the great vistas are not doing anything requiring a natural setting or making use of nature in any such way as sawing wood, hunting, fishing, or building a fire. They stand transfixed, gazing in wonderment at the landscape, contemplating its "message." This is clearly what is preoccupying the foreground figure in Thomas Doughty's *In Nature's Wonderland*, of 1835 (plate 60), as well as the two figures in Durand's *Kindred Spirits*. One of the men on the ledge in the Durand painting—the poet William Cullen Bryant—points out for the other—the painter Thomas Cole—all that is to be observed in the glorious landscape lying before them. The poet is shown instructing and elevating the painter, as though he were a professor of theology taking nature as his text. The two friends are not out for a casual stroll. Both are dressed in their Sunday best, not for roughing it, though they are out in the open. They have left their homes briefly for a noble, even sacred, purpose—to remind themselves of what nature has to teach.

In his famous poem "Thanatopsis," Bryant had written:

> To him who in the love of Nature holds
> Communion with her visible forms, she speaks
> A various language.

Precisely how contemplation of the landscape was to affect men's thoughts and influence their deeds was never made clear, but it was assumed by these painters and by such philosophers and writers as Ralph Waldo Emerson, Henry David Thoreau, and Bryant that nature did have this power; Thoreau left the comfort of his home and settled in what was then the wilderness around Walden Pond, near Concord, Massachusetts, to try to fathom the meaning of his existence. During the late nineteenth century and up to and through World War II, a period of unprecedented industrial expansion and exploitation of nature in America, the significance of the subjects of the early Hudson River paintings was little realized. In the last several years, however, our awareness of diminishing natural resources has steadily mounted, and these paintings are of special relevance.

The awesome landscape visions of Frederick Edwin Church grew out of the desolate scenes of his one-time teacher, Thomas Cole. Church saw nature not as benign and capable of edifying men but as impersonal in its grandeur. He approached it with the mind-set of a physical scientist or a geologist rather than of a philosopher or theologian. Cole, Doughty, and Durand had created visual reproductions of landscape scenes; Church sought to re-create for the spectator the experience of standing next to or within the actual scene. He often accomplished this by using gigantic canvases and a heightened realism, as in his *Niagara*, of 1857 (plate 61), where he seems to catch the feel and substance of the churning foam and the luminous rainbow shimmering before the falls. He also eliminated much of the early Hudson River painters' stagelike settings. In *Niagara* the spectator is made to confront the falls directly. Gone now are the framing trees and the tiny figures.

61. Frederick Edwin Church. *Niagara*. 1857. Oil on canvas, 42 1/4 × 90 1/2".
Corcoran Gallery of Art, Washington, D.C.

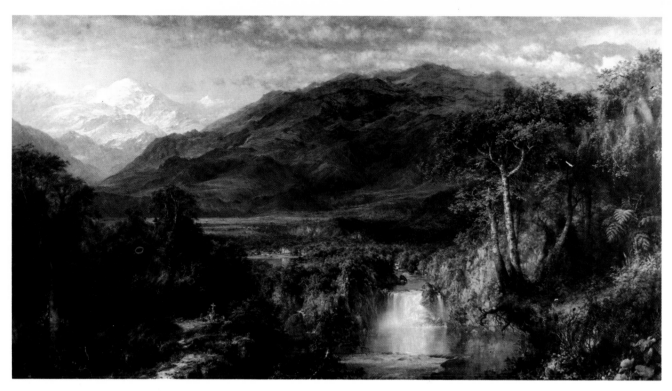

62. Frederick Edwin Church. *The Heart of the Andes*. 1859. Oil on canvas, 5′ 6 1/8″ × 9′ 11 1/4″.
The Metropolitan Museum of Art, New York. Bequest of Mrs. David Daws, 1909

The Niagara Falls suited Church as a subject. While the earlier landscapists preferred wild or barren spots, he actively sought out nature's most colossal, immediately dramatic phenomena. In his search for these subjects he traveled far beyond the areas explored by the first Hudson River painters. From 1850 to 1852 he sketched in Maine (near Mount Katahdin, on Mount Desert Island, and on Grand Manan Island in the Bay of Fundy) and also traveled about the upper Mississippi River. In 1853 and in 1857 he traveled to South America, where he came under the spell of the mighty Andes Mountains; in 1859 he explored the coasts of Newfoundland and Labrador, where he marveled at the great icebergs, which he later painted; and in 1865 he visited Vermont and the lush Caribbean island of Jamaica. From 1867 to 1869 he was in London, Paris, Beirut, Jerusalem, Petra, Damascus, Baalbek, Constantinople, in the Black Sea region, in the Bavarian and Swiss Alps, Pompeii, Paestum, and Athens— all the while pursuing the grandiose and the exotic. Church's *The Heart of the Andes*, of 1859 (plate 62), a gigantic painting measuring about 5 1/2 by 10 feet, had its beginnings in sketches made in Ecuador two years earlier. The landscape pictured was so vast and detailed that most observers made use of binoculars. At its heart is the great mountain Chimborazo, which Church painted with literal accuracy, although other parts of the scene are amalgamations of various Andean vistas. Mountain peaks held a particular fascination for Church, who, as a painter-naturalist, saw in them the manifest evidence of the earth's violent changes, its crackings and regenerations.

In Church's paintings of the Andes many Americans saw an analogy with their own American wilderness, which stretched out, seemingly, forever. What Church pictured was an Eden, the world before man made his imprint. This was a time of optimism and enthusiasm, before the Civil War, when the New World did appear to many as a Garden of Eden.

63. Albert Bierstadt.
The Rocky Mountains.
1863. Oil on canvas, 6' 1 1/4 × 10' 3/4".
The Metropolitan Museum
of Art, New York. Rogers Fund, 1907

Church, because he was able to give visual expression to this idea, was widely heralded during the 1850s and 1860s as America's greatest painter. On the banks of the upper Hudson, on a hill 500 feet high, Church built for himself his Olana, an exotic and magnificent house in a vaguely Persian style surrounded by 300 beautifully landscaped acres which were continually visible from windows, porches, and loggias. This was his own Eden, which he meant to maintain as long as he lived.

THE ROCKY MOUNTAIN SCHOOL. The terrain of the western part of America differs in scale from the eastern: the New Englander who suddenly comes upon the Rockies is awestruck, his

64. Thomas Moran. *The Grand Canyon of the Yellowstone.* 1872. Oil on canvas, 7'2" × 9'6".
National Collection of Fine Arts, Smithsonian Institution, Washington, D.C.

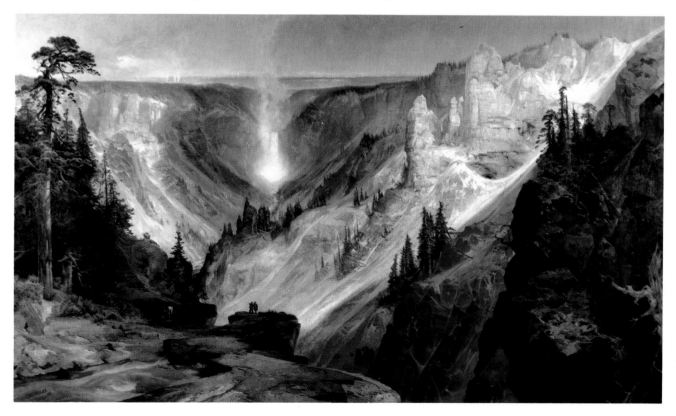

sense of scale confounded. The term "wide-open spaces" is no empty phrase. The great peaks, seemingly close at hand, are 20, 30, 40 miles away—distances that would encompass a great many hills and valleys in the eastern part of the country, where one's view, at ground level, seldom extends more than a mile or two. Despite the growth of urban sprawl in America, one can still fly the 168 miles in a small plane from Boulder to Aspen, Colorado, for example, without seeing a single house, telephone pole, or human being.

The westward trek was rapid and inexorable, interrupted only by the Civil War, from about the time of Cole's death, in 1848. The discovery of gold in California in that year drew thousands who hoped to make a quick fortune, and subsequent gold rushes helped swell the population of California and other western states. In 1845, Texas had been admitted to the Union as a state, after ten years of independence from Mexico, won at fearful cost, with 183 Texans killed in the defense of the Alamo in 1836, and revenged at the battle of San Jacinto. After the Civil War there were mining rushes in Nevada, Colorado, Idaho, Montana, Wyoming, and the Dakotas. Up to the mid-1880s, ranchers spread westward and cattle ran wild over the public grazing area, which stretched from Texas into Canada. But as the farmer came and built his house and tilled his plot of soil (barbed wire was invented in 1874), the open range was gradually divided.

In their panoramic sweep, the Rocky Mountain landscapes of Albert Bierstadt and Thomas Moran are similar in many ways to the South American scenes of Church, though Church more forcefully, as in his *Heart of the Andes*, expressed the drama of the earth itself, its becoming and consolidation. Bierstadt, born in Germany, came to America as a young child, returned to the land of his birth in his twenties to study painting in Düsseldorf, and, back in America again, joined an expedition to map a wagon route to the Pacific. During this time he made sketches of the Rockies which he converted into large oils upon his return to New York. Bierstadt's connections with Germany are the key to the appreciation of these mountainscapes. In them, the Rockies are made to look like the European Alps: rising from lush green valleys, they are capped majestically with snowy fields, and over their jagged peaks float fleecy clouds. They lack the incredible detail of Church's paintings, however, and an obviously dramatic, stagelike lighting is used. In Bierstadt's landscapes the presence of man is evident. Sometimes there are genre elements, as in *The Rocky Mountains*, of 1863 (plate 63), in which the Indian encampment in the foreground adds to the picturesqueness.

A penchant for the spectacular landscape is not inappropriate in a member of the Rocky Mountain School. The British-born Thomas Moran had this kind of imagination. His most famous painting, the enormous *Grand Canyon of the Yellowstone*, of 1872 (plate 64), measuring an overwhelming 7 by 9 1/2 feet, was bought by Congress for ten thousand dollars. As if that were not enough, Moran had a peak in the Teton Range named for him. Moran especially admired the landscapes of Turner, and atmospheric effects reminiscent of Turner's can be detected in his mountainscapes.

The great size of these canvases was the artist's response to the scale of the American West; Moran, however, was among those who, wanting the finesse of Church, resorted to bombast, making up with empty rhetoric for what they lacked in skill.

Though the landscapes of the Rocky Mountain School were greater in size, broader in panoramic sweep, and more spectacular in the scenery depicted than those of the early Hudson River School (whose pietistic messages they omitted), both sought their effects either

through the theatrical manipulation of landscape elements or through the careful choice of scenes that were inherently grandiose and dramatic. The landscapes of both groups were calculated to be showpieces, to stun and impress the viewer; and it was these landscapes which drew the most acclaim and commanded the highest prices through the second half of the nineteenth and the early twentieth century.

THE LUMINISTS. Within the last few years, a group of nineteenth-century American landscape painters has been singled out and given the name luminists because of their interest in the effect of light. Unlike the French Impressionists, with whom they were roughly contemporaneous, they did not dissolve their forms in atmospheric haze. Rather, their landscape masses and the people in their paintings are sharply defined and are given their correct local colors; they do not, in the Impressionist manner, take on the colors of nearby shadows or of the neighboring objects whose light is reflected upon them. The landscapes of the luminists are less stagy than those of the Hudson River and Rocky Mountain schools. The luminists were interested in the elements that constituted the landscape, the hills and rivers and lakes, rather than in what the landscape signified. They were less selective in their choice of sites, and painted scenes that the Hudson River and Rocky Mountain painters would have passed over as insufficiently picturesque or grand. This difference in approach can be compared to the difference between the unknown artist's *Anne Pollard*, of 1721 (plate 4), and Gilbert Stuart's *Athenaeum Portrait of George Washington*, of 1796 (plate 39). The unknown artist was concerned only with making a true likeness of his subject; Stuart, while striving to keep the likeness, was also concerned with creating a proper "image" for the Father of the American Republic. The unknown artist was humbler in his approach and regarded his subject more directly— even though what emerged was no more an exact likeness than what Stuart produced.

The most rewarding of the luminists to study are Fitz Hugh Lane, Martin Johnson Heade, and John Frederick Kensett. Kensett, like Durand, began as an engraver. Many of his landscapes are imbued with an extraordinary tranquillity. Contributing to this mood are the rounding of the contours of hills and fields—angular or sharply pointed forms are avoided—and the prevalence of a gray haze that envelops forms and softens colors. In a Kensett landscape such as *Paradise Rocks, Newport*, of about 1865 (plate 65), no sharp colors are used. The transition between colors is gradual, and most of the painting, in terms of light and dark areas, is in soothing middle tones rather than in dramatic light highs and dark lows.

Fitz Hugh Lane studied in Boston, then returned in 1849 to Gloucester, the place of his birth. Though confined to a wheelchair, he managed to travel north to Maine, where, in 1862, he painted a waterfront view, *Owl's Head, Penobscot Bay, Maine* (plate 55). Sitting on the shore, Lane loved to observe ships and boatmen, and these are given a prominent place in his paintings. A similarity to Kensett is that much of his painting is given over to sky, where it is possible to convey minute variations in haze and luminosity. Lane's paintings are distinguished for their crisp, accurate draftsmanship and skillful control of spacings. There is about them, too, a quality of understatement. There is nothing of excess; only what is essential to the composition is included. The mood of quietude that we note in Kensett's painting is here, too. Motion is frozen. But it is a magical sort of quietude, which, despite the closeness of observation, seems more imagined than real.

Heade traveled widely. In 1863 he visited Brazil with the intention of publishing a book on

65. John F. Kensett. *Paradise Rocks, Newport.* c. 1865. Oil on canvas, 18 1/4 × 30 1/2″.
The Newark Museum. Gift of J. Ackerman Coles, 1920

66. Martin J. Heade. *Thunderstorm, Narragansett Bay.* 1868. Oil on canvas, 32 1/8 × 54 3/4″.
Collection Ernest Rosenfeld, New York

67. George Inness. *Delaware Water Gap.* 1861. Oil on canvas, 36 × 50 1/8″.
The Metropolitan Museum of Art, New York. Morris K. Jesup Fund, 1932

68. Homer Dodge Martin. *Harp of the Winds: A View of the Seine.*
1895. Oil on canvas, 28 3/4 × 40 3/4″
The Metropolitan Museum of Art, New York. Gift of Several Gentlemen, 1897

69. George Inness. *Home of the Heron.* 1893. Oil on canvas, 30 × 45″.
The Art Institute of Chicago. Edward B. Butler Collection

70. John H. Twachtman.
Three Trees.
Not dated
(late nineteenth century).
Pastel, 13 × 17 1/2″.
The Brooklyn Museum,
New York

hummingbirds, a subject on which he had become a foremost expert. His South American tropical landscapes and his paintings of hummingbirds capture the seething heat and lushness of that terrain. Distantly related to those landscapes is his *Thunderstorm, Narragansett Bay*, of 1868 (plate 66), in which we can sense the torpor of the summer air in the moment before the storm breaks. The sky is an unnatural green-black, and there is a pervasive eeriness about this moment just before nature erupts. The running boatmen and the sailboats are bathed in a light so sharp and intense that we think of the unreality of dreams.

LATE-NINETEENTH-CENTURY LANDSCAPISTS. Also breaking with the pictorial conventions of the Hudson River School was the solitary genius George Inness, probably the most accomplished landscape painter in nineteenth-century America. Traveling to France early in his career, he was influenced by the Barbizon School of landscape painting and incorporated the looseness of their technique and their unified approach into his own work. His *Delaware Water Gap*, of 1861 (plate 67), has none of the blasted trees, contemplative figures staring off into a contrived vista, or finicky detail of Hudson River School paintings. Instead, through loosely painted patches, Inness caught the verdant richness, the pulsating fecundity of the earth. And the glow of a rainbow trailing off into the clouds could only have been painted as well at the time by Church. As Inness progressed, he became more withdrawn (he had always had a strong mystical bent), and his paintings grew more subjective. In his landscapes he sought to record not so much the appearance of nature as its poetry. In such of his late works as *Home of the Heron*, of 1893 (plate 69), detail is loosened and the dim objects seem bathed in fog. At first glance these works seem close to Impressionism, but it is not optical phenomena that Inness is recording. A closer inspection reveals that what he has tried to capture on canvas is the stillness and sense of mystery that nature evoked in him. In his late works, Inness's closest affinity is to such visionary American painters as Albert Pinkham Ryder (see Chapter Six).

Yet this sense of inwardness is not peculiar to Inness. The late nineteenth century abounds in soft, gauzy landscapes, among them Homer Martin's *Harp of the Winds: A View of the Seine*, of 1895 (plate 68), a nervous, flickering painting that seems more like a mirage than a recording of an actual scene. The appearance of the work may be largely attributable to Martin's failing eyesight. But at this time there are in American landscape painting approximations of the French Impressionist experiments, as may be seen in John H. Twachtman's *Three Trees* (plate 70).

The fact is that, varying causes in different artists aside, there is in late-nineteenth-century American landscape painting, as well as in other types of painting, a general sense of fragility and of withdrawal from the real world into the world of the self. This sense of withdrawal can be seen in such late portraits by Thomas Eakins as his *Addie*, of 1900 (plate 53). How different the subject is from the vigorous Dr. Gross, whose portrait Eakins painted in 1875 (plate 44)—how much more contemplative, more introverted. Perhaps this general twilight quality can be explained as evidence of a sense of resignation that came with growing industrialism as cities began to be shadowed by soot and grime (there is a prevailing dark tonality in many of these paintings). Perhaps it was the sadness brought on by the Civil War that began to seep in. Or could it have to do with the strange feeling that often comes as a century draws to its close?

71. Winslow Homer. *Long Branch, New Jersey.*
1869. Oil on canvas, 16 × 21 3/4″.
Museum of Fine Arts, Boston.
Charles Henry Hayden Fund

CHAPTER FIVE
Americans at Work and Play

Painters in all ages have taken delight in re-creating the events of everyday—in observing and recording those activities that are the stuff of which the ongoing course of life is made. This type of representation, known as genre painting, came late to America, but by the 1830s and 1840s some American painters were devoting the major part of their work to depicting the daily round: people in their houses, in their places of work, and at play. The people pictured in their paintings are anonymous, not illustrious or even particular, and what is

happening in these pictures is what happens every day, not once in an era. Their activities are those in which they engage repeatedly, as a matter of course and without fanfare.

Still, the American genre painter of the nineteenth century was not altogether random in his selection of everyday scenes and ordinary people. He favored people who were healthy, active, and self-sufficient, and it helped if they had a touch of the picturesque or unusual about them, and if what they were doing was interesting and unusual. He avoided scenes that dwelt on the tragic side of life. We do not find people sick or dying, languishing in prison, suffering in dire poverty, or slaving away in a factory. Above all, the true genre painter seems to relish his observation of the world of everyday reality, and his sense of enjoyment makes his work seem lighthearted, even humorous. He gives the impression that all's right with the world. He is not moralistic, and on those rare occasions when he does have a message, as in Frank Mayer's *Labor and Leisure*, of 1858 (plate 79), it is one that would be widely accepted and easily digested.

Like American landscape painting, American genre painting arose when it did because, with the Revolution several decades in the past, there was the time and the inclination for artists to observe their immediate surroundings. More specifically, the democratic tone set by Andrew Jackson in his two terms as president (1829–37), and by his successors, was important in establishing an atmosphere favoring the kind of approach to life and people that genre painting represents. By opposing the moneyed interests through his war against the privately owned Bank of the United States, by asserting the rights of labor, by symbolizing in his own election the establishment of manhood suffrage, Jackson put a new emphasis on people and endowed the common man with new dignity and a new sense of worth. From the time of Jackson the exclusive oligarchy of the original colonies was disrupted, as places like Pittsburgh, Kansas City, and St. Louis grew and gained influence. From the time of Jackson, also, types of characters corresponding closely with those in the genre paintings appeared in novels and poems. The industrious blacksmith in Mayer's *Labor and Leisure* reminds us of the hero of Longfellow's "Village Blacksmith" (though the poet was far from Jacksonian in his sympathies). Washington Irving's accounts of country life in the Hudson River valley parallel some of the scenes in William Sidney Mount's paintings. George Caleb Bingham's trappers and fur traders (plate 75) would be at home in Mark Twain's *Life on the Mississippi*, and Tom Sawyer and Huck Finn are cousins to some of Winslow Homer's roughhousing boys in *Snap the Whip*, of 1872 (plate 83).

GENRE PAINTING BEFORE THE CIVIL WAR. By 1850 genre painting was an established branch of American painting. The first substantial painters to devote to genre most of their efforts, William Sidney Mount and George Caleb Bingham, were born within four years of each other but in far-removed parts of the country. Mount rarely left his native Long Island, but he was always moving about, mostly in the towns and country near Stony Brook and Setauket (but also to New York City, the Hudson, and upstate New York), paying the closest attention to the activities of the people he met. He was a sociable yet private sort of person, and what intrigued him was not their feelings and motivations but the intricacies of their behavior. He was a dispassionate chronicler of the outward actions of people, and in his paintings he recorded minutiae of ordinary country events as vividly as though he were seeing something

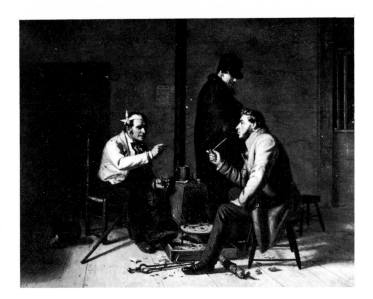

72. William Sidney Mount.
The Long Story. 1837.
Oil on canvas, 17 × 22″.
The Corcoran Gallery of Art,
Washington, D.C.

extraordinary for the first time. We know from his writings that when he attended a dance he took no note of whether the dances were executed well, or whether the participants enjoyed the evening, or whether any social intrigue was carried on; instead he became involved in the intricacies of how the steps were done. In his diaries and letters, Mount engaged in lengthy discourses on the craft of painting, the arts of fishing, dancing, music making, and a variety of other subjects. Among his interests, especially in the latter part of his life, was spiritualism.

In *The Long Story*, of 1837 (plate 72), a seated man with a crutch and a bandaged head is spinning a yarn (probably about his injury) to the interested tavern keeper, who is smoking a long-stemmed clay pipe. The attitudes and gestures of the two men have a convincing naturalism, and the artist, as was his way, gave equal attention to the surroundings. The paraphernalia of the humble tavern are carefully painted. The low, horizontal wood stove (made after a Shaker model, but with a touch of decoration) is set in a metal box. On the floor are the fire tongs, some wood shavings, the wooden chair and stools. The railroad timetable is tacked on the wall. The fire is out, so that the storyteller's pipe and his earthenware mug and the tavern keeper's glass could be safely set upon the stovetop. The mysterious dark-cloaked standing figure seen between the storyteller and the tavern keeper is one of several such figures that occur in Mount's paintings.

From Mount himself we gain no inkling of his feelings toward his fellow Long Islanders. He examined their activities with a dry objectivity. Though he studied and reproduced meticulously, without slurring or effacing a single detail, the attitudes and postures of participants in situations of every sort, we do not know whether or not he liked and admired them. Nuances of the behavior of the particular storyteller, suitor, horse trader, or other are noted with scrupulous exactness. What is remembered by the spectator is not the actor but the action, and, further, not the significance of the action but its manner and niceties. He depicts an activity precisely for what it is—no more, no less—and in the doing he pondered over details that would have seemed trivial even to most of his contemporaries. Years after he had completed his *Bargaining for a Horse*, of 1835 (plate 73), he recalled that if he had painted another version, he would have had one of the farmers whittling toward instead of away from his body, to indicate that the bargain had been clinched. In the old practice of horse trading, whittling was no doubt an invaluable aid to maintaining a poker face.

73. William Sidney Mount.
Bargaining for a Horse.
1835. Oil on canvas, 24 × 30″.
The New-York Historical
Society, New York

Mount was adept at the placement of figures and the slight shifts and alterations of architectural and landscape elements that serve to bring about a satisfying design. In the *Eel Spearing at Setauket*, of 1845 (plate 74), the horizontal boat with the fisherwoman's spear at one end and the boy's oar at the other make up the bottom and part of the sides of a stable pyramidal composition. The landscape is composed of a system of curves and counter-curves that accentuate the long, graceful contour of the reflection of the boat. The air is crisp and still, and the motion is held frozen, as in luminist landscapes (see Chapter Four). Mount's habit of careful observation is brought to bear on the precise way in which the woman holds the spear and on the boy's quick, silent handling of the paddle.

In 1860 Mount designed for himself a horse-drawn portable studio elegantly fitted out as a combined workshop and living quarters. While this enabled Mount to cover more of the

74. William Sidney Mount.
Eel Spearing at Setauket.
1845. Oil on canvas, 29 × 36″.
New York State
Historical Association,
Cooperstown, New York

75. George Caleb Bingham. *Fur Traders Descending the Missouri.*
1845. Oil on canvas, 29 1/4 × 36 1/4".
The Metropolitan Museum of Art, New York. Morris K. Jesup Fund, 1933

countryside and served to shield him from the weather, it also served as a device that enabled the occupant to see others while hardly being seen himself. Thus the mobile studio reinforced an already established mode of living featuring quick sallies into the countryside for the purpose of observing and gaining information.

Almost exactly contemporaneous with Mount, George Caleb Bingham celebrates the realities of daily life in a sector of America far removed from Mount's Long Island. Born in the Blue Ridge Mountains region of Virginia, Bingham moved with his family to Franklin, Missouri (then the largest town west of St. Louis), in 1819, when he was eight. At the age of sixteen he was apprenticed to a cabinetmaker in Boonville, but he had leanings toward the law and the ministry. Apparently his settling on art as his vocation was influenced by Chester Harding, whom he first met in Franklin, where Harding was painting his portrait of Daniel Boone (plate 41). Later he received some instruction in painting from Harding and subsequently began to work as a portraitist, setting up his studio in St. Louis. In 1838 he visited New York, where he may have seen some of Mount's paintings, and worked at the Pennsylvania Museum of the Fine Arts in Philadelphia for three months.

Returning to Missouri, Bingham became involved in politics, painting huge banners and campaigning in the election of 1840 for William Henry Harrison, a candidate chosen for his prominence in the new West. He next moved to Washington, where he painted portraits of

some of the outstanding personages of the day, but returned to Missouri for the presidential election of 1844. He did not allow his success as a portraitist to deflect him from his agenda of painting the Western scene of which he was by birth and predilection so much a part. His best genre subjects of raftsmen, fur traders, hunters, and frontier elections were painted between 1844 and 1856, the year he left the country to study art for a three-year period in Düsseldorf. Back in America, he became more deeply involved in political activity as a Whig; in 1846 he was elected to the state legislature, and during the Civil War, from 1862 to 1865, he was treasurer of Missouri.

Through engravings, Bingham had studied the works of such European masters as Poussin and Claude Lorrain, and he went about composing his frontier scenes with even more purposeful care than we sense in Mount's Long Island scenes. In *Fur Traders Descending the Missouri*, of 1845 (plate 75), the figures in the dugout are beautifully, if somewhat studiedly, silhouetted against the mist-enshrouded clumps of trees in the middle ground. In none of Bingham's river paintings is a disturbing note struck. Hard work, such as the unloading of boats, is never shown. This is a sealed-off world of men, its rough-and-ready relationships uninhibited by the presence of women. To Easterners, Bingham's boatmen personified the untamed spirit of the West, and they eagerly bought his paintings; they must have delighted in the details of such a picture as the *Fur Traders*: the rugged, scowling face, under his outlandish peaked hat, of the old trader paddling in the stern and the fresh face of the youth leaning (with the gun which has just bagged them a duck) on the well-wrapped cargo of furs, the gaudy shirts of the two men, and, above all, the little fox chained in the bow.

In the frontier regions, where the population was sparser than in the East, elections were held through open ballot and voice vote. Open voting, which usually lasted three days, was a festive time for all, and inebriated voters and political windbags were part of the high comedy of existence on the frontier. But the rough-hewn sorts of people who congregated for their frontier elections represented Jacksonian democracy in its purest form. For Bingham, who first ran (unsuccessfully) for public office in 1844, elections were predictably a favorite subject. *The County Election*, of 1851–52 (plate 76), contains more than sixty figures. A man

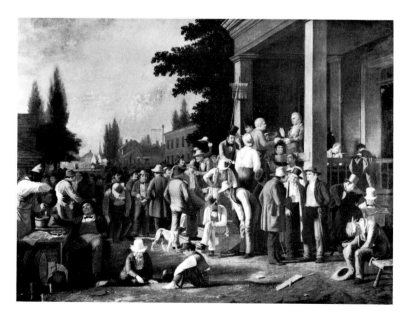

76. George Caleb Bingham.
The County Election. 1851–52.
Oil on canvas, 35 1/2 × 48 3/4″.
The St. Louis Art Museum

standing on the stairs is swearing to the judge, who holds a Bible, that he has not voted else-where. Behind the judge is the election clerk, quill in hand, recording the results of the vot-ing. Another man on the stairs is doffing his silk hat and handing to a prospective voter the card of the candidate he is supporting. In the left foreground, an already mellow voter is having another glass of whiskey poured for him. The various characters in *The County Election* were based on sketches that Bingham made from life, but the compositional structure was dictated by the artist's sense of design. Most of the figures in the right-hand portion of the canvas have been organized in a pyramidal group, at whose apex is the judge with the Bible. Horizontally there are divisions of foreground, middle ground, and background as clear-cut as in a work by Poussin. It seems paradoxical to find such stable compositional treatment in paintings dealing with the life of America's early Wild West.

During the years when Mount was recording American everyday life in the East and Bingham was documenting the backwoods and river life of the West and its rough-and-tumble politics, a talented genre painter named Richard Caton Woodville had a lamentably brief career. He came from a well-to-do, prestigious Baltimore family, whose expectations he disappointed by dropping out of medical school to pursue his interest in art. He attended a painting academy in Baltimore, then, at twenty, was allowed to go with his new wife to Eu-rope to study art. From 1845 to 1851 he studied in Düsseldorf; the remaining years of his life were spent in Paris and London in the company of a fellow student with whom he had run away from Düsseldorf. In 1856, at the age of thirty, he died in London from an overdose (probably accidental) of morphine.

Woodville sent his paintings back to America, where their fresh color, excellent drafts-manship, and genial humor gained them an eager audience. In *The Sailor's Wedding*, of 1852 (plate 77), the types are probably based on people remembered from Baltimore. We see the winsome bride, the shy but stalwart groom, the flustered father, and the irritated magistrate. The situation is an appealing one, and most spectators could picture themselves or someone they knew within the situation. The details, minute and numerous in the best Düsseldorf tradition, help enrich the story: the gleaming andirons, the almanac tacked to the side of the

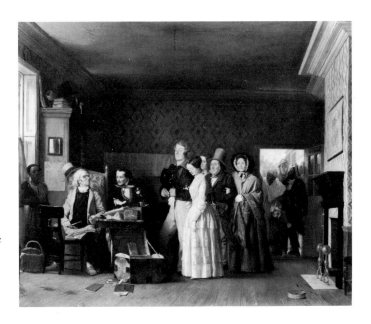

77. Richard Caton Woodville.
The Sailor's Wedding.
1852. Oil on canvas, 18 1/2 × 22".
The Walters Art Gallery, Baltimore

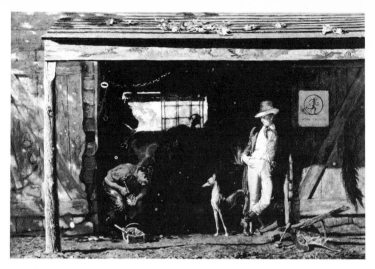

78. David Gilmour Blythe.
Art versus Law. Before 1860.
Oil on canvas, 24 × 20″.
The Brooklyn Museum, New York.
Dick S. Ramsay Fund

79. Frank Mayer. *Labor and Leisure.* 1858. Oil on canvas,
15 5/8 × 23″. The Corcoran Gallery of Art, Washington, D.C.
Gift of W. W. Corcoran

bookcase, the books on the floor, the keys in the trunk lock, the carving on the table leg, the judge's lunch of chicken just brought in by the little black girl, who, open-mouthed, is taking in the whole scene.

The only genre painter in America before the Civil War whose scenes were not lighthearted but tended toward satire, sometimes bitter, was David Gilmour Blythe. He was born in Ohio, but his life came to be centered in Pittsburgh after a variety of earlier experiences—as an apprentice woodcarver and cabinetmaker, as a ship's carpenter in the navy (for three years), as a student of art (with Harding and Sully). Blythe haunted Pittsburgh's prisons, law courts, and taverns (where he himself spent too much time after the death, from typhoid, of his wife of only a year). He painted trials where the prosecutor was obviously venomous and the judge simpleminded, and prison scenes where the inmates huddle together for warmth. Oddly, the social commentary in these paintings is almost overshadowed by the feel for caricature. Blythe himself was often the butt of humorous remarks as he walked, red-bearded and unkempt, through the city. In his *Art versus Law,* of the late 1850s (plate 78), he records his own struggles to keep himself solvent. A shabby artist, carrying his brushes and canvases, stands on the steps of a ramshackle studio. One of the signs posted on the door reads: "To LET—ON GOOD SECURITY! The 300 dolr law WAIVED and WATER tax PAID—(Provided the tenant USES ANY WATER)." As pictured by Blythe, the artist is a down-and-outer. In a society divided into haves and have-nots, he is a have-not. Yet it is hard to feel sympathy for Blythe's artist. He is a scraggly, scrawny, irresponsible-looking man—who probably does not "use any water"! He will be judged to have brought his troubles upon himself, and he will be pointed to rather than pitied.

Frank Mayer's *Labor and Leisure,* of 1858 (plate 79), is another genre painting in which differing life styles are juxtaposed. Here, though, the two classes of society represented are shown as working harmoniously together. The leisure class is represented by the well-dressed gentleman rider leaning in the doorway; labor, by the blacksmith shoeing his horse. The two are mutually dependent: one cannot maintain his role in life without the other. Mayer, who, like Woodville, came from Baltimore, was at home in the Maryland countryside, where hunt-

ing and riding were favorite pastimes, and where, in the very shadow of the Civil War, gentlemen of breeding still heedlessly pursued their aristocratic pleasures.

GENRE PAINTING AFTER THE CIVIL WAR. Most of what has been said about American genre painting before the Civil War still holds for the years after 1865. Genre painting to the end of the century focuses on the pleasanter aspects of life. Leisure activities continue to be shown, and it is still usually the country, or the countryside near the city, that is the locale. Genre painting is still not moralistic, still does not deal with disturbing truths. People in somewhat unusual situations are still favored, and we should not, then, expect to find pictures of a workingman eating his noonday lunch or of a housewife watering her plants.

However, there are differences. The national consciousness could not but be affected by the terrible experience of the Civil War. The broad, good-natured humor of such paintings as Woodville's *The Sailor's Wedding* (plate 77) and Bingham's *County Election* (plate 76) is lacking. And the people in the later genre paintings are less active. Before the Civil War we see people participating in an election, bargaining for a horse, spearing eels, telling stories, taking part in a wedding procession; they are doing things together, reacting to and with one another. After the Civil War, we are more likely to see people alone, as in Eakins's *Max Schmitt in a Single Scull*, of 1871 (plate 80), or curiously passive, as in Eastman Johnson's *In the Fields*, of about 1870 (plate 81), or standing about oblivious of one another's presence, as in Homer's *Long Branch, New Jersey*, of 1869 (plate 71). In the case of Eakins and of Henry Ossawa Tanner especially, there is an interest in the inner life, and the activity at hand is of incidental interest, a means of getting at that life. There is as well a new sentimentalism, seen in Tanner's *The Banjo Lesson*, of about 1893 (plate 82). This is an aspect of the sympathy felt

80. Thomas Eakins. *Max Schmitt in a Single Scull*. 1871. Oil on canvas, 32 1/4 × 46 1/4″. The Metropolitan Museum of Art, New York. Alfred N. Punnett Fund and Gift of George D. Pratt, 1934

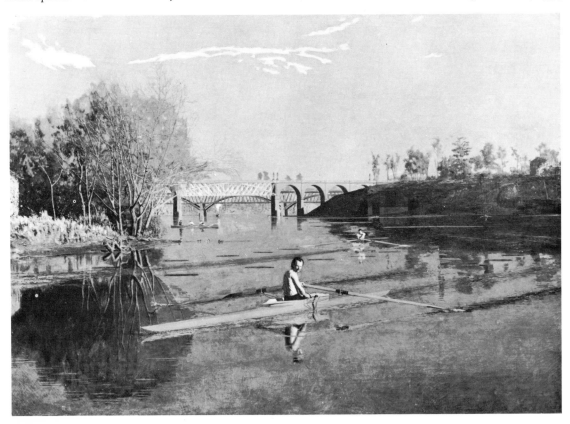

81. Eastman Johnson. *In the Fields.*
c. 1870. Oil on canvas, 17 3/4 × 27 1/2″.
The Detroit Institute of Arts. Purchase, the Dexter M. Ferry, Jr. Fund

82. Henry Ossawa Tanner.
The Banjo Lesson. c. 1893. Oil on
canvas, 48 × 35″. Hampton
Institute, Hampton, Virginia

for the people in the pictured situation, which stems from an awareness on the part of the artist of the environmental pressures molding them.

After working as a free-lance illustrator and painting pictures dealing with the Civil War, the most elaborate of which was the *Prisoners from the Front*, of 1866 (plate 30), Winslow Homer made a brief trip to France, his first European experience, from the fall of 1866 to the spring of 1867. Though he continued illustrating for *Harper's Weekly* until 1874, he was turning increasingly to oils (the first was painted in 1862) and watercolors. Upon his return from France he painted rural scenes, finding interest in such subjects as boys at play, ladies at resorts, and woodsmen in forests. It was only in 1881–82, during his visits to the English fishing village of Tynemouth, that Homer became a painter of the sea. In 1883 he settled at Prout's Neck on the coast of Maine.

As a boy, Homer himself liked hiking, hunting, and fishing. In painting boys, he showed them directly, without mawkish sentimentality, happily absorbed in their rough games and activities. In *Snap the Whip*, of 1872 (plate 83), another quality emerges through Homer's directness of observation. It is an independence of spirit, which Homer pushes to the point of setting each individual within a self-contained world. To form the "whip," each boy holds the hand of his neighbor, of whom he is aware only as a link in the chain. Each boy looks outward rather than toward his neighbor, and the face of each boy is either turned away from us or hidden by the shadow cast by his cap or hat. We are less aware of these boys as distinct personalities than as players in the game.

Homer's genre figures are habitually turned away from us, and they seldom communicate directly with one another. This kind of detachment has thematic justification in *Snap the Whip*, where the boys are caught up in their energetic game, but in *Long Branch, New Jersey*, there exists no such psychological basis. Here two fashionable women in berthas, ruffles, and ribbons, and with parasols, stand precariously on a bluff above the beach. They do not look at each other, but they are no doubt aware, one of the other. Each, dressed in the height

83. Winslow Homer. *Snap the Whip*. 1872. Oil on canvas, 22 × 36″.
The Butler Institute of American Art, Youngstown, Ohio

of fashion for the time, is concerned with the way she appears to others, but is not prepared to extend herself. There is not here the close-knit community and easy camaraderie that typified American genre before the Civil War. The isolation of these women has to do with the air of independence that they are self-consciously maintaining; they are conspicuously unaccompanied. The term "women's liberation" had not been coined in 1869, when this picture was painted, but it is interesting to note that in that year the woman's rights movement made a signal gain when the territory of Wyoming became the first territory to give women the vote.

In Bingham's *County Election*, as we have seen, a large group of figures were organized into a triangular format. In Homer's *Long Branch, New Jersey*, the disposition of the various elements is more subtle. The two isolated women act as visual counterbalances to the bathhouse on the side of the bluff. The diagonal of the woman with the open parasol opposes the diagonal of the walkway leading from the bathhouse and echoes the diagonal of the pathway that is cut off by the frame at the lower right-hand corner of the canvas. *Long Branch*, in its subtlety and its superb design, suggests that Homer may have been influenced by the paintings of Manet and by the Japanese prints Manet and his contemporaries drew inspiration from (which Homer could have seen during his European sojourn about three years earlier).

In 1859, when Eastman Johnson painted his famous *Old Kentucky Home* (plate 84), originally entitled *Negro in the South*, America was embroiled in the slavery issue, and in that context this idyllic, sentimental scene seems like wishful thinking. Johnson had been studying art abroad from 1849 to 1855, first in Düsseldorf, then in The Hague, where he came to admire the Dutch seventeenth-century artists, especially Rembrandt; the soft light and vaporous shadows in *Old Kentucky Home* owe much to Rembrandt's inspired chiaroscuro.

Perhaps Johnson had been in Europe too long, for it was naive at this time for a Northerner to conceive of happiness as compatible with servitude. He had been out of the country, for instance, in 1850, when the barbarous Fugitive Slave Act was passed, and in 1851, when

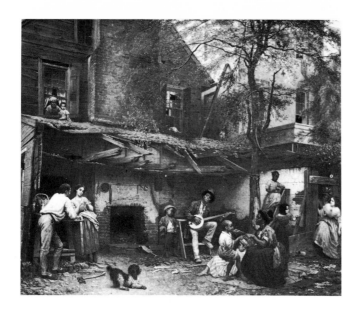

84. Eastman Johnson.
Old Kentucky Home.
1859. Oil on canvas, 36 × 45″.
The New-York Historical
Society, New York

Harriet Beecher Stowe's *Uncle Tom's Cabin, or Life Among the Lowly,* appeared to fan the flames of the impending conflict. But he was back in the United States when the bitterly contested Dred Scott Case involving the status of slavery in the Federal territories was being argued, culminating, in 1857, in the Supreme Court ruling that a slave was property and had no personal rights. Johnson's *Old Kentucky Home,* at first glance, seems completely at variance with Stowe: well-fed slaves are seen content and relaxed, rather than oppressed and harassed, and no masters are in sight except for one rather benign white onlooker. But the Negroes live in squalor in the shadow of the white man's large and substantial house, partially visible in the upper right-hand portion of the painting. (The setting of the painting is in fact the slave quarters back of the Washington home of Johnson's father, an influential politician.) It must be said, however, that Johnson's *Old Kentucky Home* and Blythe's *Art versus Law* are among the few genre paintings produced in nineteenth-century America that touch on social issues.

The human warmth radiating from *Old Kentucky Home* is not evident in many of Johnson's genre paintings of 1870 and later years. His *In the Fields* shows a group of people engaged in picking cranberries in Nantucket, the island off Cape Cod where the artist spent his summers in the 1870s. It is a work that suggests comparison with *Old Kentucky Home,* for both paintings depict groups of people at leisure. While the Negroes entertain one another by strumming guitars, gossiping, and, in the case of a mother and her child, doing an impromptu dance, the cranberry pickers tend to be absorbed in their own thoughts. If there is a companionship among them it is implicit or understated, and it is related to the job they have come together to do. As they rest, each of them withdraws into his own world. These figures are marked by an independence and isolation similar to that of Homer's elegant ladies at Long Branch.

Genre painting, though by definition extremely varied in subject matter, is, as we have seen, relatively constant in its lightness of mood. However, the aura that a painting gives off derives from the artist as much as from the subject matter. Thus a typical genre scene like *Max Schmitt in a Single Scull* (plate 80)—a scene of people spending their leisure time boating on a quiet river—has the special pensive tone that is characteristic of Thomas Eakins.

Boating scenes set on the Schuylkill River of his native Philadelphia's Fairmount Park

were a favorite genre subject of Eakins in the 1870s. Eakins himself used to row on the Schuylkill, and in the *Max Schmitt* he is the sculler in the distance. In this picture it is a late afternoon of early autumn, for the shadows are long and the leaves have just begun to turn—a time when sculling is particularly enjoyable. As the light sparkles on the water, the spot on the river becomes an idyllic setting. There is no reason to suppose that Schmitt is not enjoying himself, but as we see him—alone, pale, his shoulders slightly stooped—we are aware that he does not put the cares of life completely behind him. Unlike the people in the genre paintings of Mount, Bingham, Woodville, and, to a certain extent, Homer and Johnson, Schmitt is presented not so much in his aspect as a sculler, the performer of a certain activity, as in his aspect of an individual marked by the tensions of his time and the frailties of his being. Though a small figure, surrounded by water and situated well back, almost in the middle ground of the painting, he possesses more of an inner life than the visually more prominent people in, say, Mount's paintings. Indeed, because of his isolation on the river he symbolizes the aloneness of the human being even more poignantly than Homer's women at Long Branch and Johnson's berry pickers. Schmitt must make his decisions and guide his own destiny. But in his isolation he shares the mortality of all men: as the particular time of day in the painting, the late afternoon, fades into evening, so too will the life of Max Schmitt fade into oblivion.

In the late 1890s, Eakins painted a number of boxing scenes, among them *Between Rounds*, of about 1899 (plate 85). The match pictured here took place in the no longer extant arena in Philadelphia at Broad and Cherry streets. The fighter is one Billy Smith. The timer is Eakins's friend Clarence W. Cramer, a newspaperman, and the depictions of the men in the press box and in the crowded tiers of spectators are all portraits. Eakins dwelt neither on the excitement of the crowd nor on the violence of the fight itself. The match is in progress and Billy Smith the boxer is waiting to confront his opponent again. Set between the timekeeper and his two seconds, who are ministering to him, he is silhouetted against the spectators. Through Eakins we see the boxer not as the ultimate victor or vanquished, but as a human being thrown upon his own resources. No John L. Sullivan, he is a boxer who tries his best, though fearful of the outcome. He is on trial, then, no less than the more famous Dr. Gross (plate 44), whom Eakins had portrayed a quarter of a century earlier in an amphitheater of a different sort.

In direct contrast to the spiritual isolation expressed by Homer, Johnson, and Eakins, in other post–Civil War genre scenes there is an intimacy verging on sugary sentimentalism. It is very different from the general easy camaraderie of pre–Civil War paintings. In Tanner's *Banjo Lesson* (plate 82), the artist took as his subject an old man teaching a young boy, perhaps his grandson, to play. The soft glow enveloping the figures lends further warmth to an engaging theme. Tanner, born in Pittsburgh, grew up in Philadelphia, where his family settled when he was seven. Later he studied in that city at the Pennsylvania Academy of the Fine Arts under Thomas Eakins. Despite Eakins's admonitions, Tanner left America for Paris in 1891, and he stayed there until 1902, except for trips to Palestine in 1897 and 1898. As a Negro he felt that his art would have a better chance to be judged on its merits abroad than in his own country. Although *The Banjo Lesson* was painted in Paris, it was clearly based on Tanner's memories of his youth in Philadelphia; in it he re-created the loving kindness he found only among his own people.

85. Thomas Eakins. *Between Rounds*. c. 1899. Oil on canvas, 50 1/4 × 40″.
Philadelphia Museum of Art. Given by Mrs. Thomas Eakins and Miss Mary A. Williams

86. Charles Christian Nahl. *Sunday Morning in the Mines.*
1872. Oil on canvas, 6 × 9'. E. B. Crocker Art Gallery, Sacramento, California

GENRE PAINTING IN THE WEST. The differences noted above between pre- and post-Civil War genre painting are not evident in genre painting in the West. The observation applies to painting in the eastern part of the United States (Long Branch, New Jersey, Nantucket, Massachusetts, Philadelphia), the older, more crowded region of the country, where people tended to be more inhibited and where, too, the wounds caused by the Civil War were deeper and the scars more lasting. West of the Mississippi, from Canada in the north down to Mexico, the Wild West prevailed until the end of the century, and into this region traders, trappers, miners, cowboys, and farmers continued to come. The high point of the open range was from the end of the Civil War to the mid-1880s. It is not surprising that the genre painting of the West, like its landscape painting, took on its own characteristics. Typical figures were the grizzled miner staking his claim and the cowboy rounding up his herds of cattle.

Charles Christian Nahl, born in Germany, settled in San Francisco after the Gold Rush of 1848. In his *Sunday Morning in the Mines,* of 1872 (plate 86), he recorded the miners' varied activities on their day off. Within the boundaries of this canvas are a number of vignettes centering on the men's use of their leisure. One man calmly smokes his pipe, another, naked from the waist down, hangs his pants up to dry, and another, possibly drunk, breaks out in an uncontrolled dance, despite the efforts of two companions to restrain him; a group of riders come rushing up to the camp in a frenzy, while to the left a fist fight is erupting. Here is a rowdy, boisterous life unknown alike to Johnson's gentle blacks and Homer's energetic boys. But America's wide horizons provided scope for that variety which is the spice of life, and its genre paintings reveal many patterns of behavior.

87. Benjamin West. *Death on a Pale Horse*.
1817. Oil on canvas, 14'9" × 26'.
The Pennsylvania Academy
of the Fine Arts, Philadelphia

CHAPTER SIX
The Visionary Tradition

The category of painting called visionary is delimited not by subject or style but by a prevailing mood of fantasy. Any note in the entire gamut of this mood may be struck: it comprehends the still, unsettling reverie of Washington Allston's *Moonlit Landscape* (plate 88) and Andrew Wyeth's *Christina's World* (plate 94), the awesome turbulence of West's *Death on a Pale Horse* (plate 87) and Albert Pinkham Ryder's *Jonah* (plate 101), the tortured anguish of Arshile Gorky's *Agony* (plate 96). Styles may range from the literal rendering of people and objects of Georgia O'Keeffe's *Cow's Skull—Red White and Blue* (plate 90) to the almost total nonobjectivity of Gorky's *Garden in Sochi* (plate 95). All painters modify to some extent the literal appearance of reality, even if it is only to omit some details and emphasize others; the visionary painter works not to capture outward reality but to portray a world

he has created within himself. In American literature the visionary tradition takes in such writers as Edgar Allan Poe and Nathaniel Hawthorne.

American visionary paintings may be divided into two groups. In the first are the works of artists who were influenced to a certain extent by such widely prevailing visionary approaches as Romanticism, Surrealism, and Magic Realism—artists who painted as visionaries in some periods of their life and not in others. In the second group are works by artists who painted in complete independence and isolation, in styles unique for their time—artists who lived more or less as eccentrics in strange mystic realms, dreaming their dreams alone, and reflecting in all their paintings the authenticity of an inner vision.

VISIONARIES ASSOCIATED WITH OTHER TRADITIONS. By the first decade of the nineteenth century the lofty ideals of simplicity, serenity, and pure linearity fostered through Neoclassical art were on the wane in Europe, as the new Romantic sensibility gained the ascendancy and the emotions of awe, trepidation, surprise, and ecstasy began to be exploited in art and literature. The shift in stylistic direction is well exemplified in the work of Benjamin West. His painting *Penn's Treaty with the Indians,* of 1771 (plate 18), painted in England, while it broke new ground in that the figures were not clothed in classic robes, had adhered strictly to the Neoclassic canons. In fact West, coming to London in 1763 from Rome, where the new archaeological finds had stimulated interest in the arts of Greece and Rome, had brought the Neoclassic style with him and had become one of England's first painters in that style. Late in his career, West again foreshadowed coming developments in art when he painted his visionary *Death on a Pale Horse* (plate 87), which prefigured the Romantic trend. (This is the largest version, painted in 1817; the first version was painted in 1802.)

Death on a Pale Horse offers a sharp contrast to the sedate mood of such earlier paintings as *Penn's Treaty with the Indians.* Now there is the terror of an apocalyptic scene as described in the Book of Revelation (6:8): "And I looked, and behold a pale horse: and his name that sat on him was Death, and Hell followed with him. And power was given unto them over the fourth part of the earth, to kill with sword, and with hunger, and with death, and with the beasts of the earth." The figure to the right is the Messiah; other figures are personifications of War, Pestilence, and Famine. The space encompassing the figures is now vast and immeasurable, quite unlike the neatly receding pockets of space in *Penn's Treaty.* In the stylistic presentation West seems to be subscribing to the ideas of Edmund Burke on the sublime. In his philosophical inquiry into the subject, written in 1756, Burke observed that the sublime has qualities that are unpleasant and difficult to perceive, such as confused images and obscurity, and that experiencing the sublime gives rise to a delightful terror akin to awe. In the end, one questions whether West is not here too much the fashionable visionary, and his work too contrived, to evoke a truly apocalyptic terror.

Also caught up in the Romantic movement in Europe was a young South Carolinian graduated from Harvard in 1800. Washington Allston, who must be adjudged the father of America's visionary tradition in painting, studied from 1801 to 1803 in London (where he admired the first, small version of West's *Death on a Pale Horse,* which was influential in the development of the Romantic movement in France), in 1803–4 in Paris, and in 1804–8 in Rome, where one of his close friends was the English Romantic poet Samuel Taylor Cole-

ridge. In Italy Allston was entranced by the paintings of the great late Renaissance Venetians, Titian, Tintoretto, and Veronese; he found that their colors and resonance of tone, regardless of subject, stimulated his imagination, "giving birth to a thousand things which the eye cannot see. . . . " Thus inspired, Allston painted some of his most beautiful pictures, drawing upon nature and his own inner vision. Returning to America in 1808, Allston settled in Boston, where he occupied the very painting room that had been Smibert's and that Copley and Trumbull had used. In 1811 he sailed for England, taking with him his pupil Samuel F. B. Morse; he remained in Europe this time until 1818. Leaving behind him a glowing reputation, he returned to America, where he was appreciated by the choicest spirits of the time, but where the artist—especially the artist who forged new paths—had little reward in public esteem or support. It did not benefit Allston's position that he was not in sympathy with the widely popular President Jackson and all that he represented in terms of mass culture. Basing many of his paintings on English literature and on the Scriptures, Allston (like Morse, Trumbull, and Vanderlyn, who likewise in early-nineteenth-century America tried to go beyond portraiture, genre scenes, and literally rendered landscapes) suffered neglect.

Allston found in the Scriptures not precedents for moral guidance nor stirring historical dramas nor the revelation of God's law, but elements of mysticism and the supernatural, of "Gothick" horror and suspense, that appealed to his imaginative temperament and, as subject matter, accorded with his ideas as a Romantic painter. In 1811–13 he painted *The Dead Man Restored to Life by the Bones of the Prophet Elisha* (Pennsylvania Academy of the Fine Arts, Philadelphia) and *The Angel Releasing St. Peter from Prison* (Museum of Fine Arts, Boston). In 1817 he began an enormous canvas, *Belshazzar's Feast* (Detroit Institute of Arts), that was to depict the scene of the last feast of the last king of Babylon, where the mysterious hand, writing on the wall, predicted the fall of his empire (Daniel 5:25). The painting, begun in England, was taken up, put down, then taken up again at the end of Allston's life but never finished. On the day of his death in 1843 Allston was preparing to work on the figure of King Belshazzar. If it was Allston's feeling of cultural isolation in America that contributed to his inability to finish this painting, the implicit theme, the hidden forces behind the rise and fall of empires, adds a curious touch of irony.

One of Allston's most haunting paintings had its source not in literature but in his memories of the Alban hills by the Tiber. This is the eerie *Moonlit Landscape*, of 1819 (plate 88). An unnaturally bright moon casts its light upon the shingle shore of a river. The silver path of the moon's reflection passing under the arch of the bridge and shimmering on the still water is among the most evocative passages in nineteenth-century American painting. But it is the mysterious figures on the shore that raise the effect to a visionary height. We cannot help but wonder who they are, where they are going, why they are there. No answer is forthcoming. Allston plays on the mystery for its own sake. The unsettling silence of this work looks forward to much of the Surrealism and Magic Realism of the twentieth century—to the brooding architectural vistas of the Italian painter Giorgio de Chirico, and to the strange suspension of Andrew Wyeth's *Christina's World* (plate 94).

Recurrent in America's nascent Romanticism was a theme that, by extension of its scientific meaning, might be termed catastrophism. The theory that the geological and biological development of the world was the result not of continuous and uniform processes but of sudden and violent upheavals was a terrifying prospect to consider. In Peale's *Exhuming the First*

88. Washington Allston.
Moonlit Landscape.
1819. Oil on
canvas, 24 × 35″.
Museum of Fine Arts,
Boston. Gift of
William Sturgis Bigelow

89. Thomas Cole.
The Titan's Goblet.
1833. Oil on
canvas, 19 3/8 × 16 1/8″.
The Metropolitan Museum
of Art, New York.
Gift of Samuel Avery,
Jr., 1904

90. Georgia O'Keeffe. *Cow's Skull—Red White and Blue*. 1931. Oil on canvas, 40 × 36″.
The Metropolitan Museum of Art, New York. The Alfred Stieglitz Collection

American Mastodon, of 1806–8 (plate 27), there was the implication of bygone eras when now extinct monsters roamed the earth; Allston's unfinished *Belshazzar's Feast* was clearly catastrophist in theme; Durand's *Morning of Life* and *Evening of Life* of 1840 (plate 58), and Thomas Cole's five-painting series of about 1840, entitled *The Course of Empire* (New-York Historical Society, New York), had similarly catastrophist implications. Between 1810 and 1845 many books appeared dealing with catastrophism in one form or another; among the most widely read in America were Edward Bulwer-Lytton's *The Last Days of Pompeii,* Edgar Allan Poe's *The Fall of the House of Usher,* William Ware's *Zenobia: The Fall of Palmyra,* and Edward Maturin's *Montezuma, the Last of the Aztecs.*

Catastrophism as a theme was not unknown in European art, but it seems to have been especially significant to Americans of the first half of the nineteenth century, perhaps because they saw themselves, with the vast expanses of the country stretched out before them, as the beginners of a new era. This is the idea that seems to have been in the back of the mind of the Hudson River landscapist Cole when he painted his fantastic *Titan's Goblet,* of 1833 (plate 89). A huge ossified goblet is perched upon a mountain range; at the base of the range are the figures of men dwarfed to miniature scale by the great stone looming above them, of whose shape they are unaware. Upon the waters collected within the colossal goblet sail boats likewise minified by the giant cup. The thoughts of the viewer turn to the ill-fated mythological Titans, or, since the terrain is presumably America, to some doomed race of giants, now vanished or destroyed, that once inhabited the land and left this one remnant, a goblet too huge to be seen for what it is.

While it is the essence of the visionary tradition that the artist turns inward rather than outward for subject matter, visionary painters cannot but be affected by ideas and events and, especially, styles prevalent during their time. Thus, when we come to the visionary painters of the twentieth century we see Georgia O'Keeffe painting the simple, geometricized objects and using the dry, linear format favored during the 1920s and early 1930s by the group of modernists called Precisionists. She differs from others in the group—from Charles Sheeler (see plates 118, 119) and Charles Demuth (see plate 120), for example—in devoting many of her paintings to organic subject matter, mostly hills, flowers, and skulls, rather than to such severely rectilinear objects as buildings.

O'Keeffe's desire for remoteness and for closeness to nature led her to settle for four years into teaching jobs near Amarillo in the vast, dry, seemingly boundless region of the Texas Panhandle, and thereafter she visited the Southwestern desert often; in 1949, three years after the death of her husband, Alfred Stieglitz, she established her permanent residence in Abiquiu, New Mexico. In her paintings of desert skulls, the quality of fantasy arises from a contradiction: the strength of the image and the hard-edge precision of its rendering are at odds with the ideas we normally associate with a skull. O'Keeffe's skull seems incapable of decay or disintegration; this object, so deeply fraught with intimations of death, is altogether divested of them. Standing inviolably for itself, it becomes something other than itself. The coupling of the skull and the Latin cross seen in the *Cow's Skull—Red White and Blue,* of 1931 (plate 90), frequently found in O'Keeffe's work around 1930, suggests parallels with contemporary European Surrealist painting, in which objects are pulled out of their accustomed contexts and recombined illogically. O'Keeffe herself, however, has stanchly denied the existence of such a link.

Another early modernist, who, like O'Keeffe, drew upon country sources for fantasy, was Arthur Garfield Dove, a native of upstate New York. Dove bought a farm in 1910 in Westport, Connecticut, where he raised prize-winning chickens; later he spent much of his time on a houseboat he kept on the Harlem River or on Long Island Sound. His painting *Fog Horns,* of 1929 (plate 91), is one of a number of his works that show objects from a marine environment in stylized form. In 1934, at the age of fifty-four, Dove settled on a farm in Geneva, New York, close to Hobart College, which he had attended thirty-five years earlier. The circular forms in *Fog Horns* suggest not only the rims or funnels of the horns themselves but the emanation of the living waves of sound spreading over the waters, pulsating outward like the ripples in a still pool. As an artist Dove was able to project himself into the sounds and movements of his country surroundings, and to find for them apt visual metaphors.

The visionary strain in Charles Burchfield, too, evidenced itself in his ability to make the inanimate seem alive in his canvases, using paint in an expressive way that parallels the style of the German Expressionists. Some of his most characteristic paintings show the decaying wooden buildings of the Ohio towns where he spent his youth. Their aura is that of the grotesque Midwest types described by Sherwood Anderson in his novel *Winesburg, Ohio.* But Burchfield came closer to the supernatural: he showed these old buildings inhabited by dark spirits from the past. In his *Church Bells Ringing, Rainy Winter Night,* of 1917 (plate 92), the windows of the church have become faces—perhaps the congregants of bygone days—and the steeple a grotesque, hawk-shaped head. The falling rain appears as drops of blood, or perhaps tears. Nothing has disappeared, nothing is finally dead; rather, the very walls and windows of buildings contain in their fabric the living lineaments of the past.

92. Charles Burchfield.
Church Bells Ringing,
Rainy Winter Night.
1917. Watercolor, 30 × 19″.
The Cleveland Museum of Art.
Gift of Mrs. Louise M. Dunn,
in memory of Henry G. Keller

91. Arthur Garfield Dove.
Fog Horns.
1929. Oil on canvas, 18 × 26″.
Colorado Springs Fine Arts Center.
Gift of Oliver B. James

93. Peter Blume. *The Eternal City.* 1937. Oil on composition board, 34 × 47 7/8″.
The Museum of Modern Art, New York. Mrs. Simon Guggenheim Fund

In Europe, Surrealism, exploring, from the mid-1920s through the 1940s, the world of dreams, the unconscious, the accidental, hallucination, and the like, developed in several directions. In the Surrealist style of which Salvador Dali is the chief representative, objects were shown realistically in their normal appearance, but in nonrational contexts and juxtapositions. In America the style known as Magic Realism was roughly similar to, and sometimes influenced by, this type of Surrealism. In Magic Realist paintings, objects are shown with an intense, almost photographic realism, but there is always an element of fantasy, sometimes, as in the paintings of Peter Blume, bizarrely presented.

Blume, born in Russia, was brought to America in 1911, when he was five years old, and received his schooling and his art training in New York. With the aid of a Guggenheim Fellowship, he went to Italy and painted there from 1932 to 1936; it was in Italy that he began *The Eternal City* (plate 93). With extraordinary jewel-like clarity of detail, Blume gives us a composite view of Rome, ancient and modern, dominated by a poison-green jack-in-the-box head of Benito Mussolini. In the foreground are the fragments of marble statues, in the middle ground, the ruins of the Forum—symbols of Ancient Rome. The Man of Sorrows laden with ex-votos (chiefly gold epaulets) to the left is a symbol of Christian Rome, while the beggar woman in front of the shrine is a comment on the poverty that lay behind the facade of

Fascist Rome of the mid-1930s. While Blume was in Italy, Mussolini invaded Ethiopia, drew close in political alliance to Hitler, and announced a national mobilization of twenty million soldiers. In its expression of the artist's anti-Fascist views, this picture comes close to Social Realism as well as to Magic Realism.

A Magic Realist painting that achieves its effect with no element of the bizarre or the nonrational is Andrew Newell Wyeth's *Christina's World,* of 1948 (plate 94). A crippled girl in a faded pink dress, her back to us, is dragging herself up a deserted hillside toward a farmhouse. But looking over the girl's shoulder up the steep hill which she is painfully climbing, we have to see the world through her eyes. The familiar, the recognizable, appears in a new light, mysteriously transformed: the hill (because of Wyeth's subtle tiltings of the plane) seems steeper, the ascent more arduous than it actually is, and the broad hillside more overwhelmingly lonely. Wyeth, with startling insight and empathy free of maudlin pity, takes us into the girl's world. This world is in fact a farm in Maine where the Olsons, Christina and her brother, lived. Wyeth lived nearby, and Christina and the farm provided him with many subjects.

The more abstract side of Surrealism as it appeared here is represented by Arshile Gorky (his original name was Vosdanig Manoog Adoian), who emigrated to America from Armenia in 1920, when he was sixteen years old. Gorky began his art studies in Tiflis and continued them in New York. His early paintings, through the 1930s, showed, progressively, a depend-

94. Andrew Wyeth. *Christina's World.* 1948. Tempera on gesso panel, 32 1/4 × 47 3/4". The Museum of Modern Art, New York. Purchase

95. Arshile Gorky. *Garden in Sochi*. 1943(?). Oil on canvas, 31 × 39″.
The Museum of Modern Art, New York. Acquired through the Lillie P. Bliss Bequest

ence on Cézanne, on the Synthetic Cubism of Picasso, on the early nonobjective work of
Wassily Kandinsky, and on the biomorphic abstractions of Miró. Arriving at his own in-
dividual style early in the 1940s, he produced, among other works, a series of paintings en-
titled *Garden in Sochi*. The garden in Sochi was a real place that Gorky remembered from his
childhood in Armenia; it was believed to have magical properties for fulfilling wishes. Gorky
recalled that on a spot perpetually in the shade was a blue rock, and rising above it was an
enormous leafless tree known as the Holy Tree. Women would brush their bare breasts
against the rock to induce fertility, and people making other wishes would attach strips of their
clothing to the tree. In the *Garden in Sochi* shown in plate 95 the vertical rectangular form in
the upper half of the canvas (which appears in all the paintings of the series) represents the
tree, and the large, dark form at the lower right may be the rock. The fluttering forms, sug-
gesting simultaneously flowers and parts of bodies (and still slightly reminiscent of Miró),
could have been derived from the artist's memories of the strips of clothing tied to the tree.
Gorky's power as a fantasist lies in his ability to endow a single form with multiple identities.

In the last two years of his life, Gorky was dogged by misfortune. In 1946 his studio caught
fire, and much of his work was destroyed; the next year he was afflicted by cancer; and an
automobile accident in June 1948 left his painting arm paralyzed. On July 21 he took his
own life.

Agony, of 1947 (plate 96), which is so revelatory of Gorky's torment, began as a picture of a room in the Virginia home of Gorky's wife's parents. From preliminary drawings we know that the room contained a fireplace, rocking chair, and crib. The fireplace is no longer indicated in the painting, although the color of fire is dominant. There is still some indication of the rocking chair at the left, and of the crib in the smaller form at the right, but the old identities of the objects have been almost entirely sloughed off, and a fantastic world of plantlike and biomorphic forms has replaced them. A pattern replete with sexual allusions is punctuated with motifs suggesting mouths open as if to scream. There are purples, cold yellows, and blacks in the painting, but the pervasive tonality is a smoldering, fiery red, perhaps a reference to the fire in Gorky's studio the year before the picture was painted.

THE ECCENTRIC VISIONARIES. Twentieth-century visionary painting is a continuation of the trend that began early in the nineteenth century with Washington Allston. The impact of Expressionism and Surrealism wrought an increase of visionary elements in American painting as a whole. But with the waning of Romanticism, from about the middle of the nineteenth century up to the first decade of the twentieth, there were painters who worked—alone, apart from any movement or group—entirely within the visionary tradition. Their solitariness fostered the sense of inwardness that was there to begin with, an inwardness that brought strength to their art. In circular fashion, the eccentricity of their art for its time reinforced this solitariness. Thus the chain from Washington Allston even up to the present day has never been broken.

John Quidor was born in Tappan, on the banks of the Hudson; at the age of ten he moved to New York, where he became known as a painter of banners and decorative panels for fire engines. From 1814 to 1822 he studied with the portraitist John Wesley Jarvis, but none of his portraits have survived. It was in his works based on literature (above all, the writings of Washington Irving) that Quidor summoned up the bizarre world that lay within his own imagination. The spirit of these paintings is Quidor's own rather than Irving's, for he underlays the genial humor of the writer with a current of violence and grotesqueness, combined—if one sees it that way—with a sardonic humor. (The closest contemporary parallel would be the lithographs and political cartoons of the French artist Honoré Daumier.) The earliest of his Washington Irving paintings is the *Ichabod Crane Pursued by the Headless Horseman* (Yale University Art Gallery, New Haven), of 1828. *Money Diggers*, of 1832 (plate 97), is derived from an episode described in Irving's *Tales of a Traveller*: three men, digging by night for pirate treasure, are terrified by an awakened neighbor, whom they imagine to be the ghost of a drowned buccaneer. To heighten the tension, Quidor alters nature; the tree to the left writhes, and its branches are like claws or fingers reaching out to grab a fleeing digger, while the hill over which the nightcapped head of the neighbor appears seems made of wax rather than rock. The unearthly light that bathes parts of the painting intensifies the mood. Some have seen Quidor as evoking true terror, but his flamboyant imaginings are probably closer to Halloween spookiness than to Boris Karloff at his most fearsome. In the 1860s the mood of Quidor's work changed. Paintings based on Irving's *Diedrich Knickerbocker's A History of New York* (1809) are bathed in a hazy, golden glow that gives them a remote, elegiac quality.

96. Arshile Gorky. *Agony.* 1947. Oil on canvas, 40 × 50 1/2".
The Museum of Modern Art, New York. A. Conger Goodyear Fund

Among the solitaries who exercised their talents outside the main current of American art, William Rimmer was one of the most versatile and least fortunate. Born in Liverpool, England, the son of an impoverished French nobleman, he arrived in America with his father when he was two, and they settled in Boston in 1816, when he was ten. The elder Rimmer believed that he was the Lost Dauphin, heir to the French throne, and lived in fear of Louis XVIII's assassins. Nourished by this delusion, father and son lived as recluses in dire poverty. The young Rimmer was briefly apprenticed to a shoemaker. He applied himself earnestly to learning anatomy, music, etching, lithography, painting, and sculpture, and became an able teacher of drawing and anatomy as well as a physician. In his maturity he turned out what was perhaps the most original sculpture made by an American in the nineteenth century. At a time when grandiose narrative pieces were the rule, he produced small pieces expressive of struggle or tragedy—such as the *Dying Centaur,* of 1871 (Museum of Fine Arts, Boston)—perhaps symbolic of his own despair. His failure to win support for his art made him withdraw more and more into himself.

In a most intriguing painting of 1872, which Rimmer called *Flight and Pursuit* (plate 98), he showed running frantically through the hall of a resplendent Moorish palace two figures who, except for their garb (the one in the background is veiled and carries a sword), are mirror images of each other. There are ominous shadows preceding and following them; judging

97. John Quidor. *The Money Diggers*. 1832. Oil on canvas, 16 3/4 × 21 1/2".
The Brooklyn Museum, New York. Gift of Mr. and Mrs. Alastair Bradley Martin

98. William Rimmer. *Flight and Pursuit*. 1872. Oil on canvas, 18 × 26 1/4".
Museum of Fine Arts, Boston. Bequest of Miss Edith Nichols

99. Elihu Vedder. *The Lair of the Sea Serpent*. 1864. Oil on canvas, 21 × 36″.
Museum of Fine Arts, Boston. Bequest of Thomas G. Appleton

from the shadow in the lower right-hand corner, a two-headed creature is about to move into view. Whether the two men are being pursued or one of them is pursuing the other is an unresolved question; the possibility must be entertained that the two men are pursued not by anyone or anything actual but by some appalling inner fear. However, we know that the artist gave the painting the variant title "On the Horns of the Altar," and it has been pointed out that, in biblical times, for a fugitive to "catch hold on the horns of the altar" was to obtain protection from his enemies.

A statement that most visionary artists would subscribe to was made by Elihu Vedder in trying to explain his art. Vedder said: "I have tried to give my impression on first meeting the strange beings in my wanderings in the little world of my imagination. So I must use my painting as a mirror and only reflect without explaining. If the scene appears extraordinary, all I can say is that it would be strange if it were not."

Born in New York City, Vedder spent most of his time abroad, especially in Italy. For a while he was influenced by the English Pre-Raphaelites, and while living in Florence from 1858 to the end of 1860 he became immersed in the art of Michelangelo and other Italian Renaissance artists. But in the end his art reflected his own reveries. The objects and creatures may be painted in a meticulously realistic style, as in *The Lair of the Sea Serpent*, of 1864 (plate 99); the atmosphere created is utter fantasy.

The particular vision that haunted Ralph Albert Blakelock was the American wilderness. A native New Yorker, Blakelock was the son of a physician and thought for a while of becoming a physician himself. But by the time he was eighteen his artistic bent had asserted

itself and, already painting, he left college and entered Cooper Union. He found the rigors of his training at Cooper Union too taxing, and decided to carry on his artistic ventures in the West. He set out in 1869, at the age of twenty-two, for the unsettled frontier and traveled by railroad and stagecoach through the states and territories of Nebraska, Kansas, Colorado, Wyoming, Utah, Nevada, and California. The impressions of his three years in the Far West never left him. A recurrent theme is an untouched forest bathed in the light of a round, radiating moon; sometimes, as in *Moonlight,* of 1882 (plate 100), tiny figures of the Indians whose life Blakelock had observed during his Western sojourn can be seen. Blakelock's paintings of the wilderness—among them this evocative rendering of moonlight shining through the lacy foliage of silhouetted trees—were indifferently received in the New York to which Blakelock returned. There was little response to the strangeness and deep feeling of his wilderness visions, and, living in poverty in midtown Manhattan, he helped sustain himself and his large family by peddling. The neglect eroded his spirit, and in 1891, when he received a few hundred dollars from a wealthy New Jersey collector rather than the thousand dollars he thought he had been promised, he destroyed the money. This was the onset of the insanity that almost continuously from September 1899 until his death, in 1919, caused him to be confined in an institution. He continued to paint, using instead of canvases pieces of paper, cardboard, pieces of board, windowshades, and wallpaper.

The giant among the nineteenth-century visionary painters was Albert Pinkham Ryder, who was born in New Bedford, Massachusetts, and moved to New York in his early twenties, around 1870. Ryder lived in a world of dreams; the world of here and now bypassed him. He would walk about New York City all night long, soaking in the moonlight; some nights he would take the ferry to New Jersey. His appearance became more and more disheveled. By the mid-1880s he was living in a room full of old newspapers, assorted boxes, unwashed dishes, and unlaundered clothes, with money and uncashed checks scattered about. On some of his paintings he worked for a decade, adding layer upon layer of glazes and pigments, leaving them for months or years and then returning to them. Because of these constant reworkings and the use of such unsuitable substances as wax and candle grease as mediums, his paintings have darkened and lost much of their detail, and their surfaces are cracked and wrinkled like a crocodile's skin; in many of the late paintings, only the large, simplified masses are clear. For this reason many forgers have found Ryder a tempting mark. Yet, even in their ruinous state, Ryder's paintings capture a private world that on its own terms is inviolable. Forgers can catch the outward forms, never the inner spirit and integrity. When, late in life, he was taken to task for his disregard of technique, Ryder's answer was: "When a thing has the elements of beauty from the beginning, it cannot be destroyed. Take . . . the Venus de Milo . . . ages and men have ravaged it, its arms and nose have been knocked off, but still it remains a thing of beauty because beauty was with it from the beginning."

In Ryder's paintings, perhaps because he had grown up in a whaling town on the coast of Massachusetts, the sea plays a major role. There was nature manifestly visible, exultant, infinitely varied in mood, free of all restraint. Thus he drew upon his earliest memories for *Jonah,* of about 1885 (plate 101). He painted the prophet as a tiny figure floundering in the boundless ocean into which he has been cast forth. As he is about to be swallowed by the "great fish," the divine instrument, Jonah is watched over by God, a bearded figure at the top of the canvas, holding the sun in His hand. Ryder did not disregard the moralistic aspects

100. Ralph Albert Blakelock. *Moonlight*. 1882. Oil on canvas, 27 1/4 × 32 1/4″.
The Brooklyn Museum, New York. Dick S. Ramsay Fund

of the Book of Jonah (can one flee from God's command?) but he focused on the fantastic adventure of Jonah, which arose from the inner conflicts of a rebellious man, and his struggles in learning to accept his destiny. The swirling of the waves occupies most of the canvas: the maelstrom of the ocean is but a mirroring of Jonah's own inner turmoil.

Like Quidor, Ryder based many of his paintings on literature, but there was nothing humorous or grotesque about Ryder's results. In the Bible, in Chaucer, Shakespeare, Byron, Poe, and in Wagnerian operas, he found stories in which he could frame his conception of man as part of the eternal rhythms of nature, sometimes turbulent and menacing, sometimes benign. For Ryder, nature was not merely a neutral setting for man's actions. Rather, nature and man were one; or, better, nature reflected the storminess and the ecstasy that lay within man.

For another of his great paintings of the sea, *Flying Dutchman* (plate 102), Ryder drew upon Wagner's opera of that name, in which, as in the Jonah story, there is the theme of the quest for salvation; the hero, Vanderdecken, is doomed to sail the sea endlessly until he finds the pure love of a woman. In Ryder's painting the mist above the stormy sea and the brightly shining moon (or sun) materializes into a shrouded figure, the personification of the

101. Albert Pinkham Ryder.
Jonah. c. 1885.
Oil on canvas, 26 7/8 × 33 3/4".
National Collection
of Fine Arts,
Smithsonian Institution,
Washington, D.C.
Gift of John Gellatly

102. Albert Pinkham Ryder.
Flying Dutchman. c. 1887.
Oil on canvas, 13 3/4 × 16 1/2".
National Collection
of Fine Arts,
Smithsonian Institution,
Washington, D.C.
Gift of John Gellatly

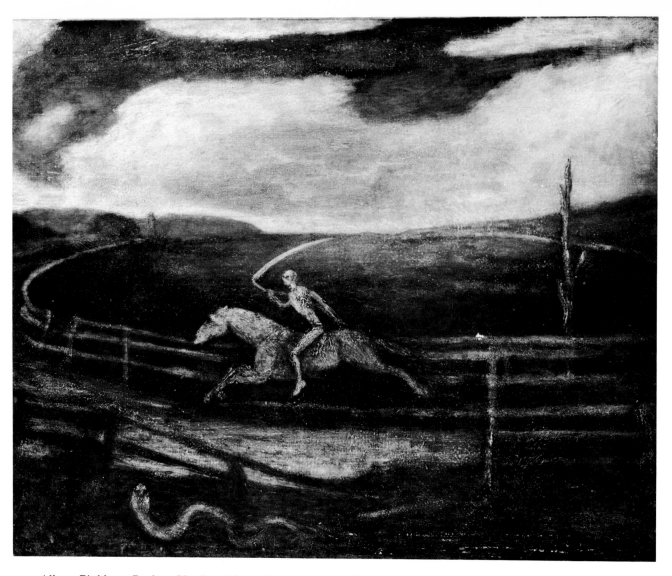

103. Albert Pinkham Ryder. *The Race Track (Death on a Pale Horse)*.
c. 1910. Oil on canvas, 28 1/4 × 35 1/4″. Cleveland Museum of Art. Purchase from the J. H. Wade Fund

fate besetting the hero. Through his heavy incrustations of paint, Ryder suggests the very substance of the churning water.

Only once did Ryder base a painting on an actual event. *The Race Track (Death on a Pale Horse)* (plate 103), which he worked on sporadically from about 1895 to about 1910, commemorated the death by suicide of a waiter who had bet his life's savings on a horse race and lost. As an augur of the event, the lone horseman Death, holding his grim scythe, circles a race track. There are no competitors, no spectators: the victory belongs to Death alone. An unearthly light hovers over the track. When asked whether the time was day or night, Ryder replied that he had never thought about it. In the midst of America's burgeoning expansion around the turn of the century, no doubt the waiter's suicide went unnoticed; for Ryder, oblivious of the larger issues of the day, it became central.

In Louis Michel Eilshemius the visionary and the eccentric strain are intermingled. Born

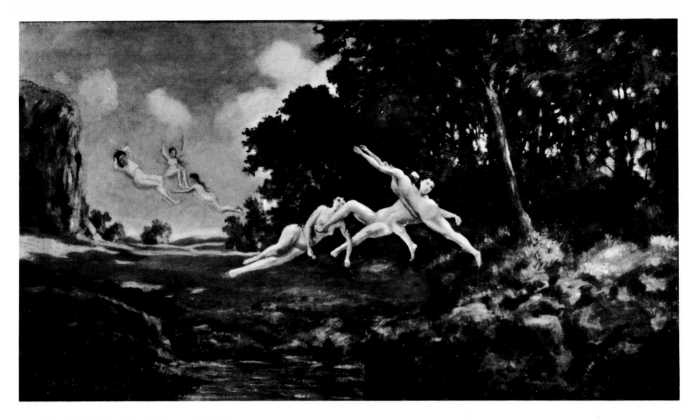

104. Louis Eilshemius. *Afternoon Wind.*
1899. Oil on canvas, 20 × 36″. The Museum of Modern Art, New York

in Newark, New Jersey, to wealthy parents, he was brought up in Dresden, Germany, returned to America in 1882, when he was eighteen, then, in 1886, sailed for Paris, where he studied under the leading French academician, Adolphe William Bouguereau. A restless soul, he traveled throughout Europe and North Africa, and visited Samoa in 1901. In 1908 he was admitted by Ryder to his studio, a rarely granted privilege. Eilshemius was the inventor of electric belts and various homeopathic procedures, but neither these nor his writing nor the music he composed nor his paintings—which ranged from sensitive landscapes to poetic, dreamlike visions—had a favorable reception. In 1921 he gave up painting because of the indifference it met. In 1932 he became permanently paralyzed, and he died penniless in Bellevue Hospital.

Eilshemius did have, especially toward the end of his life, a few stanch supporters, some of outstanding discernment (in 1917 Marcel Duchamp included him in the first Independents' exhibition). Floating or flying figures are a favorite motif of Eilshemius, and some of his paintings have a strange power. About others, such as *Afternoon Wind,* of 1899 (plate 104), there is an air of contrivance. Yet this is a painterly expression of an inner vision no less authentic, no less consuming, than those that drove Ryder.

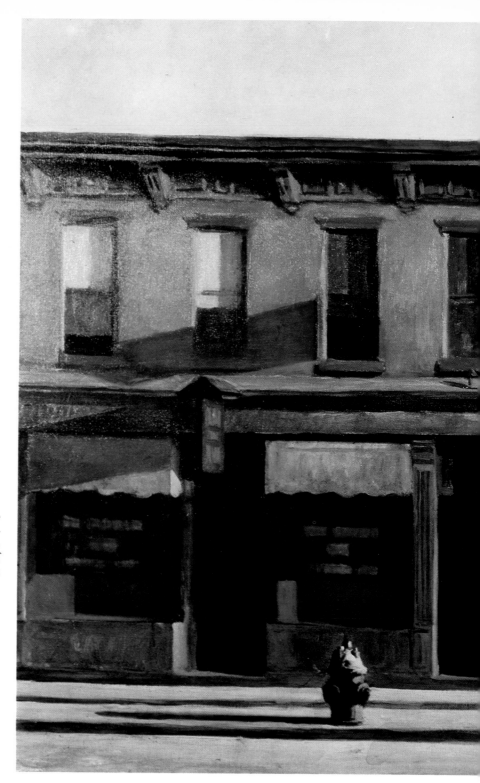

105. Edward Hopper.
Early Sunday Morning.
1930. Oil on canvas, 35 × 60″.
Whitney Museum of
American Art, New York

CHAPTER SEVEN
The American Urban Landscape

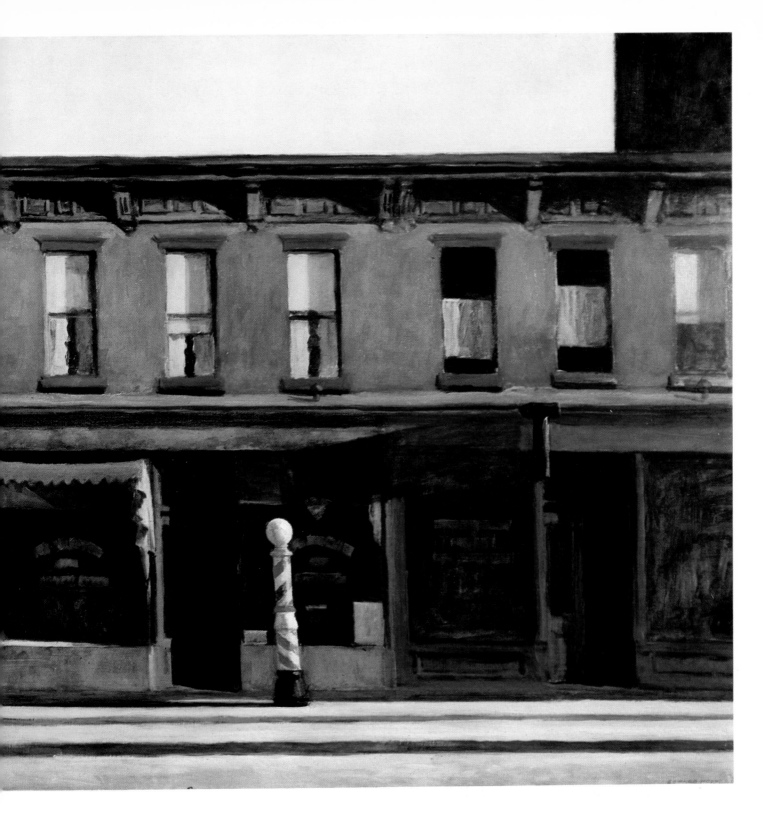

Until the beginning of the twentieth century the city was a subject almost completely un-explored in the art of the United States. For the American artist, and his patrons, art could be ennobling or inspiring (as were most of the landscapes), instructive (as were the history paintings), escapist (as were most of the bucolic genre scenes), even terrifying or mystifying (as were the paintings by Ryder and others of the visionary tradition). But it could never be ordinary or demeaning or depressing—the very qualities that the city, crowded with men and women going about their routine activities in typically grimy surroundings, represented. In

the rare instances, toward the end of the nineteenth century, when the city was depicted, the scene chosen would be a street in the half light of dusk or after a rainfall, with trees and buildings reflected in the gleaming surface of puddles. The city as a place of action and confrontation, the urban container of people—enraged, triumphant, disillusioned, bored, despondent, or whatever—that city is hardly to be found in American art of the nineteenth century. Quite exceptional is David Gilmour Blythe's *Art versus Law*, painted before 1860, which poses the social and economic problems of the uprooted artist (plate 78); a more typical urban scene is Thomas Eakins's *Max Schmitt in a Single Scull*, of 1871, set on the Schuylkill River, a portion of Philadelphia away from the hustle and bustle of the city proper (plate 80).

While cities had existed in America from before the time of the Revolution, their appearance changed most radically at the beginning of the twentieth century. At the time of the Civil War one out of every six Americans lived in a city with a population of 8,000 or more; by 1900 the proportion had increased to one out of every three. From 1880, foreign immigration increased by leaps and bounds, transforming the ethnic makeup of Boston, New York, Chicago, San Francisco, and other cities. As the population of the cities grew, pressure for room increased, and land values rose, the cities began to grow vertically as well as laterally. The group of tall commercial buildings erected in Chicago in the 1880s and 1890s represented the first stirrings of the cultural ferment that, following upon a period of rapid industrial expansion, was to lead to the emergence of the progressive and modern spirit in the early twentieth century. The skyline of New York, an older city, was completely transformed in the first three decades of the twentieth century. In literature too, during this time, strong forces were at work, and the new realists, among them such writers as Theodore Dreiser, were focusing on the human casualties of industrialization and on the special problems of the urbanite, whose life was shown as being more exciting, unstable, and sometimes unsavory than that of his rural counterpart.

In its immensity, congestion, and bewildering variety, New York stood alone. As its population grew from 800,000 in 1860 to 2,500,000 in 1900, it became a composite of ethnically consolidated neighborhoods, a rich mosaic of many cultures and folkways. In the first decade, the garment industry became concentrated in Lower Manhattan. Pennsylvania Station was built with tunnels under the Hudson and East Rivers and a connection with New England through the Hell Gate Bridge. The second decade saw enormous development in the area around the station, including the building of the Pennsylvania Hotel, the General Post Office, and the great department stores. New York was the probable port of entry of the European immigrant. By the second decade it had become one of the world's great industrial, shipping, and financial capitals.

THE ASH CAN SCHOOL. Appropriately it was in New York that the first group of American artists to use the city as their subject came together. It is hard for us today, looking at the paintings of John Sloan, Maurice B. Prendergast, and other members of what has come to be known as the Ash Can School, to find anything revolutionary about them. In their day, though, these paintings represented a sharp break with the previous course of American art, and when the nucleus of the group—the Eight Independent Painters (usually shortened to The Eight)—exhibited in New York's Macbeth Gallery in 1908, a great deal of notoriety at-

tached to the event. For they were the first group of American painters to show men and women with no pretensions to glamour going about their daily activities. The term Ash Can School (they were also dubbed the "revolutionary black gang") was a negative one, and was aimed derisively at these painters who dealt only with the life of the alleys and backyards, or at least of the shabby people who were at home there. The spokesman of the group, Robert Henri, urged the importance of the common man, the man in the street. (Among the many causes he espoused was that of the Russian revolutionaries.) Henri argued that art, both in its subject matter and in the quick, slapdash handling of it, ought to reflect "life" (a favorite word of his, used to connote the gusto of everyday urban activity as commonly experienced by ordinary people). He would have condemned equally the strange visions of Ryder, the near-abstractions of Whistler, the late, lonely seascapes of Homer, the quiet nostalgic scenes of Inness, as all in their way being too esoteric and too removed from the ongoing daily urban round.

But while the paintings of the Ash Can School correctly revealed the New York of the early twentieth century as a place of tawdry glamour, as well as of companionship, warmth, lively bustle, and close family ties, they were nonetheless biased in their appraisal of urban life. For they avoided such unpleasant phenomena of urban life as the wretched conditions in the sweatshops and the miseries of tenement dwellers. Probably without realizing it, the Ash Can painters were as unduly optimistic in their view of the city as the nineteenth-century genre painters had been in their view of the country. The urban poor all seem to be happy with their lot. Whether poor or middle-class, people relate easily and naturally to one another. There is always much to do in the city; and people come together to participate in common activities, like the two boys building a snowman in Sloan's *Backyards, Greenwich Village,* of 1914 (plate 106), to witness theatrical events, or simply to be with one another, to see and be seen at the city's beaches and parks, as in Prendergast's *Central Park in 1903* (plate 107). Of course, early-twentieth-century New York was in many ways a happier place than it is today. Where the contemporary urban problems of loneliness, depersonalization, crime, pollution, and traffic snarls existed, they seemed capable of solution or could be easily over-

106. John Sloan.
Backyards, Greenwich Village.
1914. Oil on canvas, 26 × 32".
Whitney Museum of
American Art, New York

107. Maurice Prendergast. *Central Park in 1903.* 1903. Oil on canvas, 20 3/4 × 27″
The Metropolitan Museum of Art, New York

looked. By the urban poor, America was then looked upon as a golden land, and many fervently believed, with justification, that the possibilities were limitless for those who worked hard and persevered.

John Sloan worked for many years as a newspaper illustrator, and because of this background many of his paintings have an anecdotal quality. It is easy to weave little stories about the gaggle of girls in *Sixth Avenue Elevated at Third Street*, of 1928 (plate 108), who after a hard day in the office have gotten together to spend the evening. Where shall they go? Whom will they meet? What adventure will befall them? Amassing a multiplicity of detail, Sloan fashions the urban environment in which his people move and react and of which they are a meaningful part. There is an authenticity to this world. Sloan re-creates accurately this particular corner at Sixth Avenue and Third Street (it is only there that the Elevated made precisely that kind of loop). His paintings catch the atmosphere of Lower Manhattan—the squalor as well as the warmth and the charm. In Sloan's *Backyards, Greenwich Village,* the snow is not deep enough to cover up the dinginess. The wash is out on the line for all to see. We suspect there is no craving for privacy: everyone knows his neighbor's business, and would aid his neighbor in need. Along with the squalor there is close companionship. Through the window at the right a little girl, perhaps the sister of one of the boys building the snowman, is smiling, and a contented cat is curled up on the fence.

Prendergast was attracted to crowds; he had come to appreciate the crowd as a spectacle.

108. John Sloan. *Sixth Avenue Elevated at Third Street.*
1928. Oil on canvas, 30 × 40″.
Whitney Museum of American Art, New York

109. George Bellows. *Cliff Dwellers.*
1913. Oil on canvas, 39 1/2 × 41 1/2″.
Los Angeles County Museum of Art

In 1898 in Venice he had painted crowds milling about the piazzas and near the canals; in New York he naturally transferred his attention to the beaches and, more especially, to Central Park. In his park scenes Prendergast painted the people sitting on the benches, the promenaders sedately strolling by, holding up their parasols, and the riders on horseback and in horse-drawn carriages—all fine ways to enjoy the city! These people have none of the boisterousness of Sloan's office girls; they are middle-class and the label Ash Can School is particularly inappropriate here. Of the early realist painters of the city, Prendergast is the most unusual technically. He had never been a newspaper illustrator, and anecdote meant nothing to him. Organizing the picture in terms of the strong verticals of the trees and the horizontals of the benches, he nearly dissolves the subject in bright dabs of yellow, blue, orange, and green. From a distance, a Prendergast painting looks like a small, rich tapestry. His technique is similar to that of the contemporary French followers of Seurat, who in the 1880s invented a technique called Pointillism, which consisted in building up the picture through tiny dots of color. Prendergast's color spots are larger and arranged less systematically.

Though he was not one of the exhibitors in the Macbeth Gallery show of 1908, George Bellows, a pupil of Henri's, was closely associated with the Ash Can group. He represented personally what the group advocated through its art. A rugged athlete, later very much a family man, he fitted into the society he pictured; he was extroverted, uncomplicated, the precise opposite of so oversensitive an aesthete as, say, Whistler. Prize fights, caught at their most violent, were among Bellows's favorite subjects. Like the man himself, Bellows's paintings were unusual in size, most of them larger than the *Cliff Dwellers,* of 1913 (plate 109), which is small, for this artist, measuring only 39 1/2 by 41 1/2 inches. The denizens of the tenements in his *Cliff Dwellers* are typically blowzy, gregarious, hardly able to control their energies. The boundaries of the painting seem inadequate to contain them. Here there is no attempt to compose the scene neatly and coherently, as in Prendergast's painting. The handling of the paint, too, is loose, unconstrained, in keeping with the character of the city people

Bellows preferred to show. This vitality of brushwork curiously foreshadowed that of such Abstract Expressionists as Jackson Pollock and Franz Kline in the 1940s and 1950s.

LATER REALISTS. From the end of World War I, in 1918, until almost the end of the 1920s, the United States, taken as a whole, passed through a period of buoyant optimism. The 1920s—the Roaring Twenties, as they have been dubbed—were the decade when the most popular dance was the lively Charleston, and when the great national heroes were such sports stars as Babe Ruth and Jack Dempsey and, especially, tall, shy Charles Lindbergh, who made the first nonstop solo flight across the Atlantic. It was a time marked by the popularizing of such important inventions and improvements as the internal-combustion engine and the application of electricity to domestic appliances. The buoyancy ended with the stock market crash of 1929 and the ensuing Great Depression, when bread lines were everywhere and when an increasing number of Americans came to realize that hard work and application were not enough to ensure prosperity—or even a standard of living above mere subsistence.

But even within the 1920s there was an awareness of the boredom and despair lurking beneath the surface of America's towns and cities. In his novel *Main Street*, of 1921, Sinclair Lewis revealed the isolation, dullness, and stifling conformity of small-town America, conditions bitingly portrayed by Edward Hopper in his *Early Sunday Morning*, of 1930 (plate 105).

There is of course no distinct dividing line about the year 1930 separating generalized happiness from generalized unhappiness. Undoubtedly many early-twentieth-century immigrants suffered wretchedness and despair—even some of those who outwardly looked like the untroubled, energetic people in Sloan's and Bellows's paintings. And it was in 1897 that the poet Edwin Arlington Robinson wrote about one Richard Cory, who

> was a gentleman from sole to crown,
> Clean favored, and imperially slim.
>
> And he was always quietly arrayed,
> And he was always human when he talked;
> But still he fluttered pulses when he said,
> "Good-morning," and he glittered when he walked.
>
> And he was rich—yes, richer than a king,
> And admirably schooled in every grace:
> In fine, we thought that he was everything
> To make us wish that we were in his place.
>
> So on we worked, and waited for the light,
> And went without the meat, and cursed the bread;
> And Richard Cory, one calm summer night,
> Went home and put a bullet through his head.

Still, there is reason to think that with the thirties there was no longer a generalized optimism to mitigate one's private unhappiness, and that the problems peculiar to the city- and town-dweller became more poignantly defined. Certainly in American painting of the 1930s and after, the city and town appear less frequently as a place of fulfillment than as an outpost of loneliness and alienation—a locale requiring special skills of adaptation.

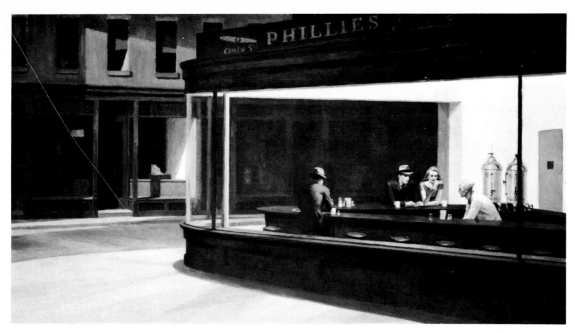

110. Edward Hopper. *Nighthawks.* 1942. Oil on canvas, 30 × 60″.
The Art Institute of Chicago. Friends of American Art Collection

Sloan's *Backyards, Greenwich Village,* of 1914, and Hopper's *Early Sunday Morning,* of 1930, are both pictures of drab urban environments. But there the similarity ends. Sloan's backyards seem open and accessible, while Hopper presents us with a facade of tenements as austere as a fortress. In front of this facade is a deserted sidewalk upon which stand only a barber's pole and a fire hydrant, and stretching alongside that, closer to us, is the empty street. Sloan's environment is lived in and used, and every bit of space is filled; in Hopper it is the emptiness of space we notice. In Sloan's painting not only do the cats, the two boys and their snowman, and the little girl in the window, but even the inanimate objects—the hanging clothes and the telephone pole—allude directly to human usage. Also, in Sloan's painting there is a great variety of objects of different shapes and materials, reflecting the range of experiences of those using the backyards. By contrast, Hopper's prominent facade is punctuated by a monotonous row of blank windows, all identical in size, shape, and orientation. The only variety to these windows is the degree to which the shade has been drawn. The deserted street is occupied only by the shadows cast by the barber's pole and the hydrant. Hopper has purposely chosen Sunday morning, when the inhabitants of the town are customarily inside their drab houses. The one bright spot of the facade is the garish red brick beneath the overelaborate gray cornice. The building is outlined in bright light, as if to focus the viewer's eye on its limits and to emphasize the narrowness of small-town life.

When Hopper does people a cityscape, he still evokes a mood of loneliness. These people, even in company, are introverted, uncommunicative, absorbed within themselves. In *Nighthawks,* of 1942 (plate 110), Hopper gives us a night view of a diner in a big city. Through large glass windows (which act as a partition between us and the interior of the diner) we see three customers and the counterman. These are people who, for one reason or another, are active while the city sleeps, while other people are at rest in their homes, with their families. By their very presence in the diner at this forlorn hour these individuals are separated from others. The diner, far from being a permanent resting place, is a place to stop for

111. George Tooker. *The Subway.* 1950. Egg tempera on composition board, 18 1/8 × 36 1/8". Whitney Museum of American Art, New York

112. Raphael Soyer. *Office Girls.* 1936. Oil on canvas, 26 × 24". Whitney Museum of American Art, New York

a few minutes. The man and woman who are sitting together make no attempt to reach toward one another; they are spiritually detached. Several seats away, a man sits slouched, his back to us, his hat drawn low. The counterman faces the woman as though taking her order. Everything about the diner is functional, antiseptically clean, bare—underscoring the lack of warmth among the people within it. In paintings of the Ash Can School the human figures are the protagonists, the vital actors, and the city is their stage. In *Nighthawks,* the people are motionless props and seem no more important than the two gleaming coffee urns or the "Phillies" sign on the outside of the diner above the window.

Unlike Hopper, who presents his scene as it existed, with no alterations, making a memorable statement on the loneliness of the city through his lack of commentary, other painters of the city through the 1930s and 1940s fused their realism with strange combinations and alterations of appearances. In George Tooker's *The Subway,* of 1950 (plate 111), the corridors, stairways, and metal turnstiles appear to lock in the commuters, who are trapped, bewildered, and defeated, like prisoners in a jail. Toward the left, the same figure appears twice. Users of the great American subway systems are well aware of occasional prisonlike aspects. Tooker has exaggerated these aspects to convey the dehumanization to which urban Americans are subjected. It is easy to see in his image of the subway a symbol for the city as a whole.

Not all later realist paintings of the city are as grim and depressing as those of Hopper, as eerie as those of Tooker. The three Soyer brothers—Raphael, Moses, and Isaac—painted the city's poor and lower-middle-class workers with a good deal of insight and compassion. In his *Office Girls,* of 1936 (plate 112), Raphael Soyer shows us working girls, as did Sloan in his *Sixth Avenue Elevated at Third Street* (plate 108). But Soyer's girls, rather than being out for a good time, are going to or from work. Hemmed in by the crowd, whose presence they do not acknowledge, they are absorbed in coping with life in the city. Soyer penetrates below the surface: the faces of his urbanites reveal the stresses of living in a large city. His people—appealing, even noble—are marked by the frailties, anxieties, and emotional traumas inflicted on them by their environment. How different these portrayals are from the skin-deep likenesses produced by the Ash Can School.

The Depression of the 1930s and the federal encouragement of art that was set in motion by it led to a demand for the decoration of public buildings, and a number of American painters, influenced by the Mexican revival of mural painting under such artists as Diego Rivera, José Clemente Orozco, and David Alfaro Siqueiros, worked on a large scale, making their paintings part of the surface of a wall. This was a kind of painting that could be grand and impressive, and it fitted in with the Regionalist movement of this time when America as a whole was committed to the course of isolationism entered upon at the end of World War I. Thomas Hart Benton strove to catch in his scenes a flavor and look that was authentically American. A Missourian, and proud of it, Benton in his *City Activities*, of 1930–31 (plate 113), endowed his urbanites with the forthright, bumptious energies of his country neighbors, basing their muscular figures on the sculpture of Michelangelo. Benton's city paintings, at first glance, appear to be a throwback to that optimistic, carefree view of the city popularized by the Ash Can group—people dancing, bringing up their young, eating together, working together. Such it is, except that Benton overstates everything. He has to shout to make his point, a point that the Ash Can group made naturally, without strain. Benton's figures are forced into poses, the compositions of the scenes are elaborately contrived. These paintings are propaganda pieces, restating the virtues of city life that were most in evidence during the first two decades of the century.

EARLY MODERNISTS. Between about 1910 and 1930 the new artistic movements in European art were making themselves felt in America. American artists became acquainted with the new art on their trips to Paris and at the exhibitions in the famous gallery, "291", of the

113. Thomas Hart Benton. *City Activities.* 1930–31.
Egg tempera and distemper on linen mounted on panel, 7′7″ × 12′ 1 1/2″.
New School for Social Research, New York

photographer Alfred Stieglitz (named after its address on Fifth Avenue). But most important in the spread of the modern movements in the United States was the sensational Armory Show of 1913 held in New York, in which the works of many of the leading European artists were seen along with the works of a number of progressive American painters.

Several of the American modernists who were influenced by the Armory Show found the urban landscape, especially New York, an appealing subject. Compared with the works of the realist painters, theirs were much further removed from the actual appearance of the city; they were more interested in the "feel" of the city, more concerned with the meaning behind appearance. However, both the painters of the Ash Can School and the later realists were still tied to nineteenth-century or earlier styles, while the early modernists shared in the international breakthroughs of the art of the twentieth century.

The greatest of these breakthroughs was Cubism, developed most fully in France by Pablo Picasso and Georges Braque between 1907 and 1914, which brought about a major revolution in Western painting. It overturned the rational tradition that had been built upon since the Renaissance. In Cubism, natural forms were broken down analytically into geometric shapes. No longer was a clear differentiation made between the figure and the background of a painting: the objects represented and the surface on which they were painted became one. The Cubists abandoned the conventional single vantage point of the viewer, and objects depicted from multiple viewpoints were shown at the same time.

One of the first American artists to adopt the Cubist principles was Max Weber, a Russian-born Jew who came to America when he was ten. From 1905, when he was twenty-four, until 1908, he was in Europe, mainly in France, where he studied under Matisse, came to know the primitive painter Rousseau and the Cubist Robert Delaunay, and studied at first hand the works of Cézanne and Picasso. His *Chinese Restaurant*, of 1915 (plate 114), shows influences of the broad color patterning of Matisse and, more directly, of the Synthetic Cubism of Picasso. Like Picasso, in his Cubist paintings of the time, Weber has taken his subject, here the interior of a Chinese restaurant, and has broken up and reconstituted its parts. Recognizable are wall moldings, parts of draperies, the tiled floor, and a figure or figures within the restaurant. The jarring arrangements of the patterning, quite unlike some of Picasso's quieter groupings, suggest the hectic pace of urban night life. Overlappings of what may be a single figure are used to capture motion in two-dimensional terms, a device that contributes to the overall mood of excitement. Even the subject is different from that of the typical European Cubist painting—the secluded world of the café with its musical instruments and wine glasses. Weber went far afield for his sources. The discordant colors of the *Chinese Restaurant*—a checkered yellow-and-black pattern, pinks, oranges, deep blues—may owe something to such non-European sources as North American Indian art, for example the blankets of the Navaho and the Hopi Kachina images.

By the overlappings of the figure within his restaurant interior, Weber independently arrived at an approach characteristic of the pre-World War I Italian movement called Futurism, in which the stages of an action were shown simultaneously next to one another, as in stop-action, or multiple-exposure, photography, sometimes intermingled with their surroundings in a kaleidoscopic fashion so as to convey the impression of violent movement.

Another American painter, Joseph Stella, was doubtless directly influenced by the Futurists. Born in Italy, he emigrated to New York in 1896, when he was nineteen, then

returned to Italy in 1909 or 1910; while in Europe, he attended the large Futurist exhibition held in London in 1912. The next year, back in America, he painted his *Battle of Lights, Coney Island* (plate 115). So crowded are the elements that the subject—a crowd milling about the amusement palaces of the famous seashore resort—can hardly be made out. It is a subject that would have lent itself to the Italian Futurists. The circular composition contributes to the sense of swirling motion. The colors, garish greens, reds, and violets, hint at the raucous hedonism pervading the scene.

In Stella's *Brooklyn Bridge* of 1917 (plate 116), the motion is stilled, as the various parts of the bridge, carefully drawn, are meticulously separated from one another. The structure is presented symmetrically, with care given to the rendering of the ray-like cables and wires, and the cathedral-like tower at the far end, beyond which the skyscrapers can barely be discerned. But there is great drama here as well. We are made to look directly into the maw of the spanning cables. The shimmering play of light and dark partially obscures the careful arrangement, and makes the bridge seem aglow in a cold flame. Perhaps more than any other structure in or around New York the Brooklyn Bridge represented to a young immigrant like Stella the technological and engineering prowess of America. The awesome history of the bridge is well known. John A. Roebling, the engineer who conceived the project and designed the bridge, died as the result of a fall while surveying the location of the Brooklyn foundation tower in 1869, shortly before the actual construction began. His son Colonel Washington A. Roebling, who spent as much time under compression as many of his workers, early became a victim of caisson disease and had to supervise the work from a wheelchair. Completion of the bridge took a toll of at least a score of lives. When it was opened after thirteen years, this great cable suspension bridge stood as a durable symbol of America's emerging machine age and the unity of the people of New York City. Stella became obsessed with the structure, and according to his own account had trembled with emotion when he set foot upon it. The poet Hart Crane is believed to have based on Stella's paintings his uncompleted epic poem on America, "The Bridge" (1930), which contains such lines as the following:

> Through the bound cable strands, the arching path
> Upward, veering with light, the flight of strings,—
> Taut miles of shuttling moonlight syncopate
> The whispered rush, telepathy of wires.
> Up the index of night, granite and steel—
> Transparent meshes—fleckless the gleaming staves—
> Sibylline voices flicker, waveringly stream
> As though a god were issue of the strings. . . .

In his *Lower Manhattan,* of 1922 (plate 117), John Marin catches the excitement and vigor of the city by setting his buildings at an angle, and by merging one with another, as the European Cubists did with their forms. The rapid, jagged strokes in watercolor also contribute to this effect. The full title is *Lower Manhattan (Composing Derived from Top of Woolworth)*. The Woolworth Building, opened on April 24, 1913, was the New York headquarters of the retail store tycoon Frank Woolworth, who by 1918 owned a thousand stores. Almost 800 feet high, it was for a while New York's tallest building. It had been painted by Marin

114. Max Weber.
Chinese Restaurant.
1915. Oil on canvas, 40 × 48″.
Whitney Museum of
American Art, New York

115. (*below*)
Joseph Stella.
*Battle of Lights,
Coney Island.*
1913. Oil on
canvas, 76 × 84″.
Yale University
Art Gallery,
New Haven. Gift of
the Collection
Société Anonyme

116. Joseph Stella.
Brooklyn Bridge.
1917. Oil on
canvas, 84 × 76″.
Yale University
Art Gallery,
New Haven. Gift of
the Collection
Société Anonyme

117. John Marin. *Lower Manhattan (Composing Derived from Top of Woolworth).* 1922. Watercolor, 21 5/8 × 26 7/8″. The Museum of Modern Art, New York. Acquired through the Lillie P. Bliss Bequest

118. Charles Sheeler. *Classic Landscape.* 1931. Oil on canvas, 28 7/8 × 36″. Collection Mr. and Mrs. Edsel Ford, Detroit

119. Charles Sheeler. *Church Street El.*
1920. Oil on canvas, 16 1/8 × 19 1/8″.
Collection Mrs. Earle Horter, Philadelphia

even while it was being erected. The star-shaped paper form stitched onto the bottom of the picture represents light flashing from the gold-leaf cupola on the old World Building, which could have been seen easily from the top of the Woolworth Tower; it is a wonderfully appropriate shape because in it are coalesced the sense of outward radiation and thrust expressed in the buildings themselves.

While Weber, Marin, and Stella found in the city motion, excitement, and turbulence, and the inspiration for occasional technical virtuosity, Charles Sheeler and Charles Demuth found in it order and containment, and it impelled them toward geometrical purity. Sheeler and Demuth were prominent among those who came to be called Precisionists, in reference to their hard, linear manner of rendering objects, even those on the distant horizon. In Sheeler's *Classic Landscape,* of 1931 (plate 118), the faraway smokestacks are as distinct as the rails in the foreground. All objects are handled in the same even way. It is an impersonal treatment, for the evidence of the creative act, the brushstrokes and the method of the application of the paint, are imperceptible. Beyond this, the Precisionists simplified objects down to their basic shape, their geometric core, often eliminating surface details and patterns and textures; Sheeler's *Church Street El,* of 1920 (plate 119), is an extreme case. Demuth likes some surface patterning, but keeps the geometrical core intact. Found in many of his architectural landscapes—for example his *Modern Conveniences,* of 1921 (plate 120)—are mysterious beams or rays that flicker over the surfaces of buildings. Because of their stylistic interests, the Precisionist painters were drawn to the clear-cut geometrical objects in industry and architecture—whether barns in Bucks County, Pennsylvania, smokestacks of factories, factory buildings, grain elevators, or New York skyscrapers.

Besides being a matter of form, Precisionism constituted a way of looking at the world—and at the city. It was a way that grew out of the stylistic approach but was not necessarily

120. (*opposite*)
Charles Demuth. *Modern Conveniences.*
1921. Oil on canvas, 27 × 20″.
The Columbus Gallery of Fine Arts,
Columbus, Ohio.
Ferdinand Howald Collection

121. Stuart Davis. *Town Square.*
1925–26. Watercolor, 11 3/4 × 14 3/4″.
The Newark Museum. Purchase, 1930

dependent on it. The Precisionists evoked a magical world in which all activity is suspended. In Sheeler's *Classic Landscape,* a scene of the Ford River Rouge Plant, near Detroit, industrialism is stripped of its rough edges, of its people, of all signs of activity, and an airless world of pristine purity is created. The smoke of the chimneys has been filtered of its grime and soot and become as white as the fleeciest of clouds; it floats serenely above, contrasting with the rectangular rhythms of the factory blocks below. Perforating the factories are large windows, but since these are darkened and are at a distance from the frontal plane, we gain no access to the activities within. This is an art of powerful fantasy; at its core is the vision of a gross materialism wrapped about by a transcendental purity and innocence. The Precisionists either could not see or refused to see what was before their eyes. All that was unpleasant, brutal, or even overly complex was avoided, as was anything that had to do with passion and feeling. What emerges in Precisionism, which ignored so much of experience, is a view of the world and of the city that is incredibly simple and naive and yet is compelling for its suggestion of timeless perfection.

Stuart Davis's *Town Square,* of 1925–26 (plate 121), is less extreme than Sheeler's *Church Street El*—both in the severity of forms (although the painting as it stands could not have been done without a knowledge of Cubism) and in the aura of timelessness that is evoked. There is more in it of the actual, of the contours of a specific town square in a particular place in America. But still the innocence prevails—in the lack of activity, the absence of troubling overtones of any kind. Here is a townscape painted during the Roaring Twenties, that age of euphoria and exuberance when it was believed that antitrust laws and other reforms could cure all social ills. After 1930, a far different view of the city emerges. But up until 1930, whether in the realist paintings of the Ash Can School or in those of the early modernists, the city in America is revealed positively as a place of coming together, of explosive energies, of technological triumphs, of magical quietude, but never as a place of boredom, foreboding, or tragedy.

122. Robert Motherwell. *The Voyage.* 1949. Oil and tempera on paper mounted on composition board, 48 × 94″. The Museum of Modern Art, New York. Gift of Mrs. John D. Rockefeller, 3rd

CHAPTER EIGHT
Nonobjective Painting

Art historians like to speculate as to why revolutions in art occur when they do. In the case of the appearance and efflorescence of nonobjective painting a major contributing factor is held to be the development of photography, which superseded painting as a means of representing (at least in black and white) the appearance of the material world. It may be that the wider use of microscopes and telescopes, which provided views of the intricate configurations of cellular tissue and of the stars and nebulae of galactic space, was another stimulus. From about 1880, at least in Europe, the way was being prepared for the breakthrough to a nonrepresentational art: the expressive power of colors and shapes and composition in painting was being realized, and subject matter began to play a secondary role.

The breakthrough occurred at a time then regarded as being especially auspicious for a new order of things—just prior to and during World War I. For Kandinsky, the Russian painter who is generally credited with producing, in 1910, the first independent nonobjective painting (an untitled watercolor), nonobjective painting was spiritual in the purest sense because it was unencumbered by the materialism of represented objects and was therefore in keeping with the reworking of the world that was at hand; the Dutch artist Piet Mondrian felt that his nonobjective forms reflected nature's unchanging, eternal relationships.

EARLY NONOBJECTIVE PAINTING. By the second decade of this century, painters both in Europe and in America were painting nonobjectively. There were no recognizable objects in their paintings, even though their shapes, lines, and colors may have been ultimately derived from visible appearances. Nonobjective painting had been used, of course, from earliest times in the decoration of walls and floors and on the surfaces of clay vessels; now such painting was to take its independent place in the repertory of art.

It is not very widely known that in the same year that Kandinsky painted his historic watercolor the American artist Arthur Garfield Dove painted a series of nonobjective subjects. However, Kandinsky, who wrote important treatises justifying the existence of nonobjective art, consistently maintained this mode of painting, while Dove returned to it only sporadically.

The earliest American group of nonobjective painters, the Synchromists, were not as mystically inclined as Kandinsky; their philosophic basis was new color theories, and they arrived at their completely objectless art by way of Impressionism and Cézanne. The principal figure of the group, Stanton Macdonald-Wright, observed that Synchromism (which literally means "with color") is to color what symphony is to sound. In other words, the Synchromists' goal was to create on the canvas an ensemble, a coherent whole, using only color. They rejected representational form altogether: the illusion of volumes was to be brought about only through the interrelation of colors (which were never to be isolated by an outline) or through modeling by the manipulation of lights and darks.

In 1907, at the age of seventeen, Macdonald-Wright left his native California for Paris, where he saw and admired the work of Cézanne, of the Pointillists Seurat and Signac, and of Matisse, who was just then taking the Parisian art world by storm. He also read texts dealing with the scientific and quasi-scientific analyses of the effects of color. He found that he could arrange colors in groups analogous to musical chords, placing the individual color notes at given intervals. The scale of yellow, for example, consisted of seven "notes": yellow, green, blue, blue-violet, red-orange, yellow-orange, and back to yellow. The tonic chord of a color consisted of the first, third, and fifth "notes"; the first, fourth, and fifth "notes" constituted another important chord. All other chords were subordinate to these two. As in music, minor chords could be formed that had a subtle air of sadness or unresolvedness. Thus colors, too, had certain emotional values. Macdonald-Wright believed that to express the feeling of a harsh clash the colors red-orange and blue-green should be used. These are the dominant colors in his *"Oriental." Synchromy in Blue-Green*, of 1918 (plate 123).

In his Synchromist paintings, Macdonald-Wright used the human body as the basis of the formal arrangements. This did not mean that parts of the body were actually depicted, although in some of the paintings there is the vague appearance, as in the right-hand part of

the *"Oriental,"* of a limb held under tension. Rather, throughout the canvas a rippling surface movement was used which suggested the taut movement of muscles beneath the skin. Macdonald-Wright acknowledged his debt to Michelangelo, who made the expressiveness of the human body the basis of his art. In focusing on the body, Macdonald-Wright stood apart not only from the other Synchromists but from contemporary European nonobjective painters, including the Cubist-Orphist Robert Delaunay, who represented only one of a number of sources that affected the development of Synchromism.

Another Synchromist—in fact a co-founder of the school—was Morgan Russell. He had earlier studied architecture, then was in Paris on and off from 1906; he did not meet Macdonald-Wright until 1911. (It was Russell who in 1913 in a show in Paris exhibited the first painting under the banner of Synchromism.) In 1908, Russell was much taken with the recent luminous work of the Impressionist painter Monet, whom he described as the "master of light." He became part of the avant-garde world of Paris: he was friendly with the legendary poet, writer, and art critic Guillaume Apollinaire and with Modigliani, and he frequented the salon of Gertrude and Leo Stein, where he met, among many others, Matisse and Picasso. In 1909, contemplating sculpture as a career, he received instruction from Matisse and studied the work of Michelangelo and Rodin. Because of his earlier leanings toward architecture and sculpture, Russell tended to give his painting a distinct planar organization that sets it apart from the more painterly production of Macdonald-Wright. In his *Synchromy in Orange: to Form,* of 1913–14 (plate 124), the flat slabs of color, sharply hewn out and articulated in clear-cut shapes, are in direct contrast to the swirls and gestures of paint found in Macdonald-Wright's work. The choice of color is also different: defining the planar construction there are not the subtle chords of interweaving, flickering off-key hues, but slabs of pure or nearly pure color.

In the second decade there were working nonobjectively in America perhaps a dozen artists who while not rallying to the name Synchromism were either directly or indirectly influenced by Macdonald-Wright or Russell. Thomas Hart Benton, who, as we have seen, was to emerge as one of the important Regionalists of the 1930s, was close to Macdonald-Wright and experimented with the Synchromist manner for a couple of years but, in his own words, "drew back from wholly abandoning representational form for a disembodied color form." Andrew Dasburg came under Russell's influence in 1914 in Paris, where he, too, was interested in Matisse's painting. His *Sermon on the Mount,* of 1914–15 (plate 125), is a rather unintegrated but startling work with its bright red wedges superimposed on a backdrop of open and closed gray-blue rectangular compartments. Oppositions predominate: the verticals and horizontals counter the diagonals, and the bright reds counter the more neutral tones. The *Sermon* may have been conceived with a specific idea in mind, for the diagonal elements in the lower part of the painting could allude to the slope of a mountain. In an interview in 1965, Dasburg recalled that he painted the picture one morning under the inspiration of the idea of Moses and Christ as opposed to the war.

The aftermath of World War I brought an end to America's first strong commitment to nonobjective art. The reliance of American artists on European modernism of the second decade virtually disappeared during the 1920s as a consequence of the political isolationism that developed as a reaction to the disillusionment over the war and the peace that followed it. This isolationism, which set the tone for the next two decades, came about rather abruptly

123. (*above*)
Stanton Macdonald-Wright.
"Oriental." Synchromy in Blue-Green.
1918. Oil on canvas, 36 × 50″.
Whitney Museum of American Art,
New York

124. Morgan Russell.
Synchromy in Orange: to Form.
1913–14. Oil on canvas, 11′3″ × 10′3″.
Albright-Knox Art Gallery,
Buffalo, New York.
Gift of Seymour H. Knox

125. Andrew Dasburg.
Sermon on the Mount.
1914–15. Watercolor, 11 3/4 × 9 1/4″.
Roswell Museum and Art Center,
Roswell, New Mexico

with America's refusal to join the League of Nations, a step that became final in 1919. Macdonald-Wright, disappointed that he could not convert all the early modernists in New York to Synchromism, returned to California in 1919, and that year helped produce the first full-length stop-motion film ever made in full color, creating for it at least five thousand pictures in pastel. For the next decade he painted in relative seclusion, and did a good deal of writing on color theory. Dasburg, his most radical work behind him, after the second decade moved in and out of Cubist stylizations. Russell returned to figurative painting from 1916 to 1920, then again worked nonobjectively, from 1920 to 1929—but in Europe.

The modernism of the 1920s was characterized by the more moderate Precisionism of Charles Sheeler, Charles Demuth, and Georgia O'Keeffe. During this decade the dominant trend was the naturalism of such Regionalists as Grant Wood and Thomas Hart Benton and of the Social Realists, including Ben Shahn, many of whose works are informed with deep awareness of injustices in American society and of the suffering brought on by the Depression.

Still, in the period between the end of World War I and the rise of Abstract Expressionism in the mid-1940s, some nonobjective painting was produced by such of the early modernists as Arthur Dove, Georgia O'Keeffe, and Stuart Davis, and by a younger group of artists including Josef Albers, Willem de Kooning, Arshile Gorky, John Graham, Ad Reinhardt, and Ilya Bolotowsky, who grouped themselves in 1936 in an organization called American Abstract Artists. Much of the work of the American Abstract Artists depended on the geometrical ideals of Mondrian and the artists who clustered about the Bauhaus before the progressive German school of design was closed by the Nazis in 1933. Ilya Bolotowsky's *White Abstraction,* of 1934–35 (plate 126), has the look of the geometrical layout renderings

126. Ilya Bolotowsky. *White Abstraction.*
1934–35. Oil on board, 34 3/4 × 19″.
Grace Borgenicht Gallery, New York

127. Mark Tobey. *Tundra.* 1944.
Tempera on board, 24 × 16 1/2″.
Collection Roy R. Neuberger, New York

and the two-dimensional planar experiments typical of the Bauhaus. By and large, though, the nonobjective painting in the 1930s of Albers, Gorky, de Kooning, Reinhardt, and other Abstract Expressionists was preparation for their better-known work of the 1940s and 1950s.

At least one major nonobjective artist developed fully in the late 1930s and early 1940s. This was the Seattle-based painter Mark Tobey, who worked independently of organizations and is not identified with a particular group. His inspiration came not from any school of European modernism but from Far Eastern calligraphy, in which he became interested in the early 1920s and which he studied especially closely in Japan in 1934. His delicate white forms and linear skeins came to be known as "white writing." In his *Tundra,* of 1944 (plate 127), barely perceptible but unidentifiable images are entangled within a web of gossamer-thin lines. Tobey was a member of the Bahai World Faith, a creed affirming the basic unity of all men and the ultimate concordance of all religions. The web of *Tundra* is indivisible: it has no beginning or end or discernible divisions.

ABSTRACT EXPRESSIONISM. As was predictable, a radical change in outlook became apparent in the work of nonobjective, or abstract, artists after the war. The name of the new movement—Abstract Expressionism—explains itself: while still abstract, it does not exclude content or emotion. Though the Abstract Expressionists were closely associated with one another and exhibited together consistently from the mid-1940s through the 1950s (in some cases even earlier), they did not constitute a school in the formal sense. What was common—

besides the basic nonobjective approach—was the extraordinarily large size of the canvas and the type of procedure. These two factors were interrelated. For the canvas was regarded as a sort of arena wherein the artist was to act out or, better, fight out his impulses through the explosive application of paint. Jackson Pollock used to tack the canvas onto the wall or floor so that he could work on it from all sides at once. He spoke of being literally *in* the painting. The Abstract Expressionists valued the unpremeditated, unconscious gesture and tried to avoid pre-planning their paintings in any way. Each canvas was a new opportunity for working out inner impulses, and there was to be no reliance on past paintings, either their own or others'. To release their impulses, many Abstract Expressionists applied the paint in impetuous fits and starts, at times jabbing, pushing, and throwing it at the canvas; not only brushes but fingers and sticks were used as a means to working as quickly and directly as possible. Many of their canvases look unfinished and indeterminate because there was to be no thought, no conscious process, between the original impulse and the actual application of the paint. We can see for ourselves on these canvases the movements of the artist's hand, the hesitations and gropings, the very dynamics of the creation of the painting. It was to be expected that the Abstract Expressionists would set store by the psychoanalytical theories of Freud and Jung in view of the importance given by them to the unconscious in the explanation of behavior.

The Abstract Expressionists and the critics who defended them against the charge that these quick, spontaneous paintings were no more than mere doodling or mere decoration insisted that the successful Abstract Expressionist painting had content, and they pointed out the danger and drama involved in the painter's rescuing the welter of strokes, drippings, and splatters from the edge of chaos. Attributing content to these paintings did not mean that the viewer could or should find recognizable images within them. Rather, it meant that inevitably he would find in the arrangement of the nonobjective forms references to or reminders of events or feelings or experiences in his own life. That such references are not willed by the painter but come about of their own accord does not detract from their importance. For example, Clyfford Still's *1957-D No. 1*, of 1957 (plate 128), suggests the flaking away of surfaces and the emergence of new ones underneath. This may suggest to the viewer the erosive processes of nature and, by extension, may conjure up for him the wearing away of interests or friendships as new ones are formed. For each viewer, different images in nature and different events, a different cast of characters, different circumstances, will be evoked. But even if the viewer makes no subjective associations beyond the simple idea of destruction through flaking away, he will still have grasped the painting's content.

Abstract Expressionism gave American painting the lead in avant-garde art. New York replaced Paris as the major art capital, and European painters turned to their American colleagues for direction. The boldness and assertiveness of Abstract Expressionism came about as a concomitant of America's new economic, political, and military supremacy. Of the major powers, only America emerged from the most devastating war in world history unbombed and uninvaded; following the war, only America possessed what was then the ultimate weapon—the atomic bomb, with which she had forced Japan's surrender in 1945. With her vast wealth and resources America proceeded, through the Marshall Plan, the Truman Doctrine, and other treaties and measures, to strengthen and, in some cases, to build up from the ashes impoverished nations which she believed stood with her against Communism.

128. Clyfford Still. *1957-D No. 1*. 1957. Oil on canvas, 9'5" × 13'3".
Albright-Knox Art Gallery, Buffalo, New York. Gift of Seymour H. Knox

The political isolationism that had followed World War I was no longer regarded as a viable policy. Abstract Expressionism left behind not only the insularity of Regionalism and Social Realism but the close dependence on or similarity to European modernism that was evident in Synchromism.

While in general Abstract Expressionism reflected the new world status of America, in particular it could have been brought forth only in New York. The speed of the metropolis and, more important, the impersonality that its vastness fostered moved these painters to produce, as a kind of antidote, an art celebrating impulsive freedom. They came from far and wide to live and work in New York: Arshile Gorky (often grouped with the Abstract Expressionists) came from Armenia; de Kooning, from the Netherlands; Pollock, from Wyoming; Kline, from Wilkes-Barre; Still, from North Dakota; Rothko (originally), from Russia; Guston, from Montreal; and Reinhardt, from Buffalo. Some came expressly to join the New York School, while the others who had arrived before 1940 stayed on to remain part of it. These American artists were encouraged by the mere presence in New York of celebrated European modernists who came as émigrés between 1930 and 1941. They included Mondrian, André Masson, Salvador Dali, André Breton (who, in 1924, had written the first Surrealist Manifesto), Roberto Echaurren Matta, and Max Ernst (whose wife Peggy Guggenheim was among the first to exhibit Abstract Expressionist paintings).

Before arriving at their nonobjective or near-nonobjective art, several of the Abstract Expressionists worked in a variety of figurative styles that were influenced by European artists. Especially important among these influences were the Synthetic Cubism of Picasso,

the organically derived Surrealism of Miró, the automatic Surrealism of Masson and of Matta, and the early nonobjective work of Kandinsky. Pollock and a few others also drew upon American Indian art, whose mythological symbols they, taking Jung's lead, found of universal significance as archetypes drawn from man's primordial past. In Pollock's *Male and Female*, of 1942 (plate 129), where the figures facing one another—or facing the viewer, it seems, the next moment—are recognizable, the combination of frontal and profile views and the partial breaking up of the figure derive from Picasso's Synthetic Cubism. But the quick improvisatory approach and the violent brushwork are Pollock's own. The gaudy reds, the thin strips of yellow squeezed apparently from a small tube, the spattered streaks of white, yellow, green, and black, reveal an approach antithetical to the more carefully finished European modernist works of the time. In the work of Franz Kline, Willem de Kooning, and Philip Guston, there is a similar approach to painting. Their work stands on the brink of failure: it is in this daring and willful rejection of talent that the power of their art lies.

By 1947 Pollock altogether eliminated recognizable forms from his work. In his *Autumn Rhythm*, of 1957 (plate 130), he used a tracery of freewheeling lines to create an impenetrable network. The energy is continuous and all-embracing. The paint is now dripped rather than brushed onto the canvas. Yet, despite the spontaneity of execution, a sense of grandeur emerges. The browns, grays, and blacks vaguely suggest the colors of autumn leaves, and one may be led to think of the wind blowing vigorously about. These associations (the title may have been added afterward) come, if they do, not from any actual representation of leaves but from the colors and the way in which the lines interlace and the spots of color are spaced—and from the enormous scale of the work, which makes it a kind of environment enveloping the viewer rather than merely a painting to be looked at. *Autumn Rhythm* measures more than 8 1/2 by 17 feet, dimensions somewhat above even Thomas Moran's astounding *Grand Canyon of the Yellowstone*, of 1872 (plate 64). To tack such canvases onto the wall or the floor while working was essential, since they exceeded easel size. (It should be noted that while all paintings lose something in reproduction, in the case of illustrations of Abstract

129. Jackson Pollock.
Male and Female. 1942.
Oil on canvas, 73 1/4 × 49″.
Collection Mrs. H. Gates Lloyd,
Haverford, Pennsylvania

130. Jackson Pollock. *Autumn Rhythm*. 1957. Oil on canvas, 8′9″ × 17′3″.
The Metropolitan Museum of Art, New York. George A. Hearn Fund, 1957

Expressionist works, whose effect depends to a large degree upon scale, the loss is particularly noticeable.) The superficial similarity of *Autumn Rhythm* to Tobey's *Tundra* (plate 127) is misleading, for the Pollock work is based on an entirely different aesthetic and technique. Further, *Tundra* is far smaller in scale, executed more meticulously.

De Kooning's *Marilyn Monroe*, of 1954 (plate 47), is one of his more placid interpretations of a theme that he treated with savage intensity in his *Woman* series, comprising a number of paintings of female figures that materialize from a chaos of forceful, slashing brushstrokes. Something of the same violence is seen in *Excavation,* of 1950 (plate 131), which appears to be composed of fragments of torsos crowded together, with parts of the environment affixed here and there. In places the bodies merge into or become doors or windows opening onto a crowded but illegible backdrop. Not only do flesh and environment intermingle; the one can serve as, or become, the other. De Kooning, developing out of a style in which he used relatively few images, then responding to the fragmentations of European Analytical Cubism, by the mid-1940s was packing those images so densely that each part of the canvas could give rise to multiple responses. In *Excavation* even the parts of the body are subject to permutations and sudden shifts of scale. What begins as a back or a shoulder suddenly seems to change into a finger; a bit of a jaw is fastened to what may be a shoulder or a knee. The colors are mostly flesh tones, but spots of garish red and blue occur. The rhythms of the forms are collisive, changing direction and scale abruptly. De Kooning's ambiguous spaces and the hybrid forms inhabiting them allude to the dislocated spaces—the "no-environment"—in which the rush of urban life takes place. Such paintings as *Excavation,* then, are visual metaphors of the anxiousness and rootlessness underlying the swift-paced life of their time. De Kooning observed in 1951, "Art never seems to make me peaceful or pure, I always seem to be wrapped in the melodrama of vulgarity."

144

Like most of the Abstract Expressionists, Franz Kline worked in a figurative mode before he espoused nonobjective painting. He emphasized the abstractness of his new approach by restricting himself to a monochrome palette. From about 1949, when he made the transition, until 1957 or 1958, he limited himself to huge black streaks and bars applied with 6- or 8-inch brushes to a painted white ground. The effect is gained, without hue, through the direction, thickness, density of surface, apparent speed of movement, and area of the black strokes compared to the white surfaces. The black and white were meant to be of equal importance, the one interacting with the other. The notion that Kline was influenced by Oriental calligraphy is a mistaken one. The raw energy and size of Kline's strokes are worlds away from Far Eastern sophistication and delicacy. Nor is it correct to see in the black-and-white paintings the broad configurations of such specific objects as skyscrapers or railroad trestles. Works like *Painting No. 7*, of 1952 (plate 132), bear no relation to visual reality, though the energy of application, the largeness of format, the immeasurability of space both laterally and in depth, allude to the vastness and speed of the urban experience. It is possible that Kline settled on black and white because of his early memories of the coal country around Wilkes-Barre, Pennsylvania, where he was raised; none of the other Abstract Expressionists who worked in black and white were as committed to this format as Kline.

Abstract Expressionism is also known as Action Painting, in recognition of its emphasis on the creative act itself. One of a number of artists who have put the Abstract Expressionist ethos into words, Philip Guston, has described his painting in terms suggesting those used by modern Existentialists, to whom the issue of personal freedom versus determination is paramount. In painting, he said, "even as one travels toward a state of 'unfreedom' where only certain things can happen, unaccountably the unknown and the free must appear." For the final disposition of colors is really destined, as they are products of unconscious and unrecognized memories of the past. What was destined becomes known only when the painting is completed. The final painting, then, is both recognized and, since the past has been recast into a different state, new and surprising. The Abstract Expressionist painter in the person of Guston epitomizes the plight of modern man, poised between the freedom he imagines himself to have and a variety of inner controls.

Many of Philip Guston's nonobjective paintings from 1951 to 1958 show a central zone

131. Willem de Kooning.
Excavation. 1950.
Oil on canvas, 6' 8 1/8'' × 8' 4 1/8''.
The Art Institute of Chicago

132. Franz Kline. *Painting No. 7*. 1952. Oil on canvas, 57 1/2 × 81 3/4".
The Solomon R. Guggenheim Museum, New York

composed of a loose network of short horizontal and vertical strokes quivering out of a more broadly textured field. A characteristic painting of 1954 is entitled *Zone* (plate 133). The colors are soft and delicate, perhaps somewhat influenced by a trip to Italy in 1948, when Guston painted in the Mediterranean light; the mood produced is one of gentleness, even melancholy. The average viewer, who thinks in terms of freedom and determinism, still senses the tenuous, hesitant way the strokes were applied, and thus recognizes Guston's struggle to reconcile "unfreedom" with "the unknown and the free."

In these works of Pollock, de Kooning, and Guston, dominant throughout is an energized movement, a constant restlessness. In the works of other Abstract Expressionists, including Rothko, Still, Motherwell, Reinhardt, and Newman, there are areas of unmodulated color, and the movement is slowed down. This does not mean that the latter group does not work impulsively and improvisationally, only that each stroke is not the product of a momentary impulse. For them impulsiveness is balanced by a degree of premeditation.

In 1947 Mark Rothko eliminated from his paintings any directly recognizable detail, and in 1950 he reduced his rather diffuse nonobjective forms to two to four large bands or rectangles, softened at the edges. These large, apparently slow-floating, cloudlike forms offer the viewer asylum, a relief from the convulsive movements and hesitations and gropings of our earthbound existence brought to mind by the paintings of Pollock, de Kooning, and Guston. Some of these bands, or rectangles, such as the large light-orange form occupying most of the upper half of *Number 10*, of 1950 (plate 134), seem to move gently forward to

133. Phillip Guston. *Zone*. 1954. Oil on canvas, 46 × 48 1/4".
Collection Mr. and Mrs. Ben Heller, New York

134. Mark Rothko. *Number 10*. 1950.
Oil on canvas, 90 3/8 × 57 1/8".
The Museum of Modern Art,
New York.
Gift of Philip C. Johnson

135. Josef Albers. *Homage to the Square: Apparition*.
1959. Oil on board, 47 1/2 × 47 1/2".
The Solomon R. Guggenheim Museum, New York

136. Barnett Newman. *Covenant.* 1949. Oil on canvas, 48 × 60″. The Hirshhorn Museum and Sculpture Garden, Smithsonian Institution, Washington, D.C.

137. Ad Reinhardt. *Red Painting.* 1952. Oil on canvas, 60 × 82″. Marlborough Gallery, Inc., New York

envelop the viewer. These paintings are capable of evoking deep psychic responses. For some they summon up images of death, for others, images of gardens or fleecy clouds.

The fact that the rectangles are indeterminate both in color and in boundary makes all the difference. To compare *Number 10* with Josef Albers's *Homage to the Square: Apparition* (plate 135), one of countless versions where the boundaries are clean-cut, is instructive. Rothko's rectangles are like ghostly residues. Albers's painting, where the approach is one of exactitude and precise craftsmanship, does not produce mysterious emotional responses. Albers, who arrived in America in 1933 after teaching at the Bauhaus, represents a disciplined and restrained branch of nonobjective painting that stood opposed to Abstract Expressionism. Some of his color theories were important for the development of the Optical painting of the 1960s (see Chapter Nine).

The fissure-like images reminiscent of crags or crevices, or perhaps of flames or bolts of lightning, in Clyfford Still's *1957-D No. 1* (plate 128), must have been outgrowths of the artist's experience of the great plateaus and mountains in the western part of the United States and Canada. From 1904, the year of his birth (in Grandin, North Dakota), until 1920, Still lived in Spokane, Washington, and Bow Island, Alberta, Canada; from 1935 to 1941 he taught at Washington State University. The latitude of Abstract Expressionism offers room for personal visions molded by the artist's unique experience. In Still's paintings there is the suggestion of vast terrains and of the erosive processes at work in them, subjects that had been dealt with representationally in the second half of the nineteenth century by the Rocky Mountain School artists (see plates 62–64).

The two artists allied with Abstract Expressionism who were least gestural in their approach were Ad Reinhardt and Barnett Newman. Using large areas of unmodulated paint and perfectly ruled straight lines forming neat rectangles, they seem at first glance closely related to the color and formal experiments of Albers. Actually they saw their art not as perceptual problems per se, but as expressions in modern terms of mystical ideals.

Newman was deeply responsive to the mystical and poetic elements of his Jewish heritage, and his thinking was infused with concern for man's age-old need to address the unknowable, to invoke the sublime. There are biblical references in the titles of many of his works:

Abraham (1949), *Covenant* (1949), *Eve* (1950), *Joshua* (1950), *Adam* (1951), *Jericho* (1968–69), *The Stations of the Cross* (1958–66). He became convinced, though, that the symbols and images of the past were outmoded, and that meaningful visualizations of the sublime have to be cast in new terms. For the *Covenant*, of 1949 (plate 136), Newman used two vertical strips running down an otherwise uninterrupted field of pure color. The color seems stretched to its extremes. The left-hand strip emerges faintly, tremblingly, like a voice struggling to be heard. In other works the edges of the vertical strips are eroded, as though weakened or ravaged by the surrounding field of color. There is never, then, the utter perfection and coolness of Albers. Also, Newman insisted that he did not work with remnants or compartments of spaces (as Albers did) but instead declared the indivisibility of the entire space.

Reinhardt's color fields hover on the brink of indivisibility. In his *Red Painting*, of 1952 (plate 137), the various rectangles of different shades of red are discernible only on careful examination. The painting can be seen as a quest for unity, and, by extension, for timelessness and endlessness. Reinhardt was not motivated to perform visual pyrotechnics for their own sake, as were such Optical painters of the 1960s as Richard Anuszkiewicz, whose work is superficially similar to his. Long interested in Far Eastern religions, Reinhardt sought in his art an ideal similar to that of Zen Buddhism. He objected to what was momentary, spontaneous, expressionistic, accidental, and unconscious—in short, the very qualities prized by such gestural painters as Pollock, de Kooning, and Guston. Instead, he tried to create an art changeless and timeless, "vacant and spiritual, empty and marvelous." In this there is a denial of the self analogous to that suggested by the art of Rothko and Newman. Reinhardt stands within Abstract Expressionism in his concern with the human predicament and his awareness of human frailties. In its way his art, like that of these other New York artists, transcends its basic repertory of shapes and colors ostensibly representing nothing, and contains references to various states of being and experiencing.

An early member of the New York School, and perhaps the most articulate of the Abstract Expressionists, Robert Motherwell drew freely from such modern European masters as Picasso, Matisse, Miró, and Mondrian, from French Romantic literature, and from current events. His series of paintings under the title *Spanish Elegy*, begun in 1949, was inspired by the Spanish Civil War of 1936. A painting of 1949, *The Voyage* (plate 122), was named after Baudelaire's poem *Le Voyage*. The strong verticals in this work give it a sense of progression or movement across the canvas.

It is Motherwell's view that to give oneself over completely to the unconscious is to become a slave, and that automatism in art ought to be a means to be controlled, a means to bend to the invention of new forms. Indeed, Motherwell's art, while capitalizing on the surprising and the unpredictable, has a European sense of finish and polish that reveals his thorough familiarity with European modernism. Motherwell strikes a balance between intellect and impulse. We do not find in him the turbulent power of Pollock, Kline, and de Kooning, the sense of asylum offered by Rothko, the sense of spiritual quest felt in Newman and Reinhardt. But if his daring is not as great—because he did not reject his talent—his contribution is no less significant. Motherwell represents a rarely cultivated aspect of Abstract Expressionism: only he could, or would, have so sensitively placed the strip of green amidst the blacks, whites, ochers, and yellow in the lower right-hand corner of *The Voyage*. If this sensitivity is atypical of the group, it completes its gamut.

138. Roy Lichtenstein. *Whaam!* 1963. Magna on two canvas panels, 5′ 8″ × 13′4″. The Tate Gallery, London

CHAPTER NINE
Painting in the 1960s

After having dominated American art for about fifteen years, Abstract Expressionism appeared to have run its course, and around 1960 its influence as a vital approach came to an end. These artists had made their statement, and the times called for something new. This does not mean that Abstract Expressionist works were no longer being painted; it means that the most progressive artists and the most influential museums and galleries became interested in new developments, those of the 1960s. In trying to account for the change, one has to keep in mind the American passion for change for its own sake, in jobs, homes, fashions —and art. But this fact does not really help us understand why the new painting of the 1960s took the precise turn it did; we have to consider some of the many and rapid changes that had been taking place in American life since the end of World War II.

In the years since 1945 the standard of living of the average American rose substantially, as was widely evidenced by the proliferation of all sorts of material goods, from cars to kitchen appliances, from TVs to tractors. These goods were to be found everywhere in ever-increasing numbers—to the point where they molded the American way of thinking and reacting. The manufactured products with which Americans surrounded themselves and which they used continuously provided readymade experiences and blunted their sensitivities. The impact of grisly automobile accidents and the brutalities of war became almost agreeable when they were pictured in slick magazines or on the TV screen or in paintings by Andy Warhol. By air-conditioned cars, by deodorants, by canned and other "convenience" foods, by all the multiplying props of the new consumer society, American life was depersonalized and standardized. Andy Warhol's painting of a hundred Campbell's Soup cans (plate 142), with its rows of identical items, becomes an allegory of the supermarket.

These changes profoundly affected American painting, in style as well as in content. Andy Warhol, Roy Lichtenstein, Claes Oldenburg, and James Rosenquist not only used standardized, mass-produced goods as the subjects of their paintings but came as close as they could to the shiny, impersonal containers in which these products were packaged. The paintings looked like advertising signs, labels on cans, or comic-book pages blown up. In some cases, the paintings, except for the change in size, looked like the "originals." Thus objects so commonplace that we hardly examined them closely or gave them a second thought appeared in paintings as large, bright designs. The new Pop (from "popular") Art was disturbing, first because such ordinary, "unworthy" objects were chosen as subjects for paintings, and second because in their treatment they were hardly, if at all, transformed. To such charges, the Pop painter might have replied: Why are these objects unworthy? Since they are everywhere and are around us constantly, they govern our lives. And the exact label, the exact brand, is what they are about. If it is argued that we should get below the label, get below the surface, the answer might be: Do we want that in America? In short, Pop painting was presented as a "new realism," an accurate measure, or reflection, of contemporary life in America.

The artists of the 1960s paint in styles that are calculated to be cool and detached. By neither commenting on nor transforming the object, Pop artists are not criticizing commercialism and advertising; they are simply reporting that these are all-pervasive. Yet in its blasé imitation of the methods of advertisement, its breaking down of the boundary between fine art and advertisement, Pop Art becomes thought-provoking, even threatening. Similarly cool and impersonal is the nonobjective painting of the 1960s—Post-painterly Abstraction. In contrast to the Abstract Expressionist paintings, which were their forerunners, these paintings of the sixties do not tell us how they were made. We do not perceive, as we did in most Abstract Expressionist works, the gestures and brushstrokes of the artist, which reveal the gropings and decisions that went into the final product.

Post-painterly Abstraction does not lend itself to individual personal interpretation: we do not tend to read our own experiences into this later nonobjective painting as we could with Abstract Expressionism. In Franz Kline's *Painting No. 7,* of 1952 (plate 132), even though there was no recognizable object, we could sense a certain violence in the application of the paint and could read into this certain of our own experiences. To be sure, these experiences would differ for each individual. Like Warhol's soup cans, however, the nonobjective paint-

ings of the 1960s proclaim that they are what they seem—Ellsworth Kelly's *Blue Red Green*, of 1962–63 (plate 149), for example, the combination of blue, red, and green shapes. The piece is, like industrial art, perfect in its glossy finish. It suggests nothing beyond itself, requires no interpretation, encourages no extension of meaning or reading into on the part of the viewer. (Contributing to this new effect was the use of paints having acrylics as their medium, so that bright, lustrous, even surfaces would be produced. It is not accidental that acrylics should have gained wide acceptance during the 1960s.)

In a sense, this development suggests the end point of American pragmatism and inventiveness—a matter-of-factness so complete that the way is closed to human imperfections and yearnings. The vanguard art of the 1960s refers ultimately to the affluent life of the 1960s, a life grown bland with too many comforts. This, though, is not all of America in the 1960s, nor all of its painting; it is the most interesting. Ironically, the majority of the collectors of Pop Art have been the groups least associated with Pop objects themselves and most specifically the target of its implicit social criticism.

POP ART. Two artists who may be considered as bridging the gap between Abstract Expressionism and Pop Art are Jasper Johns and Robert Rauschenberg. Though, like the Pop artists, they often deal with commonplace, mass-produced items, they do not use the glossy format of brand-new products just off the assembly line. There is still evident in their work the brushwork typical of the Abstract Expressionist.

A favorite subject of Johns during the Abstract Expressionist period was the American flag, something familiar to virtually all Americans and to most people of the world. In *Flag*, of 1958 (plate 139), Johns presented the flag not as the emotion-charged emblem that prisoners in Vietnam have, at great risk, made out of scraps of their clothing, or that opponents of American foreign policy have burned as a symbol of imperialist aggression, but simply as a pattern on a cloth. Removed from any environment, not windblown, not waving at the top of a pole, not even set within a three-dimensional space, John's flag is what it is in its literal, de-symbolized sense, without any suggestion of emotional overtones or political implications. Johns has enabled us, if such a thing is possible, to see the American flag through the eyes of a person who has lived in utter aloneness, away from news broadcasts, newspapers, and the visual stimuli of the streets. By presenting the flag so impersonally, and without context, Johns anticipated the deadpan approach of Andy Warhol and other of the Pop painters. By eliminating any sense of measurable space, he foreshadowed the utter flatness of many of the Post-painterly Abstractionists of the 1960s.

For *The Bed*, of 1955 (plate 140), Robert Rauschenberg splashed a pillow and a patchwork quilt liberally with paint. At first glance the piece seems an affront. What is important is the issues that have been raised: when we think about it, it is not mainly the randomness that is at stake here—there was felt to be randomness in Abstract Expressionism too—but the fact that the artist has taken over real objects from the environment and by transmuting them has asserted his identity as an artist. We have been used to thinking of art as being separate from life. We have regarded art as an interpretation (even when it shows life as it really is) or a distillation, as something apart from the undisturbed flux of events and the ongoing existence of objects. In a way, Rauschenberg has extended much further the experiments of the Ash Can group, who painted scenes of real people in everyday situations, as

139. Jasper Johns. *Flag.*
1958. Encaustic on canvas, 41 1/4 × 60 3/4".
Collection Mrs. Leo Castelli, New York

contrasted, for example, with the fantastic visions of Ryder and Blakelock and the near-abstractions of Whistler. But while the Ash Can School gave us a painted facsimile of life, Rauschenberg has entered into its flow, has taken a piece of it and given it back to us unaltered—as, well, what? Once we ask whether *Bed* deserves to be called a work of art, we are falling into Rauschenberg's trap. He might answer that the distinction between what is art and what is not can only be made by the artist. On his near-replicas of comic-book pages, Roy Lichtenstein observed that the closer he is to the original, the more threatening he becomes. Once we wonder what the difference is or ought to be between life and art, the artist has succeeded in making his point. Analogous to Rauschenberg's *Bed* are musical compositions in which street sounds have been incorporated into the score or long intervals are left so that such random sounds as a cough in the audience can become part of the composition.

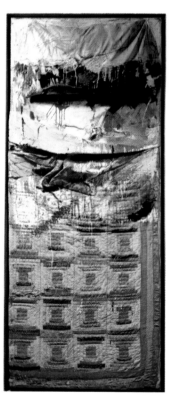

140. Robert Rauschenberg.
The Bed. 1955.
Combine painting, 74 × 31".
Collection Mr. and Mrs.
Leo Castelli, New York

141. Andy Warhol.
Campbell's Soup. 1965.
Oil on canvas, 36 × 24".
Kimiko and John Powers,
Aspen, Colorado

142. Andy Warhol.
One Hundred Campbell's Soup Cans.
1962. Acrylic on canvas, 82 × 52".
Collection Karl Ströher, in the
Hessisches Landesmuseum, Darmstadt

Andy Warhol's *Campbell's Soup*, of 1965 (plate 141), is an extension of the issues Rauschenberg raised ten years earlier. So accurately has Warhol reproduced the labeled can, so scrupulously has he avoided any interpretation, any commentary, that we feel we are looking at a replica of the object itself, flattened and blown up. What disturbs us is that this ordinary, everyday item should be made the subject of a painting, in the first place, and that, in the second, it should be painted on so huge a scale. Our first feeling might be that here, in contrast to Abstract Expressionism, is an art that is easily understood. But it is not so much understanding as recognition that is offered us. In making himself into a mere recording machine and in choosing to reproduce an item that is a discard—one so commonplace that we would never give it a second glance—Warhol is challenging our attitudes about art and, perhaps, our values. We tend to infer a social comment on the extent to which we are controlled by the advertising media and have surrendered our independence and freedom of choice: perhaps we are operating as mechanically as the method used to manufacture a Campbell's Soup can, or as the method Warhol used to make his painting.

In identically repeating on his canvas commonplace and immediately recognizable images—Coca-Cola bottles, Marilyn Monroe (as she appeared on billboards and in magazines),

143. Andy Warhol.
Green Disaster 2. 1963.
Acrylic and liquitex
on canvas, 8′10″ × 6′7″.
Collection Karl Ströher,
in the Hessisches
Landesmuseum, Darmstadt

dollar bills, and, of course, Campbell's Soup cans—Warhol is applying the principle of mechanical mass production used in advertising and in commercial enterprises. Mechanical reproduction, Warhol is indicating, is a salient fact of our affluent society, and is a legitimate artistic technique. Repetition tends to work in one of two ways. Either the repeated object makes a firm impression upon us or we become glutted with it (and its importance thus becomes diminished). Warhol is at pains not to overwhelm us. On a canvas of 1962 he painted the Campbell's Soup can one hundred times (see plate 142) rather than twenty times or a thousand times—neither of which would have been as effective. Warhol used the idea of duplication in a variety of ways. One of his works consists of huge exact replicas of Brillo boxes that he had manufactured. He even sent a "replica" of himself on a speaking tour for which he had been booked!

Warhol has also made use of press photographs of scenes of disaster, incorporating them into his paintings with the utmost objectivity. Automobile wrecks have been a favorite motif: an example is the *Green Disaster 2*, of 1963 (plate 143). Remarkably, in these scenes, through the very understatement of the means used, feelings of horror appropriate to the event are aroused. So accustomed have we become to the exploitation of the sensational aspects of a disaster that an impersonal recording enables us to see the event anew, to give vent to our own feelings and make our own associations—just as in Truman Capote's book *In Cold Blood*

our sense of horror and outrage was heightened through the neutral recording of minute details. Perhaps more significant, when we consider that Warhol's approach to his painting of a Campbell's Soup can is precisely as cool and detached as his approach to a human disaster, we realize with a shock the intended irony of this absurd uniformity in the way in which images and events are presented.

In Roy Lichtenstein's *Whaam!*, of 1963 (plate 138), so close is the artist to the original comic strip and so visually imposing has he made the comic-strip image through its enlargement (to over 13 feet in length) and its bright colors that, like Warhol, he is celebrating the banal and the commonplace. A very important distinction to make is that *Whaam!* is not a painting of war but a painting of a comic strip about war. We know that participation in an air battle causes physiological changes: the heart beats faster, adrenalin flows into the bloodstream, and so on. Reading a comic book about war produces far fewer physiological changes—if any. The experience is a vicarious one. Through his painting Lichtenstein has removed us one stage further from the experience itself. In doing this so obviously he is saying something about the level at which we experience or, rather, do not experience events. Excitement is packaged and fed to us. We respond to the facsimiles of experiences. Again, Lichtenstein's *Sussex*, of 1964 (plate 144), is not so much a painting of an airy mountainscape as an adaptation of a glossy travel poster advertising that mountainscape. Gone are the softness of the clouds and the openness of the great vista as they are normally experienced. What we have is a thrice-removed copy of a mountainscape—a copy of a copy (poster) of a copy (painting) of the original. Lichtenstein does not try to hide this fact; he makes it very clear what he has done, and that is what makes his painting so witty and, upon reflection, so threatening.

144. Roy Lichtenstein. *Sussex.* 1964. Oil and magna on canvas, 36 × 68″. Collection Robert Rosenblum, New York

The largest Pop painting ever produced is James Rosenquist's *F–111*, of 1965 (plate 145), 10 feet high and 86 feet long. It is 13 feet longer than the fighter-bomber which it represents and with which it deals. During the 1950s Rosenquist was a painter of billboards, a fact that might account for the gigantic scale as well as the format and style of the *F–111*. Rosenquist seems to be making a direct indictment of American war policy. He has both combined and equated, through similarity of form, subjects having to do with American consumerism and the destructiveness associated with the F-111: a little girl's head appears under a hair dryer that looks like the nose cone of the plane; spaghetti takes on the general look of human entrails; behind an umbrella is an umbrella-shaped atomic explosion; running along the panels is the fuselage of the F-111.

The jumble of images and the fact that they are seen at different distances from us, in different degrees of completeness, from different angles, and in different colors makes it impossible for us to take in the work as a whole. So chaotic an impression befits the course of America during the 1960s. For there has gone along with the standardization of items a proliferation so excessive that our senses are continually being assaulted. Traffic signals, billboards, a variety of sizes and types of facades of buildings, moving cars, swirling crowds, window displays perpetually bombard us. By making his 86-foot painting enfold the spectator, Rosenquist has simulated the pop culture of the 1960s. Typical of American painting of the 1960s are, on the one hand, works in which the elements are too multifarious for us to assimilate comfortably, and, on the other, works in which the elements are utterly homogeneous, as in Warhol's painting *One Hundred Campbell's Soup Cans*, of 1962 (plate 142), or Kenneth Noland's *Bend Sinister*, of 1964 (plate 146), with its repetition of chevron shapes.

Claes Oldenburg's *7-UP*, of 1961 (plate 147), is a painting in enamel on plaster. (Olden-

145. James Rosenquist. *F-111* (portion). 1965. Oil on canvas with aluminum, 10 × 86′.
Collection Mr. and Mrs. Robert C. Scull, New York

146. Kenneth Noland. *Bend Sinister*. 1964. Acrylic on canvas, 7′8 3/4″ × 13′5 3/4″.
The Hirshhorn Museum and Sculpture Garden, Smithsonian Institution, Washington, D.C.

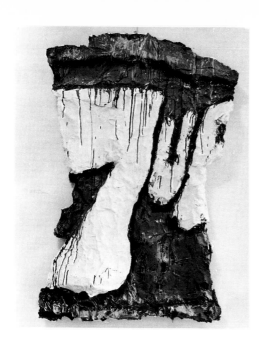

147. Claes Oldenburg. *7-UP.* 1961. Enamel on plaster, 50 1/8 × 37 3/8 × 6 1/4". Collection Mr. and Mrs. Burton Tremaine, Meriden, Connecticut

148. (*opposite, left*) Helen Frankenthaler. *Interior Landscape.* 1964. Acrylic on canvas, 8' 8 3/4" × 7' 8 3/4". San Francisco Museum of Art. Gift of the Women's Board

149. (*opposite, right*) Ellsworth Kelly. *Blue Red Green.* 1962–63. Oil on canvas, 91 × 82". The Metropolitan Museum of Art, New York. Arthur H. Hearn Fund, 1963

burg is best known for his later works, the ingloriously sagging soft sculptures, huge food items, clothing, and appliances made out of vinyl stuffed with kapok.) The *7-UP* (though it is over 50 inches high) looks like a label crumpled up and discarded by a litterbug during the rush of daily activities. It is one of the left-over remains of civilization, a piece of human detritus. It is unusual to see a Pop painter producing an image of a consumer item that is not spanking new. Oldenburg is reinforcing from another direction some of the notions advanced by Warhol and Lichtenstein in their allusions to the standardization of consumer items (and the vicariousness of experience they bring in their train); he is alluding to the shortness of their life, their perishability.

POST-PAINTERLY ABSTRACTION. The name applied to the style of nonobjective American painting that followed, and grew out of, the Abstract Expressionist movement—Post-painterly Abstraction—refers to the nature and appearance of the painted surface. The Abstract Expressionist surface is termed painterly because paint has obviously been applied to it through the gesture of the brush, palette knife, or even hand: there are loose, broken strokes, overlappings of one area by another, and scumbled, flaked, unevenly handled surfaces; the actual material manipulation of the paint (usually oil) is revealed to us. In the nonobjective Post-painterly Abstraction painting of the 1960s the paint is not so much applied to the canvas as stamped onto or stained into it. This is achieved in many cases by the artist's leaving off the neutral undercoat or ground; the paint (usually acrylic) thus actually becomes part of the unprimed canvas. This is why there is no longer any sense of background and foreground, even as ambiguous a sense as there had been in Abstract Expressionist painting. The difference is apparent if we compare de Kooning's *Excavation,* of 1950 (plate 131), with Helen Frankenthaler's *Interior Landscape,* of 1964 (plate 148). The Abstract Expressionist work—with its sense of foreground and background, with its disclosure of the strokes and gestures of the artist, or at least its sense of the manipulation of the paint, still apparent in Rothko's *Number 10,* of 1950 (plate 134), and with its contrasts of light and dark—gives evidence of being composed of various parts. In Post-painterly Abstraction the work is much more unitary. To break away from the painterly approach and achieve a sense of absolute continuity of

surface and indivisibility of parts, certain nonobjective painters of the 1960s employed means that the Abstract Expressionists would never have considered. Thus to color the surface of his *Bad Bugaloo,* of 1968 (plate 150), Jules Olitski did not directly handle the paint with brush, stick, or palette knife; he sprayed it onto the canvas in a mist of tiny, nearly invisible droplets.

An aspect of Post-painterly Abstraction is Hard-Edge painting, in which sharp, clear contours are emphasized. Hard-Edge painters keep the distinctions between adjacent color areas absolutely clean and mechanically precise. There are no boundaries between such areas; rather, one color cuts directly into another. In Barnett Newman's *Covenant,* of 1949 (plate 136), there is still some wavering of line; there is none in Ellsworth Kelly's *Blue Red Green,* of 1962–63 (plate 149). In Kelly's work the subtle curves have an unhesitating spareness and sureness, and it is in such control that the best of Post-painterly Abstraction is to be found. One color area presses down upon another, but the flaring curves hold all three in check. Kelly's beautifully controlled draftsmanship is most apparent in his pencil drawings of an individual fruit, flower, or leaf; simply by a decisive outline, without modeling, without any indication of the surroundings, he catches the unique character of each.

In the *Blue Red Green* and in Kenneth Noland's *Bend Sinister,* of 1964 (plate 146), there is no sense of spatial illusion, as there still is in Newman's *Covenant* (plate 136) and in Abstract Expressionism in general. That is, there is no space cell, or box, in which something is taking place or in which something is placed. No color area is in front of or behind another. Yet there is expressed in these paintings an energy in terms of implied movement that can be resolved only outside the painting. In the *Blue Red Green* the curved shape, in order to be completed at its horizontal ends, would have to break through the frame at the left and right sides, and in the *Bend Sinister* the chevron shapes, which seem to move downward, threaten to break through the frame at the bottom. But so steely smooth are the painted surfaces, so deliberately formed are the color shapes, that we cannot relate these paintings to anything in our own experience, as we could with Abstract Expressionism.

Frank Stella extended the experiments of the Hard-Edge painters to their logical conclusion. As with Rauschenberg's *Bed,* with Warhol's painted soup cans, and with Lichtenstein's enlarged comic-strip frames, what it is important for us to grasp in Stella's work is

151. Richard Anuszkiewicz.
Injured by Green. 1963.
Acrylic on masonite, 36 × 36″.
Collection Janet S. Fleisher,
Elkins Park, Pennsylvania

150. Jules Olitski. *Bad Bugaloo.*
1968. Acrylic on canvas, 9′9 1/4″ × 43 1/4″.
The Hirshhorn Museum and Sculpture Garden,
Smithsonian Institution, Washington, D.C.

the concept, or idea. Whereas Rauschenberg, through his *Bed* and other such works, sought to bridge the gap between art and ongoing life, Stella sought to set up an unbreachable boundary between the two realms.

There is a clear relationship between the spectator and a painting of a person or a tree, since these are subjects familiar from the environment. The Abstract Expressionists, though eliminating recognizable subjects, set up relationships between us and the very apparent strokes and gestures through which their paintings were created, strokes and gestures that we could "feel" by following and retracing them in our minds. Hard-Edge painters, like Kelly and Noland, in shunning both the revealed gestures and strokes and the notion of measurable space (what has been referred to above as a sense of foreground and background) left only one aspect to which it would be possible for us to relate—the rectangular shape of the canvas with its framing edge. That is, a format was set up beforehand within which the painted shapes, the artist's formulations, occur. Stella strove to eliminate even that link by his creation of shaped canvases. In his *Union IV,* of 1966 (plate 152), we see that the direction and shape of the markings are determined with rigorous logic, from the outside in, by the shape of the frame. Once this was done, the painting became a self-referring object rather than a representation of something, however remote, even of stripes or curves or chevrons. Here, for Stella, was as literal a meaning of the concept of painting as possible. The painting must

152. Frank Stella. *Union IV*. 1966. Fluorescent alkyd and
epoxy paint, 8'7" × 14'6". Collection Richard Meier, New York

153. Morris Louis. *Saraband*. 1959. Acrylic
on canvas, 8'4 1/2" × 12'5". The Solomon R. Guggenheim Museum, New York

be entirely what it seems to be, complete within itself, utterly independent, not connected with or alluding to anything outside itself. In the shaped canvases of Stella there is a blatant matter-of-factness that partakes of the spirit of Warhol's painted soup cans.

Using the same enamel-smooth surfaces and precise forms as the Hard-Edge painters, the Optical (or Retinal) painters arrived at very different results. There is a methodical control and deliberateness to the means by which they attained their results that links their work to Hard-Edge painting. Studying the way the eye responds to various visual stimuli, they made their paintings into studies of optical illusions, probably regarding a painting as successful in proportion to the degree to which it stimulated visual reactions. After prolonged study of an Optical painting, eyeblink, headaches, and dizziness often ensue. In his *Injured by Green*, of 1963 (plate 151), Richard Anuszkiewicz used circles of two sizes and three colors, blue, light blue-green, and dark green, set against a field of uniform red. The different colors of the circles make the red appear to change from orange to a very dark red, depending on which area of the painting we are looking at. It is a far cry from this painting to the remoteness of Stella's paintings. We have no choice but to be affected by Optical paintings once we look at them—assuming we are not color-blind. But in its way, Op Art was a reaction to the spontaneity and subjectivism of Abstract Expressionism. The reactions to Op Art are automatic and involuntary.

There is something involuntary, too, about our reaction to the paintings of Morris Louis, but the end result for the viewer is one of comfort, even escape into the delicate waves of color that flow effortlessly one into another. Louis's "veil" paintings (so called from their suggestion of transparency), like the *Saraband,* of 1959 (plate 153), work as pure color, emerging before us like an atmospheric mist. No object is discernible, nor is the gesture of the artist's hand. The color itself serves as the total content. The only link with Abstract Expressionism is the impact made by the gigantic size of the canvas. Exactly how Louis produced his paintings is still a mystery. It is believed that he thinned his acrylic paint down to a liquid wash and directed the flow of this medium over the inclined surface of the unstretched canvas, thus never manually applying his paint, as the Abstract Expressionists had, but relying on its natural flow, controlled intermittently through the tilting of the canvas. To have brought about through these means such other-worldly resonances of color is an unmatched achievement. Louis died in 1962 at the age of fifty, when he was at the height of his powers. He worked outside the New York orbit, in Washington, D.C., where he was associated with Kenneth Noland and other so-called color-field painters.

Helen Frankenthaler achieves her mysterious lyrical effects by the use of thin washes. She works directly on the raw, unprimed canvas, painting with the canvas stretched on the floor, as Pollock had done, so that she can move freely about and avoid any orientation of up or down, vertical or horizontal. Her idea for her "all-over" paintings, exemplified by the *Interior Landscape,* of 1964 (plate 148), is related to her close study of Pollock's later works. As with Louis, there is the appearance of effortlessness in the way her forms are projected. They seem to arrive of themselves, without the intervention of the artist, like floating clouds. But there is not the serious invitation to us to lose ourselves in these forms, to transcend completely our earthbound materiality, that there had been, for example, in Rothko's *Number 10,* of 1950 (plate 134). Frankenthaler's effortlessness is marked by a lighter lyricism, a poetic fragility of a less serious tone than Rothko's.

154. Richard Diebenkorn. *Landscape I, 1963.*
1963. Oil on canvas, 60 1/4 × 50 1/2".
San Francisco Museum of Art.
Purchased with contributions of
Trustees and Friends in memory of
Hector Escobosa, Brayton Wilbur,
and J. D. Zellerbach

By spraying his paint onto the canvas, Jules Olitski completely eliminates the boundaries between painted areas and achieves a brilliant atmospheric effect. In looking at his paintings we feel that we are looking at a bright, immeasurable haze. The very surface of the canvas seems to have dissolved before us and opened up in the *Bad Bugaloo,* of 1968 (plate 150). Olitski, like Louis and Frankenthaler, has found another means of bypassing the exposed gestures and violent brushwork of Abstract Expressionism.

Landscape is a theme that has persisted strongly in American painting to this day. Working in a broadly brushed, improvisatory manner showing the influence of Abstract Expressionism, the San Francisco Bay region painter Richard Diebenkorn has wielded into a wedge-patterned, semiabstract totality the housetops, streets, empty asphalt lots, and hillsides of what appears to be an American suburban development, and has called it *Landscape I, 1963* (plate 154). The painting contains little in the way of a natural setting—and even that is trimmed into something smooth and tame, simply a patch of green within a cityscape. Bearing witness to man's encroachment upon nature, *Landscape I, 1963,* harks back to Thomas Cole's warning of 1835: "And to this cultivated state our Western world is fast approaching; but nature is still predominant and there are those who regret that with the improvements of cultivation the sublimity of the wilderness should pass away."

By the end of the 1960s, the history of American painting covered a three-hundred-year span. These three centuries saw many changes. From its limited beginnings as a vehicle for portraiture, American painting expanded to embrace the widest variety of subjects; from standing in the shadow of European painting, it stepped out into the bright light of world leadership, with American artists of the 1950s and 1960s developing such major art movements as Abstract Expressionism and Pop Art.

The 1970s have already seen new avant-garde developments in American painting—among them Photo-Realism, or Sharp-Focus Realism, which turns our minds back to the *trompe l'oeil* aspect of Charles Willson Peale's famous *Staircase Group,* of 1795 (plate 49), and to Edward Hopper's vividly naturalistic *Early Sunday Morning,* of 1930 (plate 105). Such similarities serve to remind us that, after all, the material of painting is reality, and that what the painter has to say about reality is art. Movements, or styles, are merely the means of recording, from the point of view of art history, the way an artist says what he has to say.

Index

PLATE NUMBERS ARE IN *italic type*.

Abstract Expressionism, 56, 124, 139, 140–49, 151–52, 160–62, 164
Action painting, 145
Adams, John, 29, 50; *22, 40*
Adams, Samuel, 46; *36*
Albers, Josef, 139, 140, 148; *Homage to the Square: Apparition*, 148; *135*
Allston, Washington, 14, 33, 100–101, 109; *The Angel Releasing St. Peter from Prison*, 101; *Belshazzar's Feast*, 104; *The Dead Man Restored to Life by the Bones of the Prophet Elisha*, 101; *Moonlit Landscape*, 99, 101; *88*
American Abstract Artists, 139
Anuszkiewicz, Richard, 149, 164; *Injured by Green*, 164; *151*
Apollinaire, Guillaume, 137
Ash Can School, 120–24, 126, 127, 128, 133, 153–54

Badger, Joseph, 14, 18; *James Badger*, 14, 60; *8*
Barbizon School, 81
Barlow, Francis C., 38; *30*
Bauhaus, 139–40
Bellows, George, 123–24; *Cliff Dwellers*, 123; *109*
Benton, Thomas Hart, 65, 127, 137, 139; *City Activities*, 127; *113*
Bierstadt, Albert, 76, 148; *The Rocky Mountains*, 76; *63*
Bingham, George Caleb, 84, 87–89, 95; *The County Election*, 88–89, 91, 93; *76*; *Fur Traders Descending the Missouri*, 84, 88; *75*
Blackburn, Joseph, 14, 15, 27, 47; *Isaac Winslow and His Family*, 15; *1*
Blakelock, Ralph, 112–13, 154; *Moonlight*, 113; *100*
Blume, Peter, 106; *The Eternal City*, 106–7; *93*
Blythe, David Gilmour, 90; *Art versus Law*, 90, 94, 120; *78*
Bolotowsky, Ilya, 139; *White Abstraction*, 139–40; *126*
Boone, Daniel, 52; *41*
Bouguereau, Adolphe, 117
Braque, Georges, 128
Breton, André, 142
"Bridge, The," (Crane), 129
Brown, John, 23, 37; *29*
Bryant, William Cullen, 68, 72–73
Bulwer-Lytton, Edward, 104
Burchfield, Charles, 105; *Church Bells Ringing, Rainy Winter Night*, 105; *92*

Burke, Edmund, 100
Burr, Aaron, 32

Catastrophism, 101–4
Catlin, George, 54; *Osceola, the Black Drink, Distinguished Warrior*, 54; *43*
Cézanne, Paul, 108, 128, 136
Chase, William Merritt, 56; *James A. McNeill Whistler*, 56, 64; *46*
Chatham, Earl of (William Pitt), 28–29; *20*
Chirico, Giorgio de, 101
Church, Frederick, 73–75, 148; *The Heart of the Andes*, 74, 76; *62*; *Niagara*, 73; *61*
Cityscapes, 119–33. See also Landscapes
Clark, William, 52; *42*
Cole, Thomas, 68–69, 72, 73, 165; *The Course of Empire*, 104; *The Oxbow (The Connecticut River near Northampton)*, 69; *56*; *The Titan's Goblet*, 104; *89*; *The Voyage of Life* series, 71; *The Voyage of Life: Youth*, 71; *59*
Coleridge, Samuel Taylor, 100–101
Colonial artists, 13–18
Cooper, James Fenimore, 69
Copley, John Singleton, 14, 15, 26, 27–29, 46–47, 50; *The Boy with a Squirrel*, 27; *The Collapse of the Earl of Chatham in the House of Lords*, 28–29; *20*; *Paul Revere*, 46, 47; *37*; *Samuel Adams*, 46; *36*
Corot, Jean-Baptiste-Camille, 39
Crane, Hart, 129
Cubism, 128, 133, 139; Synthetic, 108, 142, 143

Dali, Salvador, 106, 142
Dasburg, Andrew, 137; *Sermon on the Mount*, 137; *125*
Daumier, Honoré, 109
David, Jacques-Louis, 26
Davis, Stuart, 133, 139; *Town Square*, 133; *121*
Delaunay, Robert, 128, 137
Demuth, Charles, 56–59, 104, 132, 139; *I Saw the Figure 5 in Gold*, 56–59; *48*; *Modern Conveniences*, 132; *120*
Diebenkorn, Richard, 165; *Landscape I, 1963*, 165; *154*
Doughty, Thomas, 69, 73; *In Nature's Wonderland*, 72; *60*
Dove, Arthur Garfield, 105, 136, 139; *Fog Horns*, 105; *91*
Duchamp, Marcel, 117
Durand, Asher, 69–71, 73; *The Evening of Life*, 71, 104; *58*; *Kindred Spirits*, 71, 72; *57*; *The Morning of Life*, 71, 104
Duyckinck, Evert, 12
Duyckinck, Gerret, 12; *Mrs. Gerret Duyckinck*, 12–13; *5*

Eakins, Thomas, 54–55, 62, 91, 94–95; *Addie (Miss Mary Adeline Williams)*, 62, 81; *53*; *Between Rounds*, 95; *85*; *The Gross Clinic*, 54–55, 81, 95; *44*; *Max Schmitt in a Single Scull*, 91, 94–95, 120; *80*
Earl, Ralph, 17–18; *Roger Sherman*, 17–18; *12*
Eilshemius, Louis, 117; *Afternoon Wind*, 117; *104*
Einstein, Albert, 56; *45*
Ernst, Max, 142
"Essay on American Scenery" (Cole), 68
Expressionism, 105, 109

Feke, Robert, 15–17; *Mrs. James Bowdoin II*, 15–17; *9*
Frankenthaler, Helen, 160, 164–65; *Interior Landscape*, 160, 164; *148*
Franklin, Benjamin, 29, 47, 59; *22*
Freake Limner, 8, 14, 18; *Mrs. Elizabeth Freake and Baby Mary*, 8, 13; *2*
Futurism, 128–29

Gautreau, Mme. Pierre, 60–62; *52*
Genre painting, 83–97, 119
Gorky, Arshile, 107–9, 139, 140, 142; *Agony*, 99, 109; *96*; *Garden in Sochi*, 99, 108; *95*
Graham, John, 139
Grant, Robert, 42; *32*
"Great Figure, The" (Williams), 58
Gropper, William, 39, 42–43; *Migration*, 42–43; *33*
Gross, Dr. Samuel, 54, 62; *44*
Guggenheim, Peggy, 142
Guston, Philip, 142, 143, 145–46, 149; *Zone*, 146; *133*

Hancock, John, 29, 46; *22*
Hard-Edge painting, 161–64
Harding, Chester, 52, 90; *Daniel Boone*, 52, 87; *41*
Hassam, Childe, 38–39; *Allies Day, May 1917*, 38; *31*
Heade, Martin Johnson, 77–81; *Thunderstorm, Narragansett Bay*, 81; *66*
Henri, Robert, 121, 123
Hesselius, Gustavus, 17; *Mrs. Gustavus Hesselius*, 17; *10*
Hicks, Edward, 19; *Peaceable Kingdom*, 19; *13*
Hirshfield, Morris, 23; *Tiger*, 23; *16*
History painting, 25–43, 119
Homer, Winslow, 38, 92, 95, 121; *Long Branch, New Jersey*, 91, 92–93, 94, 95; *71*; *Prisoners from the Front*, 38, 92; *30*; *Snap the Whip*, 84, 92; *83*
Hopper, Edward, 124, 125–26; *Early Sunday Morning*, 124, 125, 165; *105*; *Nighthawks*, 125–26; *110*
Hudson River School, 68–77, 102

Illusionistic painting, 59, 165
Impressionism, 38–39, 77, 81, 136
Inness, George, 18, 121; *Delaware Water Gap*, 81; *67*; *Home of the Heron*, 81; *69*
Irving, Washington, 84, 109

Jackson, Andrew, 84, 101
Jarvis, John Wesley, 52, 109; *William Clark*, 52; *42*
Jefferson, Thomas, 29, 31, 32, 50, 52, 59; *22*
John Van Cortlandt (unknown artist), 13; *6*
Johns, Jasper, 153; *Flag*, 153; *139*
Johnson, Eastman, 93–94, 95; *In the Fields*, 91, 94, 95; *81*; *Old Kentucky Home*, 93–94; *84*
Jung, Carl, 141, 143

Kandinsky, Wassily, 108, 136, 143
Kane, John, 19; *Self-Portrait*, 19; *14*
Kelly, Ellsworth, 153, 161, 162; *Blue Red Green*, 153, 161; *149*
Kensett, John, 77; *Paradise Rocks, Newport*, 77; *65*
Kline, Franz, 124, 142, 143, 144–45, 149; *Painting No. 7*, 145, 152; *132*
Kooning, Willem de, 56, 139, 140, 142, 143, 146, 149; *Excavation*, 144, 160; *131*; *Marilyn Monroe*, 56, 144; *47*; *Woman* series, 144
Kühn, Justus Engelhardt, 17; *Eleanor Darnell*, 17; *11*

Lafayette, Marquis de, 32, 47; *38*
Landscapes, 67–81, 199. *See also* Cityscapes
Lane, Fitz Hugh, 77; *Owl's Head, Penobscot Bay, Maine*, 77; *55*
Lawrence, Jacob, 39, 43; *"One of the largest race riots occurred in East St. Louis,"* from the series *The Migration of the Negro*, 43; *34*
Lawrence, Sir Thomas, 31, 68
Leutze, Emanuel, 31; *Washington Crossing the Delaware*, 31; *24*
Lewis, Meriwether, 52
Lichtenstein, Roy, 152, 154, 157, 160, 161; *Sussex*, 157; *144*; *Whaam!*, 157; *138*
Limners, 8–13, 18
Livingston, Robert R., 29; *22*
Lorrain, Claude, 88
Louis, Morris, 164; *Saraband*, 164; *153*
Lowell, A. Lawrence, 42; *32*
Luminism, 77–81
Lyon, Pat, 60; *50*

McCrea, Jane, 32; *25*
Macdonald-Wright, Stanton, 136–37, 139; *"Oriental." Synchromy in Blue-Green*, 136–37; *123*
Magic Realism, 100, 101, 106, 107
Manet, Edouard, 64, 93
"March to Virginia, The" (Melville), 38

Marin, John, 129–32; *Lower Manhattan (Composing Derived from Top of Woolworth)*, 129–32; *117*
Martin, Homer, 81; *Harp of the Winds: A View of the Seine*, 81; *68*
Masson, André, 142, 143
Matisse, Henri, 128, 136, 137, 149
Matta, Roberto Echaurren, 142, 143
Maturin, Edward, 104
Mayer, Frank, 90–91; *Labor and Leisure*, 84, 90; *79*
Melville, Herman, 38
Michelangelo, 112, 127, 137
Miller, Alfred Jacob, 35; *Laramie's Fort*, 35; *28*
Millet, Jean-François, 39
Miró, Joan, 108, 143, 149
Modernists, 127–33
Modigliani, Amedeo, 137
Mondrian, Piet, 136, 139, 142, 149
Monet, Claude, 39, 137
Monroe, Marilyn, 56, 144; *47*
Moran, Thomas, 76, 148; *The Grand Canyon of the Yellowstone*, 76, 143; *64*
Morse, Samuel F. B., 26, 33–34, 101; *Lafayette*, 33, 47, 50; *38*; *The Old House of Representatives*, 33; *26*
Moses, Anna Mary ("Grandma"), 19–20; *Hoosick Falls, N.Y., in Winter*, 20; *15*
Motherwell, Robert, 146, 149; *Spanish Elegy*, 149; *The Voyage*, 149; *122*
Mount, William Sidney, 84–87, 95; *Bargaining for a Horse*, 85; *73*; *Eel Spearing at Setauket*, 86; *74*; *The Long Story*, 85; *72*

Nahl, Charles, 97; *Sunday Morning in the Mines*, 97; *86*
Neagle, John, 60; *Pat Lyon at the Forge*, 60; *50*
Neoclassical movement, 26–27, 32, 100
Newman, Barnett, 146, 148–49; *Abraham*, 149; *Adam*, 149; *Covenant*, 149, 161; *136*; *Eve*, 149; *Jericho*, 149; *Joshua*, 149; *The Stations of the Cross*, 149
Noland, Kenneth, 159, 161, 162, 164; *Bend Sinister*, 159, 161; *146*
Nonobjective painting, 136–49

O'Keeffe, Georgia, 104, 139; *Cow's Skull—Red White and Blue*, 99, 104; *90*
Oldenburg, Claes, 152, 158–60; *7-UP*, 158–60; *147*
Olitsky, Jules, 161, 165; *Bad Bugaloo*, 161, 165; *150*
Optical (Op) Art, 148, 149, 164
Orozco, José, 127
Osceola, 54; *43*

Patroon painters, 13, 18

Peale, Charles Willson, 26, 34–34, 59–60; *Exhuming the First American Mastodon*, 35, 59, 101–104; *27*; *Staircase Group*, 59–60, 165; *49*
Peale, Raphaelle, 60; *49*; *After the Bath*, 60
Pelham, Peter, 27
Penn, William, 26; *18*
Photo-Realism, 165
Picasso, Pablo, 108, 128, 137, 142, 143, 149
Pippin, Horace, 23, 37 *Domino Players*, 23; *17*; *John Brown Going to His Hanging*, 37; *29*
Pissaro, Camille, 39
Poe, Edgar Allan, 100, 104
Pointillism, 123
Pollard, Anne, 11; *4*
Pollard Limner, 11–12, 13, 18; *Anne Pollard*, 11–12, 13, 77; *4*
Pollock, Jackson, 124, 141, 142, 143, 146, 149, 164; *Autumn Rhythm*, 143, 144; *130*; *Male and Female*, 143, *129*
Pop Art, 152, 153–60
Portrait painting, 44–65
Post-painterly Abstraction, 152–53, 160–65
Poussin, Nicolas, 14, 88, 89
Precisionism, 56, 104, 132–33, 139
Prendergast, Maurice, 120, 122–23; *Central Park in 1903*, 121; *107*
Pre-Raphaelites, 112
Primitive painting, 18–23

Quidor, John, 109; *Ichabod Crane Pursued by the Headless Horseman*, 109; *The Money Diggers*, 109; *97*

Raphael, 14
Rauschenberg, Robert, 153–54; *The Bed*, 153–54, 162; *140*
Realism, 124–27, 128, 133
Regionalist movement, 64–65, 137, 139
Reinhardt, Ad, 139, 140, 142, 146, 148, 149; *Red Painting*, 149; *137*
Rembrandt, 7, 93
Retinal (Op) Art, 148, 149, 164
Revere, Paul, 46–47; *37*
Reynolds, Sir Joshua, 26, 27
Rimmer, William, 110–12; *Dying Centaur*, 110; *Flight and Pursuit*, 110–12; *98*
Rivera, Diego, 127
Robinson, Edwin Arlington, 124
Rocky Mountain School, 75–77, 148
Rococo style, 26
Rodin, Auguste, 137
Roebling, John, 129
Roebling, Washington, 129
Romanticism, 100, 109
Roosevelt, Theodore, 62
Rosenquist, James, 152, 158–59; *F-111*, 158–59; *145*
Rothko, Mark, 142, 146–48, 149; *Number 10*, 146–48, 160, 164–65; *134*

Rousseau, Henri, 128
Russell, Morgan, 137, 139; *Synchromy in Orange: to Form*, 137; *124*

Ryder, Albert Pinkham, 81, 113–16, 117, 119, 121, 154; *Flying Dutchman*, 114–16; *102*; *Jonah*, 99, 113–14; *101*; *The Race Track (Death on a Pale Horse)*, 116; *103*

Sacco, Nicola, 39–42; *32*
Sargent, John Singer, 60–62; *The Daughters of Edward D. Boit*, 60; *51*; *The Lady with the Rose*, 62; *Madame X—Madame Pierre Gautreau*, 60–62; *52*
Scharl, Joseph, 56; *Albert Einstein*, 56; *45*
Seurat, Georges, 123, 136
Shahn, Ben, 39–42, 139; *The Passion of Sacco and Vanzetti*, 42; *32*
Sharp-Focus Realism, 165
Sheeler, Charles, 104, 132, 139; *Church Street El*, 132, 133; *118*; *Classic Landscape*, 132, 133; *119*
Sherman, Roger, 18, 29: *12, 22*
Signac, Paul, 136
Siqueiros, David, 127
Sloan, John, 120, 122, 124; *Backyards, Greenwich Village*, 121, 122, 125; *106*; *Sixth Avenue Elevated at Third Street*, 122, 126; *108*
Smibert, John, 13–14, 15, 25, 47; *The Bermuda Group: Dean George Berkeley and His Family*, 14; *7*
Smith, Thomas, 10; *Self-Portrait*, 10–11, 13; *3*
Social Realism, 39, 107, 139
Soyer, Isaac, 126
Soyer, Moses, 126
Soyer, Raphael, 126; *Office Girls*, 126; *112*

Stein, Gertrude, 137
Stein, Leo, 137
Steinbeck, John, 43, 65
Stella, Frank, 161–64; *Union IV*, 162–64; *152*
Stella, Joseph, 128–29, 132; *Battle of Lights, Coney Island*, 129; *115*; *Brooklyn Bridge*, 129; *116*
Stieglitz, Alfred, 104, 128
Still, Clyfford, 141, 142, 146, 148; *1957-D No. 1*, 141, 148; *128*
Stowe, Harriet Beecher, 94
Stratton, Samuel, 42; *32*
Stuart, Gilbert, 26, 31, 47–50, 60; *Athenaeum Portrait of George Washington*, 50, 77; *39*; *John Adams*, 50; *40*
Sully, Thomas, 26, 31, 35, 90; *Passage of the Delaware*, 31; *23*
Surrealism, 100, 101, 104, 106, 109, 143
Synchromism, 136–39
Synthetic Cubism, 108, 128, 142, 143

Tanner, Henry Ossawa, 91, 95; *The Banjo Lesson*, 91–92, 95; *82*
"Thanatopsis" (Bryant), 73
Thayer, Webster, 42; *32*
Tintoretto, 100–101
Titian, 14, 100–101
Tobey, Mark, 140; *Tundra*, 140, 144; *127*
Tooker, George, 126; *The Subway*, 126; *111*
Trompe l'oeil, 59, 165
Trumbull, John, 26, 29–31, 33, 69, 101; *The Capture of the Hessians at Trenton*, 29; *21*; *The Declaration of Independence*, 29; *22*
Turner, Joseph, 68, 76
Twachtman, John, 81; *Three Trees*, 81; *70*

Van Dyck, Anthony, 8, 14
Vanderlyn, John, 32–33, 101; *Ariadne Asleep on the Island of Naxos*, 33; *The Death of Jane McCrea*, 32; *25*; *Marius amid the Ruins of Carthage*, 32
Vanzetti, Bartolomeo, 39–42; *32*
Vedder, Elihu, 112; *The Lair of the Sea Serpent*, 112; *99*
Velázquez, Diego, 7, 60
Vermeer, Jan, 7
Veronese, 100–101
Visionary painting, 99–117

Wagner, Richard, 114
Ware, William, 104
Warhol, Andy, 152, 153, 155–57, 160, 161; *Campbell's Soup*, 152, 155; *141*; *Green Disaster 2*, 156–57; *143*; *One Hundred Campbell's Soup Cans*, 156, 159; *142*
Washington, George, 29, 32, 45, 47–50, 59; *21, 23–24, 39*
Weber, Max, 128, 132; *Chinese Restaurant*, 128; *114*
West, Benjamin, 26–27, 29, 31, 33, 50, 100; *The Death of Wolfe*, 26–27; *19*; *Death on a Pale Horse*, 99, 100; *87*; *Penn's Treaty with the Indians*, 26, 27, 100; *18*
Whistler, James Abbott McNeill, 39, 56, 62–64, 121, 123, 154; *46*; *Arrangement in Grey and Black No. 1: The Artist's Mother*, 64; *35*
Williams, Mary Adeline, 62; *53*
Williams, William Carlos, 56–59
Wolfe, James, 26–27; *19*
Wood, Grant, 65, 139; *American Gothic*, 65; *54*
Woodville, Richard Caton, 89–90, 95; *The Sailor's Wedding*, 89–90, 91; *77*
Wyeth, Andrew Newell, 107; *Christina's World*, 99, 101, 107; *94*

ACKNOWLEDGMENTS

I am grateful to Professor William Jewell of Boston University, who first involved me in the study of American art. Among the staff at Harry N. Abrams, Inc., I want to extend my thanks to Lisa Pontell, who secured photographic material and reproduction permissions, and I am most especially indebted to Ruth Eisenstein—no writer was ever blessed with a more efficient and dedicated editor.

"Richard Cory" is reprinted by permission of Charles Scribner's Sons from *The Children of the Night* by Edwin Arlington Robinson. "The Great Figure" is reprinted from William Carlos Williams's *Collected Earlier Poems*, copyright 1938, by permission of New Directions Publishing Corporation.

PHOTOGRAPHIC CREDITS

The author and publisher wish to thank the museums and private collectors for permitting the reproduction of paintings in their collections. Photographs have been supplied by the owners or custodians of the works except for the following plates:

Armen, Newark, 65, 121; Blomstrann, E. Irving, New Britain, Conn., 25; Clements, Geoffrey, New York, 27, 44, 47, 52, 59, 62, 64, 68, 75, 80, 81, 88, 90, 107, 108, 111, 123, 133, 146, 150, 152, 153; Cushing, George M., Boston, 41; Greenberg-May Productions, Inc., 124; Szaszfai, Joseph, New Haven, 21